MISSC
NATURAL WONDERS
GUIDEBOOK

DON KURZ

Cloudland.net Publishing
Cave Mountain, Arkansas

Front cover: *Fog dissipates in the warmth of the sun as the St. Francis River journeys through granite boulders in a setting that seems timeless, Millstream Gardens Conservation Area. (see page 108)*

Photo by Don Kurz (as are all the photographs in this guidebook)

The author and publisher have tried to ensure that information in this book is as accurate as possible. They are in no way responsible for any loss, injury, or inconvenience sustained by any person using the book. We always welcome your ideas for improving this book. Send us your suggestions or updates and they will be reviewed for use in future editions. Thanks!

For questions, comments, and to order autographed copies of this guidebook, contact:

CLOUDLAND.NET PUBLISHING
HC 33, 50–A
Pettigrew, Arkansas 72752 (Cave Mountain)
870-861–5536
Web Page: www.Cloudland.net

The question is not what you look at,
But what you see.
Henry David Thoreau

Preface

Many of us travel far and wide across this magnificent country in order to seek out breathtaking scenery and to experience the fascinating variety of plants and animals and the habitats in which they live. However, there are also many special sites and features right here in Missouri that can captivate our attention and provide many hours of enjoyment. In addition, visiting special areas close to home has the advantage of giving you more flexibility in deciding when and where you want to go and how long you want to stay.

Missouri has a variety of public lands (although occupying only 5% of the state's land mass) that one can visit but it is often not clear what you can do or see once you get there. So, in order to aid in your search, I have reviewed over 1,600 protected areas and have selected 100 that offer a wide variety of special natural features that show why Missouri deserves a second look for closer-to-home travel destinations. And, of these 100 sites, I feel fortunate to have been involved in the acquisition, protection, and management of 27 of them.

I hope that you enjoy the areas that I have selected and maybe many of them will become favorites of yours as they have of mine.

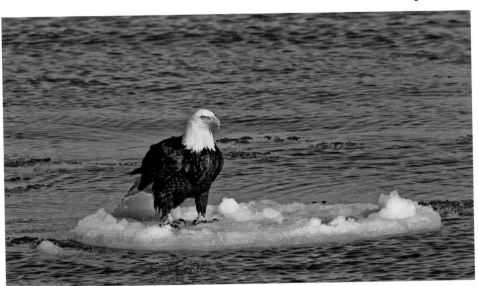

An American bald eagle ice rafting down the mighty Mississippi River.

Table Of Contents

Introduction

When the political boundaries were established for Missouri, the powers-to-be probably didn't realize how diverse they had just made the state in terms of its natural landscape ranging from the glaciated northern half with its rolling hills and deep soil; to the unglaciated Ozarks with its rugged, wooded "mountains;" to the "Bootheel" with its once extensive swamps and bottomland forests; to its grand rivers, the Mississippi and the Missouri. Within these regions, you'll find a diversity of geology, natural communities, flora, fauna, aquatic systems, and scenic beauty that can rival any other state or region.

Fortunately for us, there are many state and federal agencies and nongovernmental organizations that have actively pursued lands and waters throughout the state in order to protect and conserve these natural resources for their own intrinsic values and for the public to utilize and enjoy in the present and for future generations. In the following pages, you will find a selection of some of the finest examples of what this state has to offer.

You can use this book in a couple of different ways. If you want to visit a site close to home or decide to pick a region of the state to explore, simply refer to the state map with the numbered locations and match up the number with the list of sites on the back cover or flip through the book, which is organized in both alphabetical and numerical order. In addition, I have included a listing of areas by feature so if you are interested in seeing a particular type of feature, say prairies, all the areas where you can see this particular feature are grouped together in the table. Also, there are some areas with more than one special feature, which only adds to the experience.

I have also provided a glossary. There are some special terms used when observing and studying geologic features, natural communities, flora and fauna that would be good to understand in order to help make the experience more rewarding. These definitions also aid in explaining why these features are so special and often unique. As with the study and appreciation of any subject, the deeper you get into the topic, the more technical the terms become so I have tried to stay at a general level of understanding and if you would like to dig deeper into any of these subjects, I have provided a list of selected readings in order for you to do just that.

MAPS The maps that are included within each account provide basic information to assist you on the route to follow once you have located the area based on the directions provided. Be sure to have a highway map to get you to the nearest town which I usually include in the directions as a reference point. GPS (Global Positioning System) coordinates are also provided for each parking lot or trailhead so if you have a hand held unit or one for your vehicle, you can simply input the coordinates and navigate to the selected area. For more detailed maps of the area, there are sources on the internet where you can locate the map you want and print it out before visiting the area. MapQuest (www.mapquest.com) is free and will give you detailed driving directions and a map with labeled roads based on the origin and destination information you provide. Topographic (topo) maps are very handy because they provide the most detailed information about an area that is available. Free topographic maps can be downloaded from TerraServer (http://terraserver-usa.com) and Maptech (http://mapserver.mytopo.com/homepage/index.cfm). You can also order or download maps from the United States Geological Survey (USGS) website (www.usgs.gov/pubprod/maps.html). If you are not familiar with reading topo maps, the USGS provides a handy tutorial on their website under "Find map informa-

tion" then click on "Map Symbols." Finally, National Geographic sells DVDs containing all the topo maps for a state. Missouri is on one DVD together with Arkansas and Oklahoma. You can find out more about this product at http://www.natgeomaps.com/topo. The price for a DVD sounds expensive but if you ordered copies of all of the maps for the three states, it would cost you over $20,000!

AREA CONDITIONS All of the areas in this book where in good condition when I last visited them although a couple of trails, notably at Trail of Tears State Park and Johnson's Shut-Ins State Park, where being upgraded. They should be reopened by the time this book becomes available. Also, there were a few sites where I later contacted the area manager and notified him or her of something that needed attention. In a few cases, there were trails that led to scenic views that had grown-up with woody vegetation to the point that the intended view was obscured. Another time, I was travelling to a site but the road was blocked by a large tree that had fallen across it. I later contacted the managing agency about the problem. You too can be proactive by contacting the managing agency using the number provided for each area and by letting them know of a problem that you have encountered. It may be a blocked trail due to trees across the trail or trail signs missing due to neglect or vandalism or some other problem that not only affects your experience while visiting the site but also could be a safety issue that might cause harm to the next visitor.

Before planning to visit a site, checking the website provided for each area is a good idea. State Parks, for example, has a news link that lists those parks that are either closed, undergoing repairs, or contain some other announcement that could affect your visit. If it is a seasonal event such as the migration of snow geese at Squaw Creek National Wildlife Refuge, a call to their office for a bird count could save you a four-hour drive. You may find that the birds haven't arrived yet or maybe the majority of them have already left for the season. (At Squaw Creek National Wildlife Refuge, you can find a link to weekly bird counts on their website during the fall migration.)

So don't be afraid to contact the agency responsible for managing the area if you need additional information or if something is out of order upon visiting the site, especially if it could be a safety issue. From past experience, I know that they will want to get the problem fixed.

HIKING We are fortunate that so many of these state natural wonders have good access so that people from all walks of life have an opportunity to see them. Credit goes to the managing agencies and organizations that have spent time, money, and energy not only to construct trails but to do them in such a way as to not damage or destroy the principal features that they are trying to protect. That is why staying on these well laid out trails honors the goals of the trail planners and builders; it also helps protect sensitive features that were intended to be sustained in the first place. There is one particular feature that commonly lacks trails and that is prairie. The mixture of grasses and forbs (wildflowers) are spread out over a large area and so they can take a bit of trampling by hikers wandering about the site. Plus, the open space nature of this natural community greatly lessens the concern about getting lost because landmarks stay within sight.

The trails in this guide are typically loop trails or linear trails. Loop trails start at a trailhead and guide you, always moving forward, where you eventually finish at the trailhead. Linear trails begin at a trailhead, move you out through an area to a designated ending point then you turn around and head back the same way. Factors such as size of

the area, number of points of interest, location of sensitive sites, and cost usually determine the length and configuration of a trail. Some folks do not like to return on the same trail they began on but linear trails do have their positive aspects. Even though you are walking the same route on the return trip, you are going the opposite direction and there are opportunities to see features from a different perspective. Maybe the lighting has changed, a different view of a feature draws new interest, or something new appears on the scene such as an animal moving through. There is also something relaxing about a return trip. You are already familiar with the route so you know what to expect in terms of trail layout. And, there is a sense of accomplishment and fulfillment because you have already achieved your goal so you can now take the opportunity to relax and let your mind wander as you return on the familiar route.

The trails vary in degrees of difficulty from easy to difficult or strenuous with the latter really not so bad if you take your time. Some folks treat hiking as a marathon and hurry along a trail often missing some special feature, scene, or animal activity. Having just taken the time and effort to get to an area, why hurry through it?

WILDLIFE VIEWING Having patience and being observant are two traits that will enable you to have better success at viewing wildlife. Approaching wildlife too quickly can cause them to run or fly away before you have a chance to observe and appreciate them. You may have heard of the circle of awareness and the flight or fight response. Every animal has a comfort zone and that can change based on how accustomed to humans they become. If, upon approaching a bird, for example, you see their head turn and look at you, you have entered their circle of awareness. The distance from you to the bird varies and there is no way to know what it will be until you see them stop what they are doing and show that they are aware of your presence. If you stop right then and wait, you may see the bird resume their activity. Step in a little closer and stop if you see that the bird has made eye contact with you again. Your slow deliberate advance may reduce the bird's circle of awareness because they have become accustomed to you but at some point they will take flight for their own safety. This is the second stage of an animal's behavior: the flight or fight response. Obviously, the latter instinct is the one that you want to avoid, especially if teeth and/or claws may come into play. In approaching wildlife, use your own judgment and common sense so you don't end up harassing the very animals that you want to observe.

A great way to view wildlife is to use your vehicle as a blind. Blind is a term meaning to cover or conceal. Wildlife are generally more accustomed to seeing a vehicle than an individual so staying in your car can provide you with excellent viewing opportunities. Sometimes leaving the engine running or getting out on the opposite side of the vehicle works in not alarming the animal. A good pair of binoculars or a spotting scope also increases your viewing experience. Cheap optics degrades the viewing quality of the subject and can cause eye fatigue. You'll be wasting your time and money by buying optics listed at less than $150.

Wildlife are best observed in the morning and evening when they are the most active. Time of year is also important especially if the animals (mostly birds) are in their spring or fall migration. Most of the areas that I have listed in the Areas by Feature table under the Wildlife Viewing section are places where wildlife congregate in great numbers. Here they rest and feed before continuing on their migration. These areas also provide nesting and rearing opportunities for many resident wetland species that can be observed in the spring and summer seasons.

NATURE CENTERS AND VISITOR CENTERS

Several agencies and organizations offer facilities that provide services and opportunities to inform, educate, and experience various facets of our natural world. Several state parks and conservation areas have buildings or parts of buildings dedicated to providing exhibits, classrooms, an auditorium, gift shop, library, and restrooms. There are also naturalist led programs, special events, and programs that are provided for the public throughout the year. And, along with learning about nature in these facilities there are also trails that direct you to places where you can actually see flora, fauna, and the places in which they live.

Provided below are six completely outfitted nature centers that are owned and operated by the Missouri Department of Conservation. For more information about these areas and to get a site map, go to www.mdc.mo.gov, then click on Quick Links, then Conservation Areas, then Quick Search.

Anita B. Gorman (The) Conservation Discovery Center, Kansas City (816-759-7300)
Located on 8 acres, the center has a variety of demonstration gardens for butterflies and hummingbirds, a bird feeding station, and habitats that showcase prairie wildflowers, wetlands, a water garden, and upland and lowland forests. These areas are interconnected by two wheelchair accessible trails, each about 0.2 mile long. The indoor exhibits offer a variety of hands-on learning experiences and there are tours of the building and grounds showing environmentally friendly ways to build an urban setting in harmony with nature.

Directions: At Hwy. 71 and Hwy. 56 go west on Hwy. 56 for 0.8 mile and turn left (south) on Troost Ave. and proceed to 4750 Troost Ave.

Burr Oak Woods Conservation Area, Blue Springs, MO (816-228-3766)
Located just 20 miles east of downtown Kansas City, the 1,071-acre conservation area has a nature center surrounded by forest, glades, woodland, established prairies, and several ponds and creeks. Also, a 33-acre natural area takes hikers through a mature and old growth forest with interesting Bethany Falls limestone boulders and outcrops. There are five hiking trails totaling 6 miles with one wheelchair accessible. The exhibits include a 3,000 gallon aquarium, a wildlife viewing room, and displays showing fish, forest, and wildlife habitats in the area.

Directions: At the intersection of I-70 (exit 20) and Hwy. 7, go north on Hwy. 7 for 1.1 miles and turn left (west) onto Park Road, then proceed 1 mile to the entrance.

Cape Girardeau Conservation Campus Nature Center, Cape Girardeau (573-290-5218)
There are hands-on exhibits that highlight cultural and natural resources of southeast Missouri including Native American artifacts, aquariums, a beehive, and interactive computers. Outdoor exhibits include a hummingbird garden, a native plant landscape, a reconstructed swamp, and a demonstration marsh. A 0.3-mile wheelchair accessible trail and a 1 mile White Oak Trace trail leads hikers through the forested hills adjacent to the nature center.

Directions: Located within Cape Girardeau's North County Park, at the intersection of I-55 (exit 99) and Kingshighway (Hwy. 61), go east on Kingshighway for a short distance and turn left (north) at the park entrance; follow the signs to the nature center.

Powder Valley Conservation Nature Center, St. Louis (314-301-1500)
Sitting on 112 acres of upland forest, the center has 3 trails totaling 2.2 miles, one of which has interpretive signs and is wheelchair accessible. The nature center has two lev-

els of exhibits that relate to backyard wildlife and conservation practices in urban areas. There is a 3,000 gallon aquarium that is home to native fish found in the area and a native plant garden.

Directions: At the intersection of I-44 (exit 277B) and Lindbergh Road, go 0.5 mile south on Lindbergh Road, then turn right (west) on Watson Rd, proceed 0.5 mile and turn right on Geyer Road, cross over the interstate then turn left on Cragwold Road and follow the signs to the nature center entrance.

Runge Conservation Nature Center, Jefferson City (573-526-5544)

The center contains 3,000 sq. ft. of exhibits that highlight the major habitats or natural communities of the state. There is also a 3,580 gallon aquarium with native fish and terrariums with live animals including amphibians and reptiles. Five hiking trails, totaling 1.9 miles, weave through 107 acres of woodland, forest, prairie, glade, and along ponds and a wetland. One trail is wheelchair accessible.

Directions: In Jefferson City, at the intersection of Hwy. 50 and Hwy. 179, go north 1 mile on Hwy. 179 and turn left (west) at the entrance.

Springfield Conservation Nature Center, Springfield (417-888-4237)

There are self-guided displays that interpret the natural communities found on the 80-acre area. Three miles of hiking trails take you through old growth forest, a limestone glade, woodland, prairie plantings, creeks, and frontage on Lake Springfield.

Directions: Located in southeast Springfield just west of Hwy. 65 off of the James River Freeway (Hwy. 60). Follow the brown directional signs to the center.

SYMBOLS. Here is the list of symbols that appear above each map that can be used for a quick visual reference about the scenic area:

Hiking trail		Canoe trail	
Scenic drive		Caving, wild or commercial	
Wildlife watching		Campground or camping available	
Dogs allowed on leash		Visitor Center or Ranger Station	
Wheelchair accessible		Entrance fee required	
Boat ramp		Restroom	
Picnic area		Restaurant	
Fishing		Swimming	
Biking Trail			

Pale purple coneflowers taking on the new day (opposite page).

Areas By Feature

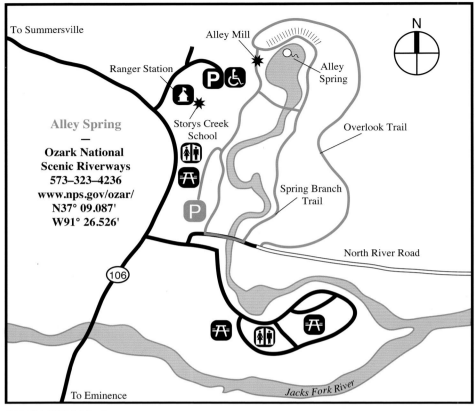

ALLEY SPRING features one of the most photogenic spring pools in all of Missouri. Its turquoise-colored water issues out of a 156-foot deep hole at a daily rate of 81 million gallons, making it the 7th largest spring in the state. Bordering Alley Spring is an impressive cliff, about 70 feet tall, comprised of Gasconade dolomite. Numerous caves and springs are formed in this porous bedrock that outcrops in the heart of the Ozarks. The pool at Alley Spring was enlarged in the past to provide water to operate the red three-story Alley Mill, one of the most photographed buildings in the state.

The spring and spring pool can be easily viewed by following the asphalt path on the far end of the large parking lot. Disabled parking is available by continuing on Hwy. 106 past the main entrance and turning right at the next road. Follow it past the Ranger's Station to the disabled parking lot.

The 0.75-mile Spring Branch Trail begins on the right as you enter the parking lot. Walk the North River Road, cross the wooden bridge over the spring branch, and access the trail on the left. The trail follows the base of the bluff to the spring. Along the way, you get a good view of the cliff face showing the porous nature of the dolomite bedrock with all of its nooks and crannies and small caves. The trail ends at Alley Mill and you can either begin the Overlook Trail or follow the asphalt path back to the parking lot.

The Overlook Trail involves ascending and descending the steep hill overlooking Alley Spring. It is moderately strenuous at both ends but relatively level across the top. Not only does it offer a great view of Alley Spring, the trail also goes through an old growth forest that was designated in 2007 as the 795-acre Alley Spring Natural Area. Along the trail, you'll see majestic shortleaf pines and impressive white oaks. On a re-

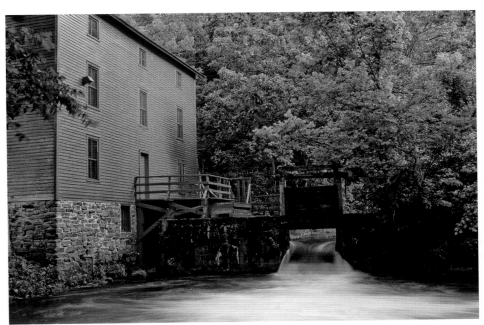

*Alley Mill, constructed in 1894, became the largest mill operating in the region. (above)
The spring runs through a second outlet on its journey through the park. (below)*

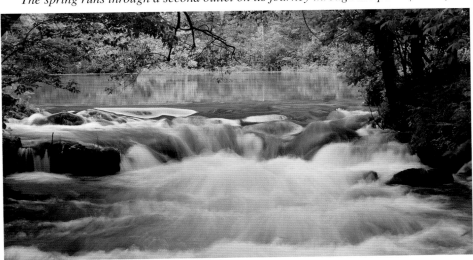

cent visit, I noticed an unfortunate white oak that had lost its grip due to high winds and had been cut away to open up the trail again. I counted 275 annual rings of growth in a trunk 24 inches in diameter. That is an old white oak tree! To access the trail, take the North River Road to the right as you enter the parking area. Walk across the wooden bridge and follow the road 0.5 mile to a set of steps on the left that lead up the hill. The Overlook Trail does give you a good view of the spring towards the end of the trail and watch for the small dolomite glade openings as you descend the hill. The Overlook Trail ends at the Spring Branch Trail near the mill.

Directions: In Eminence, at the intersection of Hwy. 19 and Hwy. 106 go west on Hwy. 106 five miles and turn right at the entrance to Alley Spring.

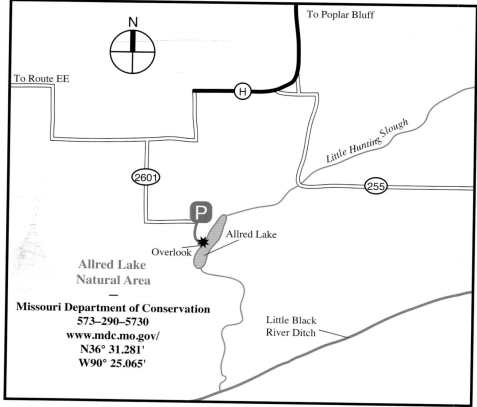

ALLRED LAKE NATURAL AREA is the best example of a cypress/tupelo pond left in the state. Here you can find huge bald cypress trees over 500 years old bordering a natural pond about 16 feet deep. This is a rare opportunity to see what much of the Missouri Bootheel looked like before 1900 when land clearing and drainage ditches began opening the way for growing crops such as corn, soybeans, cotton and rice. There is a short trail from the parking lot to a boardwalk and platform that provides an excellent view of the 7-acre pond. Notice the large bald cypress trees edging the pond, some have had their tops blown apart due to lightning strikes. The bottomland forest surrounding Allred Lake can be walked most of the year during normal or below normal water levels. Here, you can find vegetation more common in swampland further south such as willow oak, water oak, swamp privet, water elm, water hickory, water locust, swamp chestnut, overcup oak and the state champion Nuttall's oak.

If the water level is down, take a walk north, through the bottomland forest, to get a feel for what much of the Bootheel was like hundreds of years ago. As you round the upper end of the pond boundary, you will find one gigantic bald cypress in Little Hunting Slough. Crossing here is easy although shallow wading maybe required. Continue on to the east side of the pond, here you will find the ground a little higher and dominated by sweet gum trees with an understory of giant cane. In late spring, the attractive Indian pink flowers and, in August, the showy spider lily displays its large, delicate white flowers. Along the south side of the natural area you'll again find Little Hunting Slough, which meanders south for about a mile before emptying into the Little Black River Ditch. If

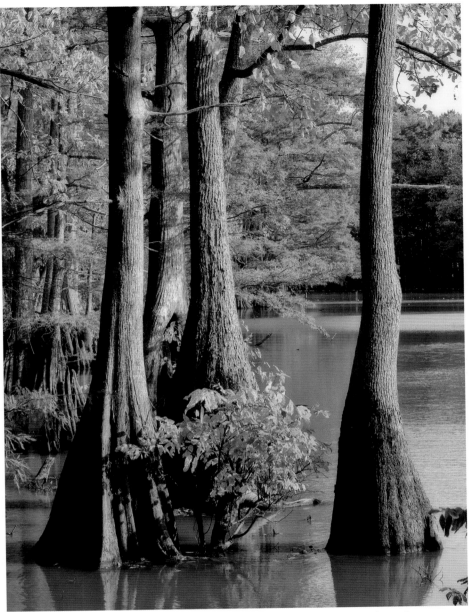

Bald cypress trees stand sentinel edging the 7-acre natural pond.

you feel adventurous, you can wade across this part of Little Hunting Slough to reach the other side and continue north back to the parking lot. The water here varies from ankle to calve deep much of the year. Just carry a walking stick to probe the bottom for fallen limbs and shallow holes, and it shouldn't be a problem crossing to the other side.

Directions: At the intersection of Hwy. 67 and Hwy. 142 at Neelyville, proceed about six miles east on Hwy. 142 to Hwy. HH, go 0.3 mile on Hwy. HH and turn right (south) on Hwy. H. Proceed 2.5 miles and turn left (south) on County Road 2601 and follow it 0.5 mile to the entrance to Allred Lake.

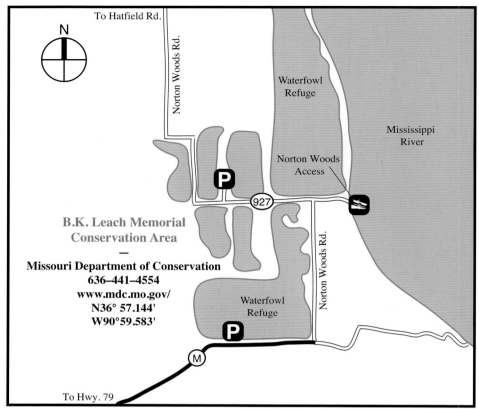

B.K. LEACH MEMORIAL CONSERVATION AREA is a large tract totaling 4,314 acres of which 2,302 acres are in wetlands. Here, you will find great opportunities to view large numbers of migrating birds in the fall and spring. Canada and snow geese, American white pelicans, a variety of ducks and shorebirds, egrets and herons, and bald eagles are commonly viewed. Of course, binoculars and spotting scopes add to the experience by bringing the birds up-close and personal. The roads take you along a wide variety of wetland habitats from mudflats and marshes to deep backwater sloughs that provide food and rest areas for migrating waterfowl. The wetlands complex also provides food, water, shelter, and nesting habitat for marsh birds and other wetland dependent wildlife throughout the year.

Peak viewing times are October and November and February and March for waterfowl; April through September for marsh birds, shorebirds, and neotropical migrants. For a list of the 234 species of birds that have been found on the area so far, go to http://www.mobirds.org/CACHE/mdcchecklists1.asp?locID=554 .

Most of the wetlands along either side of Norton Woods Road are in the Kings Lake Tract, one of three units that make up the conservation area. Along this route, you will see signs posting the wetlands behind them as waterfowl refuges from October 15 to February but you can certainly drive along them and stop to view waterfowl.

Another part of B.K. Leach Memorial Conservation Area called the Bittern Basin Unit can be visited by returning to Hwy. 79 and going to the north side of Elsberry. Turn right (east) on Hwy. P and proceed 1.4 miles to the parking area on the left. This large

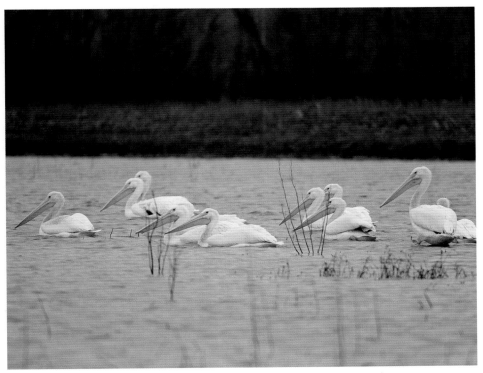

American white pelicans are a common site at the conservation area.

wetland can be observed from the parking area or by walking along the edge of the water. Another parking area is found 1.8 miles further down Hwy. P. Like the King's Lake Unit, the Bittern Basin Unit is a popular stop over for spring and fall migrants.

Other parts of the refuge drive are closed from October 15 to the end of duck season, which is usually sometime in the latter part of December.

Directions: From the intersection of Hwy. 79 and Hwy. M, 3 miles south of Elsberry, take Hwy. M for about 3 miles and turn left (north) on Norton Woods Road, go about 1.5 miles to a "T" intersection, turning right (east) goes to Norton Woods Access to view a side channel of the Mississippi River. Note the gallery of large cottonwood and silver maple trees along the way. Return and continue west beyond the "T" intersection. Observe the wetlands on both sides of Norton Woods Road (County Road 927) for the next 2 miles. Continue to Hatfield Road (County Road 920) and turn left (west) on this road to Elsberry and Hwy. 79.

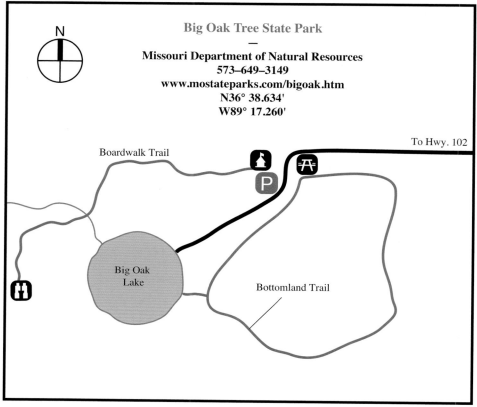

Big Oak Tree State Park

—

Missouri Department of Natural Resources
573–649–3149
www.mostateparks.com/bigoak.htm
N36° 38.634'
W89° 17.260'

To Hwy. 102

Boardwalk Trail

P

Big Oak
Lake

Bottomland Trail

BIG OAK TREE STATE PARK consists of an impressive bottomland forest and swamp that is easily accessed by a long boardwalk. As you approach the state park from any direction, you cannot help but notice the island of tall trees surrounded by a sea of cropland. It is hard to imagine that there used to be thousands of square miles of this kind of forested landscape in the Missouri Bootheel. Back in the 1930s, area residents realized that impressive stands of bottomland forest like this were rapidly disappearing so businessmen, local citizens and school children raised enough money in order to purchase this land which was then dedicated as a state park. Because of its high natural quality and size, 90% of the park or 940 acres was designated a state natural area in 1977. Take a hike along the boardwalk and get a sense of why this area is so special. You will notice a diverse array of plant and animal life. Not everything can be seen with one visit but staff and others have documented over 250 kinds of plants, 25 mammals, 31 reptiles, seven amphibians and over 150 different kinds of birds. The area is certainly rich in biological diversity! Also found in the area are 12 species of rare plants and animals and seven trees that make the state champion list. The trees are: rusty blackhaw, bur oak, black willow, possum haw, swamp chestnut oak, persimmon and pumpkin ash. The last two are also national champions. (Note: Due to the severe ice storm in late January of 2009, the champion status of some of these trees may have changed.)

The boardwalk trail begins in mesic (moist) bottomland forest which contains plants that can withstand very short periods of flooding. Notice the variety of oaks, giant cane, and pawpaw that is soon replaced by silver maple and cottonwood in wet bottomland forest where plants can withstand a little longer period of flooding. The boardwalk eventually enters the swamp where water is mostly permanent. Here you will notice bald

Evening sun highlights the gnarled branches of the state's second largest bur oak. (above)
The metal boardwalk weaves a path by massive old growth bottomland trees. (below)

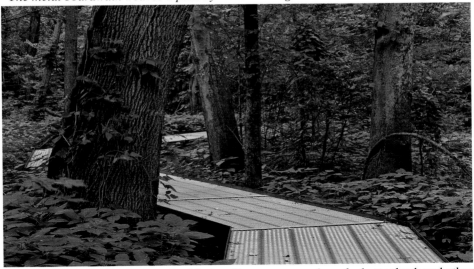

cypress trees with their knees, also black willow, swamp red maple, buttonbush and other swamp species. Along the trail, be sure to watch for interpretive signs that point out the state champion black willow and the national champion pumpkin ash.

The Bottomland Trail begins across the road from the Boardwalk Trail. It is not available during periods of flooding so you may want to check at the visitor center for trail conditions. As in most bottomland situations wearing protective clothing or using mosquito repellent is advised. Along the trail, you have the opportunity to see the state champions swamp chestnut oak, possum haw, and shumard oak, along with the national champion persimmon.

Interpretive center is open April through September, Tuesday through Saturday from 10 am to 4 pm; from October through March, accessible by prior appointment. Park grounds are open from 6 am to 10 pm year-round.

Directions: At the I-55 East Prairie/Matthews exit (Exit 58), turn east onto Hwy. 80. Follow Hwy. 80 through East Prairie and turn right (south) onto Hwy. 102. Proceed about 14 miles to the entrance road to Big Oak Tree State Park.

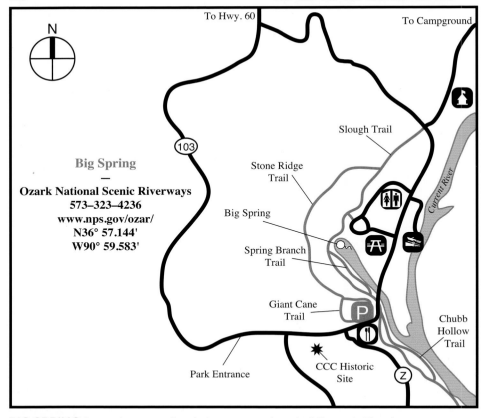

BIG SPRING is number one when it comes to springs in Missouri. Flowing at an average 284 million gallons a day also qualifies it as the largest spring in the United States and one of the top 10 springs in the world! It is an impressive site to see such a large volume of water pouring from the base of the cliff. The cliff, by the way, is Eminence dolomite, named after the town 25 miles northwest of here. (After geologists discover and describe bedrock new to science, they name the rock after the nearest town or most prominent nearby landmark.) Studies have revealed that the spring water comes from an area to the west of Big Spring, as far away as Willow Springs, a distance of more than 50 miles. It is estimated that the area drained by Big Spring covers 967 square miles. The spring has been a popular gathering place dating back 10,000 years, as evidenced by archeological excavations of prehistoric campsites. Big Spring and 17 acres around it was designated a state natural area in 1983.

As you approach Big Spring, notice a kiosk on the right that has information about two of the trails in the park. The Big Spring Trail, also called the Stone Ridge Trail, starts here. The 2.5-mile trail has a fairly steep section at each end going up and down the hill before you. The first section is the Slough Trail and it is wheelchair accessible. This section of the trail parallels the bluff and provides an opportunity to view ferns and spring wildflowers growing out of the cliff's nooks and crannies, and along the lower slope. Also notice the stands of giant cane along the trail. This native grass can grow up to 20 feet tall and was once much more common along Ozark waterways. The 0.5-mile Chubb Hollow Trail begins at the Dining Lodge, which is open for business during the warmer

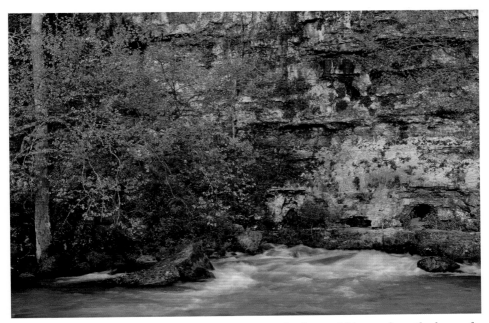

Cool, clear water from one of the largest springs in the world issues from the base of the dolomite cliff.

months, and ascends the hill to two nice overlooks of the Current River and the rugged Ozark hills. A riverbank trail returns you to the lodge or you can continue another 3.5 miles crossing through high quality oak-pine woodland called the Big Spring Pines Natural Area. The trail then leads you past the rental cabins to the lodge parking lot. There are also two other trails, the Giant Cane Trail and the Spring Branch Trail available for shorter hikes. There is also a Civilian Conservation Corps (CCC) exhibit at the visitor center where you can learn about their incredible construction projects during the Great Depression of the 1930s.

Directions: At Van Buren, take Hwy. 60 and after crossing over the Current River bridge, take Hwy. 103 four miles to the entrance to Big Spring. Follow the signs to a parking lot and a short wheelchair accessible trail to the spring.

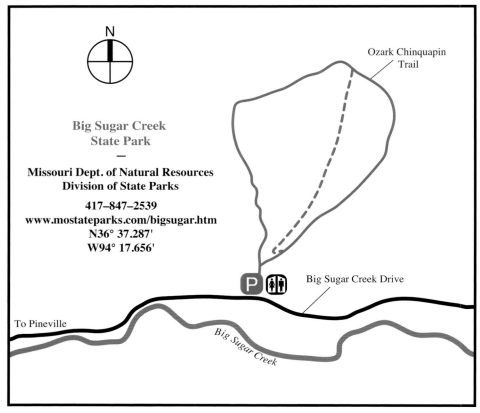

BIG SUGAR CREEK STATE PARK is located in a unique part of Missouri. While the rest of the Ozark streams drain north and east into the Missouri and Mississippi Rivers respectively, Big Sugar Creek and the rest of the Elk River watershed drains south into the Arkansas River Basin. Here you can find a variety of plants and animals that are less common or absent further into Missouri. (Check on the website for a list of plants and animals you may expect to find.) You will also notice the landscape to be a bit different as you drive from Pineville along Big Sugar Creek to the park. Not only do you get great views of Big Sugar Creek but there are also impressive rock outcrops like no other area in the state. Note the massive ledges sticking out towards the road. The softer black shale that provides underlying support is slowly eroding away leaving a balancing act for the tons of rock above. Along the drive, you will see where gravity has won out with large slabs collapsing very near the road. If you have the time, drive Hwy. 59 through nearby Noel and you'll see massive overhanging bluffs that you actually drive under. These overhangs are located on the west side of town and one mile north from town along Hwy. 59.

About half way along the drive to the state park, stop at Deep Ford Access to get a better view of Big Sugar Creek. The clear flowing creek runs about 50 miles, before it empties into the Elk River. It is a popular stream to canoe, kayak, or raft as evidenced by the commercial outfitters that you pass along the way.

The state park, which has frontage on Big Sugar Creek, is 2,048 acres in size with 1,613 acres designated as a state natural area called Elk River Breaks Natural Area. The Ozark Chinquapin Trail leads north and splits into a loop trail. It is designed to hike

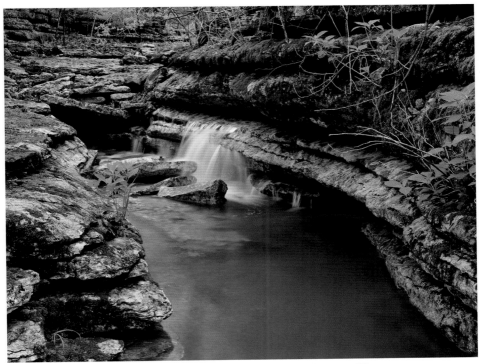

Water from a losing stream emerges between layers of limestone.

counterclockwise with small yellow markers attached to trees along the way. The trail follows a headwater stream up to its origin and crosses over a ridge and down another stream with a larger watershed. There are no bridges over the small creek crossings so wading or stone hopping is in order. The water level is usually around ankle deep or a little higher so plan on wearing shoes that you don't mind getting submerged. I counted 9-stream crossings on the way up and 5 on the way down. The best time to see the small streams in action is after a rain. The hike on the return trip is even more eventful with water coursing over ledges and through swift cascades only to disappear for sections at a time. Along the trail, note the steep chert laden hills that support a variety of plants. Occasional prescribed burns help to keep this woodland environment much the way it looked when Native American Indians once roamed the area.

Directions: At the intersection of Hwy. 71 and Hwy. H, 19 miles south of Neosho, take Hwy. H east 0.8 mile to Hwy. W, turn left (north) on Hwy. W, proceed 0.8 mile into Pineville and turn right (east) on 8th St., which becomes Big Sugar Creek Drive, and go 6.2 miles to the parking area on the left (north).

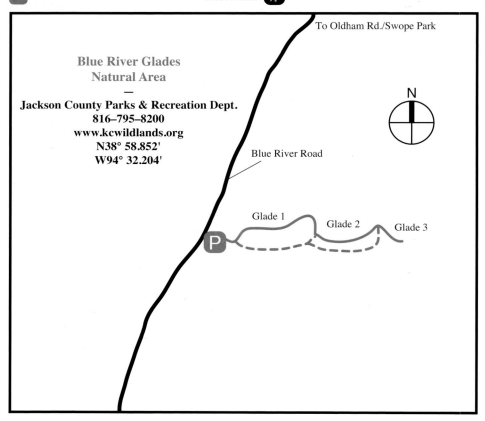

BLUE RIVER GLADES NATURAL AREA is the best example of its type left and well worth seeing. Limestone glades in Missouri are uncommon to begin with and few remain due to quarrying, land development and encroachment by woody vegetation due to lack of fire. Here you can find a diversity of wildflowers in bloom beginning in late April and continuing into October. And, as in prairies, grasses like big bluestem, little bluestem and Indian grass turn a showy golden to reddish brown with the arrival of autumn. Although the natural area, which was designated in 1983, is only 18 acres, it is packed with a variety of plant and animal life that is bound not to disappoint. As you leave the parking area and follow the trail to the left through the woods, you soon come upon large stone blocks that have broken away from the short bluff face. These blocks are composed of a fossil-rich limestone that was deposited in a shallow sea around 300 million years ago in what is called the late Pennsylvanian Period. The limestone is named after a falls near Bethany, Missouri, and is called Bethany Falls Limestone. This distinctive limestone stretches from central Iowa to Oklahoma and is the foundation layer on which the city of Kansas City was built. Also, throughout the Kansas City area, you will notice tunnel limestone quarries, mostly inactive, that now provides places for underground storage, office facilities, and mushroom farms.

 The large Bethany Falls Limestone blocks that you see along the trail were once part of the main bedrock but small cracks in the surface allowed water to freeze and expand, enlarging and deepening the cracks over tens of thousands of years. The blocks eventually separate and slide ever so slowly down the hill. Their layering and blockish nature make them unique and interesting.

Sculptured boulders of Bethany Falls Limestone supports one of the last glades of its type.

In order to view the glades, I would recommend taking the trail up the slope and onto the first glade. The trail then follows along the base of the glade to a second glade. You can continue on the trail to a third glade where the trail dead-ends and you must return. I would not recommend taking the two sections of trail along and beyond the second glade that go down the hill through the limestone blocks. The trail is not well-maintained and is very slippery. Speaking from experience, it is easy to fall along this return trail to the parking area. It is best just to return on the trail you started on. Try not to wander off the trail because the small size of the glades makes them more vulnerable to trampling and erosion. The glades are also threatened by woody encroachment, especially from an extremely aggressive nonnative shrub called bush honeysuckle. Prescribed fire and treating cut stems with herbicide is an ongoing management practice to try and control this invasive pest. (Note: You will come across access to the Eddy-Ballentine Trail but that is not part of the Blue River Glades Natural Area.)

Direction: Take I-435 to the Gregory Boulevard exit. Proceed west on Gregory Boulevard for 1.2 miles, then turn left onto Oldham Road. Proceed 0.1 mile, then turn right on Blue River Road for 1.2 miles. There is a pulloff on the left (east) side of the road marked with a sign. If a sign is not present, look for a green plastic utility box on the west side of the road to reference the general location of the pulloff.

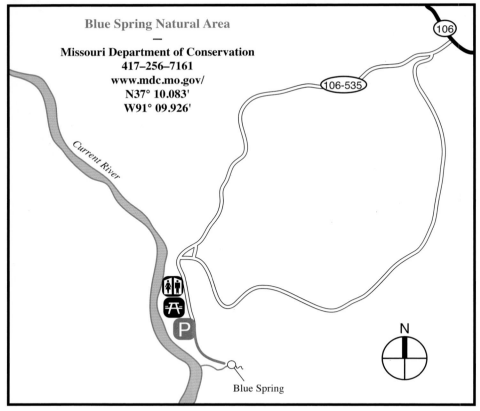

Blue Spring Natural Area
—
Missouri Department of Conservation
417–256–7161
www.mdc.mo.gov/
N37° 10.083'
W91° 09.926'

Current River

106

106-535

N

Blue Spring

BLUE SPRING NATURAL AREA is appropriately so-named because it has the most intense blue color of any spring in Missouri. With an average daily flow of 90 million gallons, it ranks as the sixth largest spring in the state. Blue Spring also has another distinction; the spring has been mapped by scuba divers to a depth of 310 feet, which makes it the deepest spring in the state. The Osage Indians called it "Do-Ge-Ke-Thabo-Bthi" or Spring of the Summer Sky. The cause for the intense blue color is thought to be the extreme depth and angle of the emerging water in combination with the scattering of blue light by minute particles of mineral or organic matter suspended in the water. Thanks to the construction of an overlooking deck, I don't know of any other spring in the state where you can get such a close-up view of an emerging spring.

 The trail to Blue Spring takes you along the edge of the Current River. Here you can see a transition from stream-edge trees like sycamore, river birch, and boxelder, to mesic upland trees such as white oak, red oak, flowering dogwood, pawpaw and spice bush. The trail also parallels the spring branch that begins at the mouth of Blue Spring and empties into the Current River. Notice partially submerged clumps of water cress along the spring branch. The peppery flavor of the leaves has been used to add flavor to sandwiches. Water cress favors the constant cool water of springs which often range from 55 to 58 degrees Fahrenheit. I have never come across a spring that didn't have water cress growing in it nor have I ever seen water cress growing in waters other than from a spring or spring branch. Water cress was once thought to have been brought over from Europe but recent genetic studies have revealed that it is indeed native to the United States. You will also

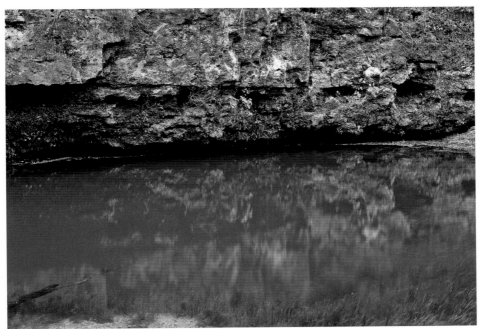

Blue Spring's royal blue color is unique amongst the 1,000+ springs in the state. (above)
Miniature cascades are formed in the spring run as it flows through a row of rocks. (below)

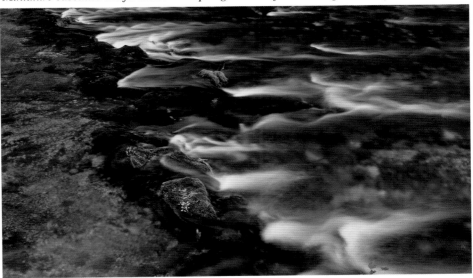

note another aquatic plant growing in the spring and spring branch. Look for long green ribbons waving in the water. This is wild celery, so called because of the taste from eating ducks that have been feeding on it. It is also called eelgrass for its shape and movement in the water.

Directions: From Eminence, take Hwy. 106 east 12 miles or 13 miles west from Ellington and turn onto County Road 106-535. Take this gravel road 2.5 miles to the parking area. (Note: The first part of the gravel road is steep and not recommended for vehicles pulling trailers.)

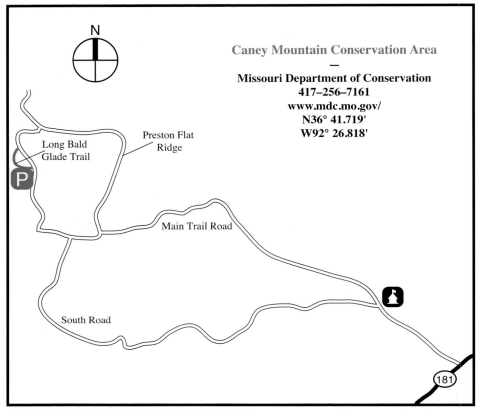

Caney Mountain Conservation Area

—

Missouri Department of Conservation
417–256–7161
www.mdc.mo.gov/
N36° 41.719'
W92° 26.818'

Long Bald
Glade Trail

Preston Flat
Ridge

Main Trail Road

South Road

181

CANEY MOUNTAIN CONSERVATION AREA, at 7,899 acres, contains several interesting features including unusual geologic formations, a state-champion tree, caves, scenic views, trails, and several large glades. The largest, most diverse glade has a nature trail winding through it and that is the subject of this trip. The 77-acre Long Bald Glade is part of the 1,330-acre Caney Mountain Natural Area. A parking lot and trail begins in a savanna-like landscape of open-grown oaks and hickories with a grassy ground layer. The path soon enters one of the largest dolomite glades in the state. This desert-like environment contains an interesting assortment of plants and animals that can be viewed from April through October. Take your time enjoying the scenery and the interesting rock outcrops. The 0.5-mile trail ends at the gravel road just above the parking area.

Also, along the drive to the Preston Flat Ridge road, you will encounter a sign on the right marking the location of the state-champion black gum. Notice the distinctive dark, blocky, "alligator skin" of the bark. Black gum is the first tree to begin turning color in the fall. As early as August, look for its glossy dark green leaves turning a brilliant scarlet color.

On Preston Flat Ridge road, there are three scenic views. From the two west-facing views, notice the tightly clustered, knobby hills in the distance. They are part of an unusual geologic formation known as the Monadnocks. They are remnants of a broad plateau that has weathered around the edges, leaving only a center high spot with fragmented hills that will eventually level off through erosion.

Directions: In Gainesville, at the intersection of Hwy. 5 and Hwy. 160, go east on

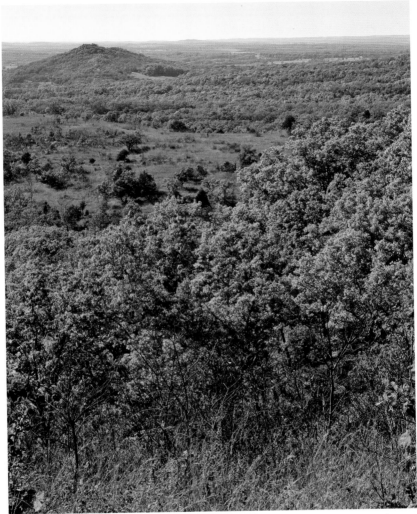

Fall colors accentuate the woodlands and glades at Caney Mountain.

Hwy. 160 for 0.5 mile and turn left (north) on Hwy. 181. Proceed 5.5 miles to the entrance of Caney Mountain Conservation Area. Follow the gravel road into the conservation area about 0.5 mile to the headquarters on the right. A bulletin board displays current information and an area brochure is available from a map box. Proceed past the area manager's house across from the headquarters and turn right onto the Main Trail Road. On this drive you will be encountering a series of low water crossings. Do not attempt to cross when the creeks are rain-swollen. In about 3 miles, the road splits, so bear right on Preston Flat Ridge. A scenic view is on the left and in 0.5 mile another scenic view is on the right. In another mile, turn left on a small road. It is a little difficult to locate, so if you encounter the sign FOOD PLOT 22 and a clearing on the right, you have just missed the turn. (Note: going past the food plot and on the left is the third scenic view along the ridge road.) Proceed 0.5 mile downhill to a valley and, in a short distance, a parking lot on the right. To exit, continue on the same road for 1 mile and follow the same road in reverse to the entrance or take the South Road to the right for a different drive back.

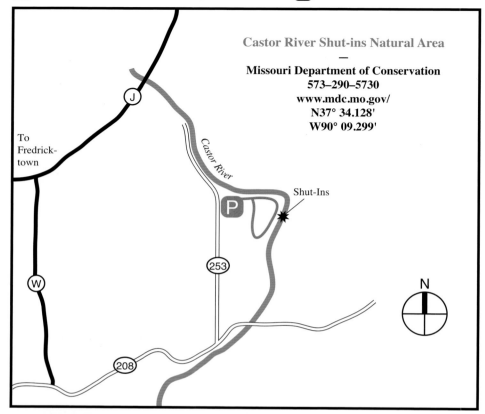
Castor River Shut-ins Natural Area
—
Missouri Department of Conservation
573–290–5730
www.mdc.mo.gov/
N37° 34.128'
W90° 09.299'

J

To
Fredrick-
town

Castor River

Shut-Ins

P

253

W

208

N

CASTOR RIVER SHUT-INS NATURAL AREA contains one of the most scenic igneous shut-ins in the Ozarks. The distinctive pink- to salmon-colored bedrock, called Breadtray granite, provides a colorful setting along the Castor River. The river, with its continually flowing waters have smoothed and polished this bedrock for tens of thousands of years. The 209-acre natural area, dedicated in 1993, is part of Amidon Memorial Conservation Area, which is 1,630 acres in size. There are several interesting features to see in the natural area and a 1.0 mile trail takes you to all of them. Shortly after leaving the parking area, the trail enters a mesic (moist) bottomland forest. Springtime is the most interesting season to be here because of the rich wildflower display. As the trail turns towards the river, you'll find a gallery of impressive trees, namely, sycamore, sugar maple, and one particularly large bur oak right along the trail. Numerous pawpaw and the fragrant spice bush can be found in the understory. Soon, the beginning of the shut-ins comes into sight. The river begins its cut into the granite which creates a chute with water tumbling and falling as it passes between the boulders. You can even cross over at the first falls during low flow but watch your footing, the rock surface is very slippery when wet. This was once the site of a mill and you can still see steel rods anchored in the boulders. You have left the trail at this point but it is okay to wander around on the rocks and wade in the pools, knowing that you can rejoin the trail at anytime as it parallels the river. Notice the large shortleaf pine trees edging the river and, if you time it right in early May, you'll see wild azaleas in bloom.

About three-quarters of the way down the shut-ins, the trail heads up the hill. At this

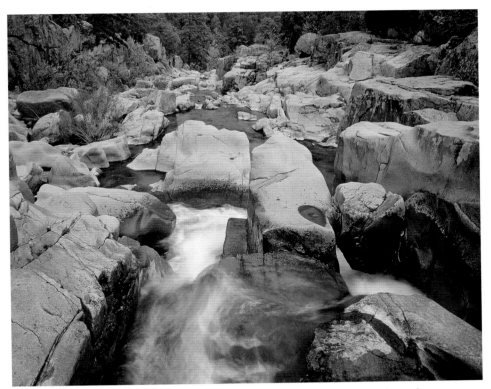

Water from the upper reaches of the Castor River courses through uniquely-colored granite.

junction, there is a one-way spur that continues along the river that ends at the last falls. A large pool is below that begins a more typical looking Ozark stream. The trail up the hill begins with a directional sign and soon leads to an impressive overlook. Here, you have a 180 degree view of the river corridor and surrounding hills. Notice the opening that you are standing in is an igneous glade comprised of the Breadtray granite. This is one of the rarer glade types in the state. From here you can view a larger granite glade across the river. Cedar removal and prescribed burning are needed to keep these glades open. The trail continues across the hill and joins the main trail that leads back to the parking lot. Note the signs at the parking lot that alert you to the fines for carrying or breaking glass containers. This law is for the safety of those wading in the shut-ins.

Directions: At Fredericktown, on the east side of town at the intersection of Hwy. 72 and Hwy. OO, take Hwy. 72 east 2 miles, turn left on Hwy. J, continue another 4.4 miles and turn right on Hwy. W. At about 1 mile, Hwy. W ends at a "T" intersection, turn left on County Road 208, continue 1 mile to a split in the road, bear left on Madison County Road 253 and go another 0.8 mile to a parking lot on the right.

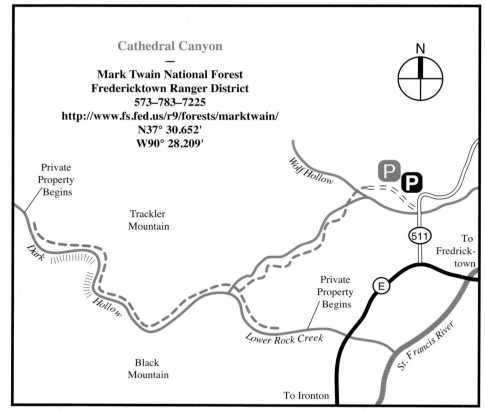

Cathedral Canyon
—
Mark Twain National Forest
Fredericktown Ranger District
573–783–7225
http://www.fs.fed.us/r9/forests/marktwain/
N37° 30.652'
W90° 28.209'

N

Private Property Begins

Trackler Mountain

Wolf Hollow

P P

511

To Fredrick-town

Dark

Hollow

Private Property Begins

E

Lower Rock Creek

St. Francis River

Black Mountain

To Ironton

CATHEDRAL CANYON, also known as Dark Hollow and Lower Rock Creek, is truly remote and one of the wildest places covered in this book. Hikers have penned the name Cathedral Canyon in reverence for one section where a 400-foot igneous wall towers above the creek. The topographic map for this area names this stretch Dark Hollow, a condition you may experience while hiking the deep narrow gorge on an overcast day. Along with outstanding cliffs, there are over 65 acres of igneous glades spread out over Trackler Mountain (at 1,400 feet) to the north and Black Mountain (at 1,502 feet) to the south. However, the predominant feature that weaves its way through this ancient volcanic complex of canyons, cliffs, and shut-ins is Lower Rock Creek. Experts have cited this waterway as an outstanding example of a headwater stream. As the water drains from a relatively undisturbed watershed it tumbles down rocky side branches and over rock ledges to collect in a massive shut-in as Lower Rock Creek. The creek is performing at its best after a good rain of 0.5 inch or more. As the water courses down the canyon at a gradient of 100 feet per mile it tumbles over ledges, around boulders, through cascades and riffles before settling into pools and then starts the process all over again. This constantly changing scenery along with the colorful pink and purple rhyolite rock makes for pleasant memories and many photographic opportunities.

The trail begins at the end of the forest service road. Park and walk past the metal gate and go about 0.1 mile where you'll see the road divide. The more defined road to the right leads up Trackler Mountain so take the path to the left and head south to the creek while crossing over a small saddle along the way. After about 1 mile, you'll arrive

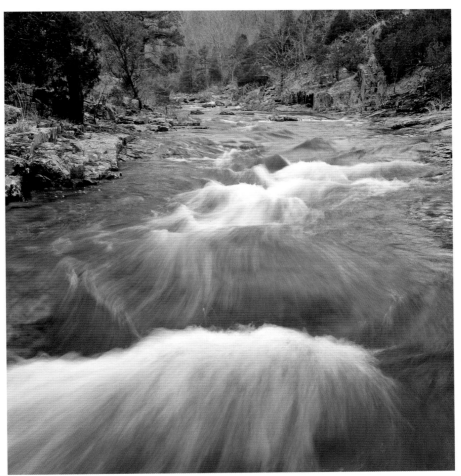

Lower Rock Creek flows through the longest and wildest shut-in in the state.

at Lower Rock Creek. Just before that look to the left and you'll notice a small igneous glade with a small wet-weather waterfall. There are many of these scenes throughout the shut-in. From here, you are on your own. Some follow the faint path usually on the right as you go upstream and some simply wade and rock hop along the creek. Either way, you will be crossing the stream sometimes so be prepared to get your boots wet on occasion. Walking sticks can aid while hiking over the sometimes slippery surface. After about 1.0 mile of hiking upstream or three bends in the creek, you'll arrive at the impressive 400-foot cliff. Beyond that and one bend later or another 0.5 mile you find a second cliff that towers 280 feet. At this point hikers either return the same way they came upstream or bushwhack up Trackler Mountain to the north and find their way to the top where a jeep trail heads back to the parking area a couple of miles away.

Directions: From the intersection of Hwy. 67 and Hwy. 72, just west of Frederick-town, take Hwy. 67 south 3 miles and turn right (west) on Hwy. E; proceed 8.9 miles, crossing over the St. Francis River, and turn right (north) on County Road 511; then go 0.3 mile turning left (west) just after a creek crossing and go 0.4 mile on a narrow woods road. If you have a low clearance vehicle I would recommend parking at the small opening on the right about 100 yards after the start of the woods road.

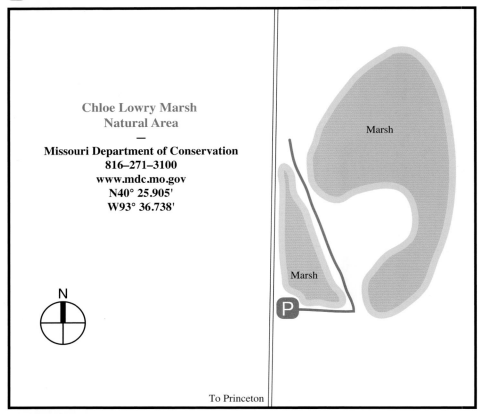

Chloe Lowry Marsh
Natural Area
—

Missouri Department of Conservation
816–271–3100
www.mdc.mo.gov
N40° 25.905'
W93° 36.738'

N

Marsh

Marsh

P

To Princeton

CHLOE LOWRY MARSH NATURAL AREA is one of the few remaining high quality natural marshes left in the state. The area was dedicated as a state natural area in 1995. There is a 40-acre marsh that can be easily viewed by walking along an old railroad bed. Forty acres sounds like a lot but Missouri used to have 4.5 million acres of wetlands and approximately 87% of that is gone. Many species of plants and animals are dependent on this habitat for feeding, nesting and shelter. Chloe Lowry Marsh was once part of the Weldon River that flows from north to south about one-quarter mile west of here. When the river changed course, as they sometimes do, this abandoned section became a slough filled with open water. Over time, the water became shallow enough for plants to grow and a marsh was borne. Many of the wetland plant species were most likely introduced by egrets, herons, geese, ducks, and shorebirds landing on the water or water's edge carrying seeds from other wetlands that attached to their feathers or legs when they took flight. Once detached, seeds were able to float to the water's edge and germinate in the moist soil. Over time, the plants multiplied to what you are seeing today. Eventually, enough sediment and decaying plant material will displace enough water to allow trees to take root and a forest will develop. Unfortunately, the Weldon River is now controlled by levees and it has lost its ability to meander so no new wetlands will be developed in this region. That is why this natural marsh is so special because it is one of the last of its kind in the state.

 When planning a trip to Chloe Lowry Marsh, be sure to bring binoculars. You may get a chance to see bitterns, rails, sparrows, wrens, wood duck, and more. You can also

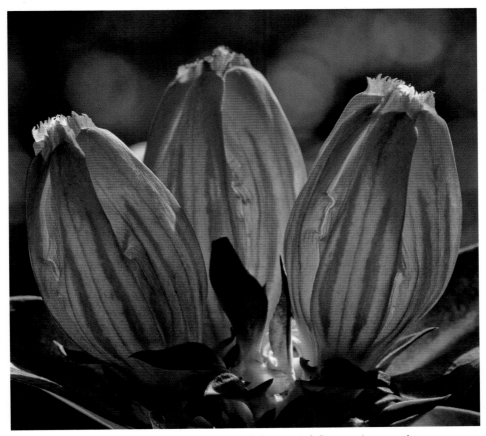

The showy bottle gentian is one of the special discoveries growing along the edge of the marsh.

use the binoculars for viewing plants from a distance. Cattails are common here, as well as bulrushes, arrowheads, bur-reed and sedges. There are also several rare species of plants that have been discovered here. An occasional prescribed fire is conducted to keep the woody vegetation in check. Once a natural process, fires would sweep across the prairies and burn into the marshes. This would burn back the dead plants to make way for new growth and keep the shrubs and trees set back. Notice the equally rare 15-acre wet-mesic prairie along the east side of the old railroad bed.

Directions: At the intersection of Hwy 136 and Hwy. 65 in Princeton, go west 0.4 mile on Hwy. 136 and turn right (north) on Hwy. FF, proceed 1.2 miles and turn left on a gravel road, go another 2 miles to the parking area on the right.

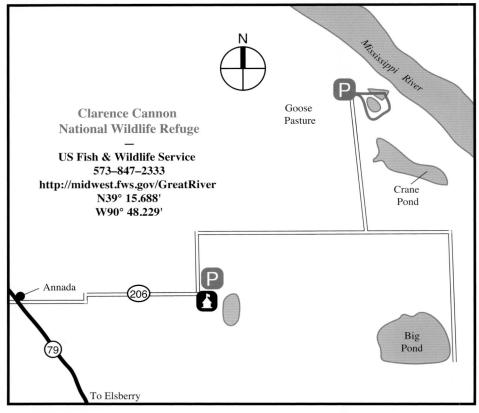

CLARENCE CANNON NATIONAL WILDLIFE REFUGE provides a great opportunity to view wildlife throughout the year but especially during fall and spring bird migration when bird numbers are at their peak. There is a 5.5-mile wildlife viewing drive that covers a good part of the 3,751 acres of refuge. Here, permanent and seasonally flooded impoundments, forests, grasslands, and crop fields provide food, water, and resting areas for over 200 species of birds that visit the refuge throughout the year. You can also see white-tailed deer, squirrel, raccoon, muskrat, wild turkey, beaver, mink, skunk, opossum, and coyote year-round.

The best times to see migrating birds is from October through November and from March into early May with shorebird and warbler migrations usually peaking around the first week of May. Because this is a refuge for migratory birds, a significant portion of the roads are closed from November through December and from February through April. However, during these closures, you can still drive the main road that goes north from the visitor center, then east for about 1.2 miles, and north 1 mile to the hiking trail.

Be sure to stop by the recently expanded visitor center. Interpretive exhibits are scheduled to be in place by the time this book is available. They also carry informative brochures, maps, and a bird list for the area. Also, check out the observation deck adjacent to the visitor center that overlooks a pool. You can usually find something swimming or wading in it. There are currently two active bald eagle nests on the refuge. The older nest on the north side of the refuge near Crane Pond is easily viewed from the road. The younger nest is located on the south side of the refuge. Because the north nest is now

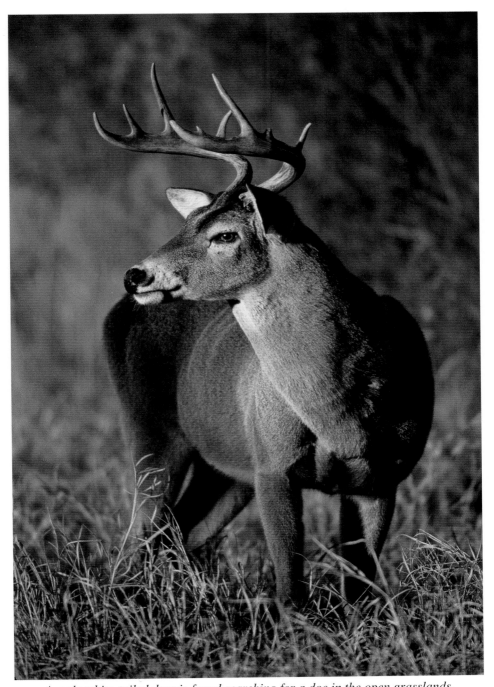

A male white-tailed deer is found searching for a doe in the open grasslands.

closer to the trail, the trail is closed from January 1 to June 30 so as to not to disturb the eagles and their nesting.

Directions: At Annada, which is 8 miles north of Elsberry, and at the intersection of Hwy. 79 and County Road 206, go east on the county road for 3.1 miles to the refuge.

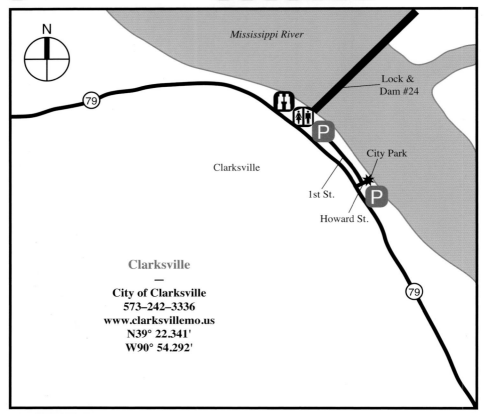

N

Mississippi River

Lock & Dam #24

79

City Park

Clarksville

1st St.

Howard St.

Clarksville
—
City of Clarksville
573–242–3336
www.clarksvillemo.us
N39° 22.341'
W90° 54.292'

79

CLARKSVILLE is the premier eagle watching capital of Missouri. The winter of 2008/2009 brought 600 American bald eagles to town, which is the highest number yet for this annual event. In fact, this could possibly be the highest gathering of bald eagles at any one place in the lower 48 states. This phenomenon occurs when the winter temperature stays well below freezing for a few days causing ice to form on the Mississippi River. Eagles need open water to fish so they concentrate below the locks and dams along the Mississippi River. For whatever reason, Clarksville Lock & Dam #24 seems to attract a higher concentration of wintering bald eagles. As fish, primarily shad, pass through the open gates of the dam, they often become dazed, disoriented, or injured and appear at the surface. This makes for easy capture by the eagles. It is not uncommon to see hundreds of bald eagles resting in the cottonwood trees on either side of the river with individuals occasionally lifting off to soar over the water and suddenly dive down to snatch a fish with their talons. It is quite a site to see and you have a front row seat right at the riverfront.

You can see eagles in action all winter long but the coldest periods draw in the largest numbers of eagles. I usually call the mayor's office (number listed above) to find out the latest eagle count before visiting the area. You can even sit in your vehicle at River Front City Park and watch the eagles if the weather is too uncomfortable. To warm-up, there are several restaurants, antique and art stores and other shops to visit. Check out the website for more information.

Just north of the city park, the Corps' lock & dam has a parking lot, viewing platform, and a heated restroom for public use. Also, be alert crossing the railroad tracks at

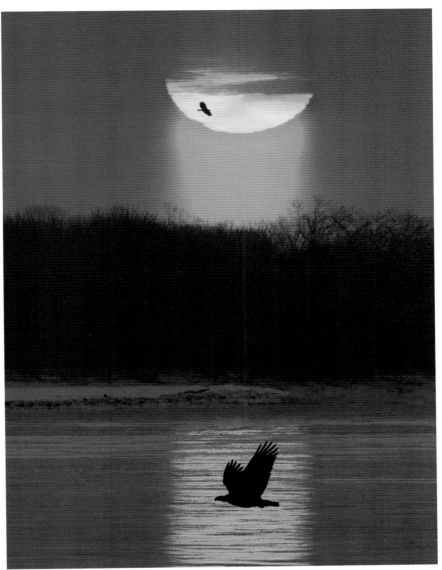

One was fortunate to see 10 bald eagles wintering here along the river in the 1980s but with the eagles' comeback, an amazing 682 bald eagles were observed in February 2009.

both eagle viewing locations. On the north side of town, there is a Visitor Center (573-242-3132) along Hwy. 79 that is open during most winter weekends. Watch for a small parking lot and a white building along the east side of the highway. Inside you can learn more about the eagles, see exhibits, use spotting scopes, and check out the souvenirs. The town has a special Eagle Days event usually the last weekend in January. A live eagle program is presented and volunteers located at the riverfront provide spotting scopes and assistance in viewing the eagles. Check Clarksville website for more information.

Directions: From Louisiana, MO, take Hwy. 79 south for 9 miles to Clarksville; proceed through town to Howard St., turn left (east) and drive to First St.; you can either park along the railroad tracks or cross over and park at the River Front City Park.

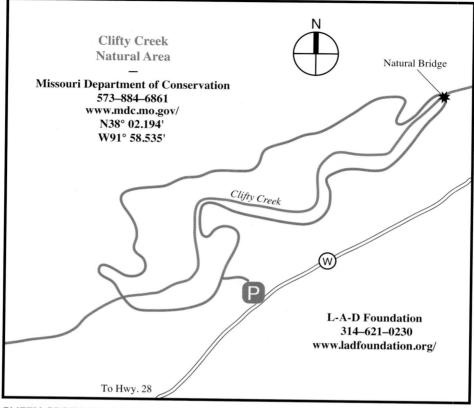

CLIFTY CREEK NATURAL AREA contains one of the most impressive natural bridges in the state. Once rather difficult to get to, you can now use a recently established trail that takes you right to it. The natural bridge spans 40 feet across with a walk through height of 13 feet and Little Clifty Creek flowing right under it. Of course, that wasn't always the case. Before the bridge, there was once a solid, narrow ridge with Clifty Creek flowing on one side and Little Clifty Creek on the other. At some point in time, Little Clifty Creek found a crack in the Gasconade dolomite and the water began to erode away the ridge. Gradually the hole became large enough to pirate or capture the creek. It may take thousands of years but the wind, rain and ice will eventually erode enough of the dolomite to collapse the bridge. Fortunately, I don't think that it will happen anytime soon.

The well-designed trail begins on the north slope of the valley. Because the slope is more protected from the sun, the soil is richer and the forest is more productive. This results in large trees that provide shelter for a variety of shrubs, wildflowers and ferns. Here you will find large white oak, red oak, sugar maple, and flowering dogwood. Also along this north slope trail, watch for little dolomite glade openings with little bluestem, sideoats grama, switch grass, Missouri coneflower, prairie dock, and others. The return trail, which is on a south-facing slope is much different. Here you will find soil exposed more to the sun and rockier, supporting trees adapted to tolerating the drier conditions such as eastern red cedar, post oak, black hickory, and mockernut hickory. When you get on top of the ridge past the natural bridge, notice the large boulders and slabs of sandstone. This is Roubidoux sandstone, the layer deposited above

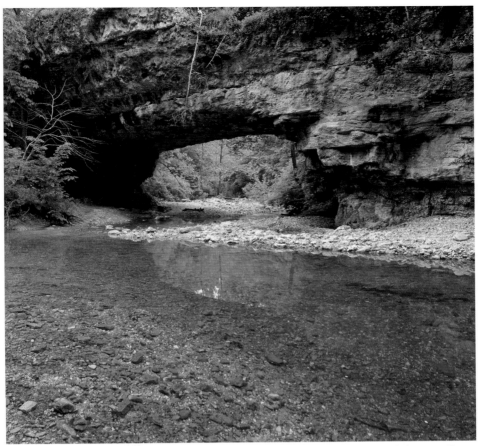

The scenic natural bridge is a midpoint highlight along the engaging hiking trail.

Gasconade dolomite, which makes up the natural bridge. The sandstone surface has blotches of gray-colored flat boulder lichen that commonly lives on acidic rocks like sandstone. You will also find small mounds of reindeer lichen on the forest floor, which is an indicator of acid rocky soils.

 Directions: At the intersection of Hwys. 63 and 28 south of Vienna, take Hwy. 28 south 13.7 miles to Hwy. W, proceed on Hwy. W for 4.2 miles and turn left at the parking lot. Or, from St. Louis, take I-44, about 12 miles west of Rolla to exit 172, then Hwy. D north through Jerome to Hwy. 28, then another 5 miles through Dixon to Hwy. W. Proceed on Hwy. W. another 4.2 miles to the parking lot on the left. From Springfield, follow I-44 to the Dixon exit #163, take Hwy. 28 north 13 miles through Dixon to Hwy. W. Proceed on Hwy. W another 4.2 miles to the parking lot on the left. (Note: There are two shallow stream crossings; do not attempt after a heavy rain.)

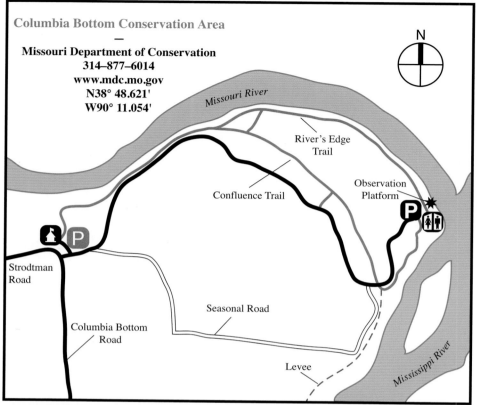

Columbia Bottom Conservation Area
—

Missouri Department of Conservation
314–877–6014
www.mdc.mo.gov
N38° 48.621'
W90° 11.054'

Missouri River

River's Edge Trail

Confluence Trail

Observation Platform

Strodtman Road

Seasonal Road

Columbia Bottom Road

Levee

Mississippi River

COLUMBIA BOTTOM CONSERVATION AREA offers a great opportunity to view the Missouri River, longest river in the United States, as it joins the Mississippi River and ends its 2,312-mile journey. The 4,318-acre tract was purchased in 1997 with one of its goals to restore the area to what it was like when Lewis and Clark made their journey up the Missouri River. The explorers' 1803-04 winter camp was just upstream from here along the Mississippi River near Wood River on the Illinois side. As you drive or hike around the area, you will see newly developed marshes, shallow wetlands, sloughs, bottomland prairie and bottomland forest. The area already attracts a variety of water-related wildlife from bald eagles, geese, ducks, gulls, white pelicans, shorebirds and wading birds to numerous types of land-related birds. You can get an area map, brochure, and bird checklist at: www.mobirds.org/CACHE/mdcchecklists1.asp?locID=887.

There are two trails in the area, the River's Edge Trail and the Confluence Trail. The River's Edge Trail can be accessed at the Confluence Observation Platform or near the Boat Ramp. The trail has a natural surface and follows the river's edge. You can make a loop trail out of it by returning on a section of the Confluence Trail. While at the Confluence Observation Platform, be sure to look downstream along the Mississippi River where you will see Duck Island. There is an active bald eagle's nest on the side of the island facing you. The nest is best seen when the leaves are off the trees.

You can access the paved 4.75-mile Confluence Trail at either the Visitor Center, the Boat Ramp or the Confluence Overlook. It is a hiking/biking trail that ties in with the River's Edge Trail so you can experience open habitats, bottomland forest, and river views.

Great horned owls, among other raptors, find great perches in which to oversee their domain in the tall cottonwood trees edging the two rivers.

Upon arrival be sure to stop by the Visitor Center to find out what is going on in the area, to pick up maps and brochures, visit the gift shop, tour the interpretive exhibits, see about scheduled programs, and familiarize yourself with the hiking/biking trails. The Visitor Center is open from 8 am to 4 pm on Saturday and Sunday and from 8 am to 5 pm Wednesday through Friday. It is closed on Monday and Tuesday. Columbia Bottom Conservation Area is open daily from 6 am to 10 pm from April 1 to September 30 and from 6 am to 7 pm from October 1 to March 31.

Directions: On the northeast part of St. Louis County and at the intersection of I-270 and Riverview Drive (exit 34) take Riverview Drive north for 2.8 miles to the conservation area.

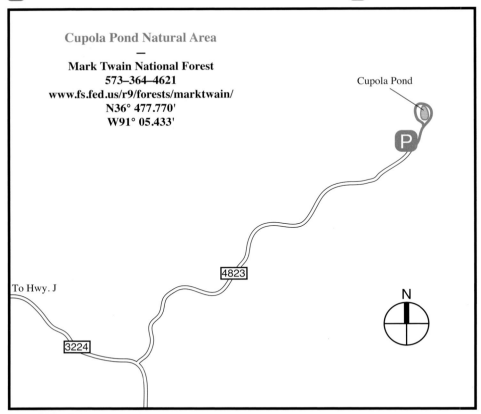

Cupola Pond Natural Area
—
Mark Twain National Forest
573–364–4621
www.fs.fed.us/r9/forests/marktwain/
N36° 477.770'
W91° 05.433'

Cupola Pond

4823

To Hwy. J

3224

N

CUPOLA POND NATURAL AREA contains the very unusual combination of a sink-hole pond edged with water tupelo trees. These trees are typically found growing in the Bootheel swamps over 60 miles to the east and not in the Ozark hills. How they got here is a mystery. An early hypothesis postulated that this landscape was once part of the coastal plain that was isolated in the last uplift of the Ozarks millions of years ago. I think that a more realistic explanation involves seed transportation. Either some large birds like Canada geese or trumpeter swans, having eaten the one inch long tupelo fruit that they found in the swamps over 60 miles to the east, landed in the pond and deposited the seeds. Or, that Native American Indians planted the seeds for an unknown reason. Whatever happened, the primeval setting is well worth seeing.

I was once told that "cupola" is a southern term for "tupelo." These southern trees grow no farther north in Missouri than the Bootheel. Unlike bald cypress trees that do quite well planted in upland landscapes, water tupelo trees seem to be less tolerable of cold temperatures and drier conditions. Here you'll see several old trees edging the pond of the natural area. Notice the huge buttresses that give extra stability in the somewhat unstable soil.

Pollen, in the sediment of the 2.5-acre sinkhole pond, has been found to be at least 20,000 years old, which gives an indication of how long this pond has been here. Most sinkholes do not form ponds. After the collapse of an underground cavern ceiling, the surface subsides and forms a depression which directs water into the cavern. Over time, if the conditions are right, the sinkhole gets plugged with debris and a pond forms. Aquatic

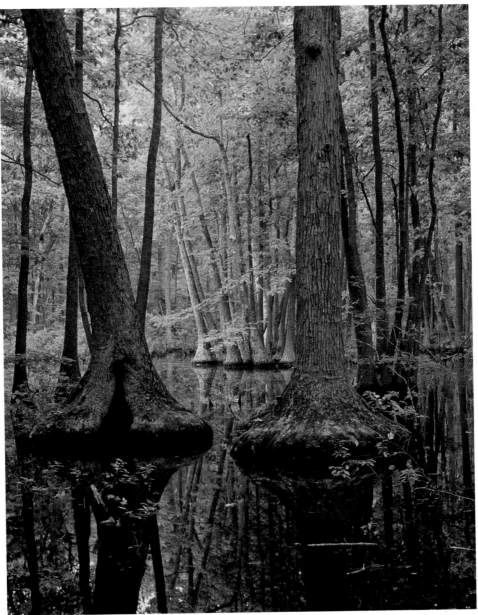

An ancient sinkhole pond provides habitat for venerable water tupelo trees.

plants soon get established from seeds brought in on the feathers and legs of waterfowl and wading birds. Be sure to walk the trail around the sinkhole pond. On the west side, the pond drains through a stand of pin oak trees with sphagnum moss carpeting the ground.

Directions: From Doniphan, go west 18 miles on Hwy. 160 and turn on Hwy. J, proceed another 14 miles to FR 3224, go another 1.3 miles to FR 4823, follow this road 1.3 miles to the parking area. Those with low clearance vehicles need to be careful on this last road.

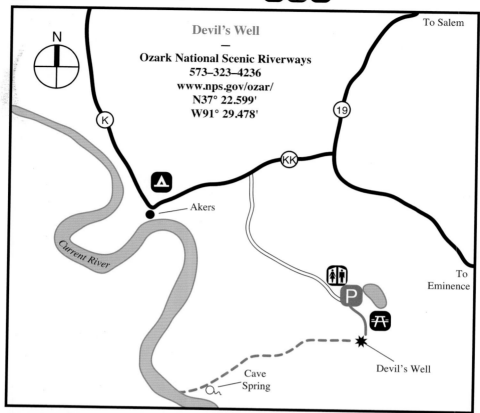

Devil's Well
—
Ozark National Scenic Riverways
573–323–4236
www.nps.gov/ozar/
N37° 22.599'
W91° 29.478'

To Salem

Akers

Current River

To Eminence

Devil's Well

Cave
Spring

DEVIL'S WELL contains the largest natural underground lake in the state and one of the largest in the United States. The lake is 100 feet deep, holds 22 million gallons of spring water and measures 400 feet long by 100 feet wide, which makes its surface area larger than a football field. In the late 1960s to early 1970's, Devil's Well was a commercial enterprise with customer's lowered 100 feet into the cavern in a bosun's chair. Although you cannot enter the cavern today, you can look down the lighted passageway to get a feel for the immensity of the underground lake. Take the walkway from the parking lot over to the interpretive displays. Beyond that is a natural sinkhole with a series of 43 steps that take you down into the sinkhole. On a hot summer's day, you will note the instant drop in temperature about one-third of the way down the stairs. Just before a stone arch, there is a light switch on the left to press. Continue to the gated overlook and peer down into the cavern. The light helps to see the interior but it's worthwhile to bring along a good flashlight for exploring more of the cavern. The water in the lake continues to flow southward about a mile and emerges from the mouth of Cave Spring. The spring water empties into the Current River at a rate of about 55 million gallons daily.

A recent trail has been constructed that will lead you down to Spring Cave and the Current River. The Cave Spring Trail is 4.6 miles roundtrip and varies from easy to moderate hiking. Plan on three and one-half hours or more depending on how many stops you make.

Directions: From Hwy. 19 south of Salem, take Hwy. KK two miles and turn left (south) on an unmarked gravel road for 1.5 miles to the parking area.

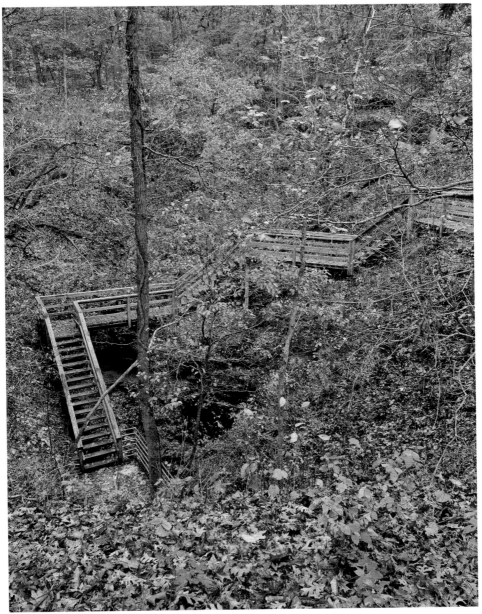

Winding stairs guide visitors into the depths of one of the Ozarks more unique natural exhibits.

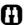

Diamond Grove Prairie
Conservation Area
—
Missouri Department of Conservation
417–895–6880
www.mdc.mo.gov
West prairie: N37° 00.957' East prairie: N37° 00.390'
W94° 23.319' W94° 21.001'

P West Unit

Lark Rd.

Carver Rd.

P East Unit

To Diamond

V

N

To George Washington Carver
National Monument

DIAMOND GROVE PRAIRIE CONSERVATION AREA is one of the largest remaining high quality prairies in the state. The 840 acres of prairie is divided into two units that are separated by a half mile. The Diamond Grove Prairie name comes from the nearby town of Diamond. I was once told by an elderly resident that early settlers, upon arriving in the area, noticed a large grove of trees, we today would call a savanna, that extended over a mile in size and that it was shaped like a diamond. When a town was established to the east of the grove they decided to call it Diamond Grove, which was later shortened to Diamond. So when Diamond Grove Prairie was purchased, it was named to commemorate the now absent diamond-shaped savanna.

The west unit of Diamond Grove Prairie was designated a state natural area in 1982 and in 1986 with an additional purchase. Beginning at the parking area, you can walk for a mile and a half eastward and still be in prairie. The landscape is nearly level to gently rolling and unobstructed by trees. The highest quality part of the prairie with a greater density of forbs begins about one-third of the way hiking eastward from the parking area. Here you will see royal catchfly, tall blazing star, blue hearts, Barbara's buttons, fringed poppy mallow and a variety of other wildflowers. Listen for narrowmouth toads, which sound like sheep, calling in the area in June after a rain. Notice the unusual mounds dotting the prairie. These are called "mima mounds." Common on western Missouri prairies, I think they have their best display on this particular prairie. See the glossary for more information on mima mounds.

The east unit of Diamond Grove Prairie is 282 acres in size. It is a good quality

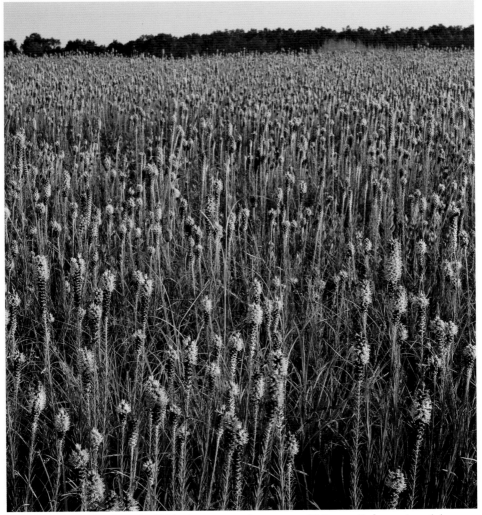

A massive display of tall blazing stars adorns one of Missouri's largest prairies.

prairie that was once over-seeded with fescue by a previous landowner. Management practices are in place to work towards eradicating this non-native grass from the prairie. Note in the southwest part of the prairie, the particularly large mima mounds. They are some of the larger ones that I have seen on prairies. Be sure to watch for scissor-tailed flycatchers sitting in trees and on fences along the road.

Opposite the turnoff to the east unit along Hwy. V, you'll notice a road leading to the George Washington Carver National Monument. I highly recommend you taking the time to visit the displays and stroll through their maintained prairie.

Directions: From I-44, take exit 18 to Hwy 59 and go south 4.4 miles to Diamond, then 2 miles west on Hwy. V and right (north) on Carver Road for 0.7 mile to the parking lot on the right. This takes you to the 282-acre east unit of Diamond Grove Prairie. To go to the main unit, continue past Carver Road another 2 miles on Hwy. V, turn right (north) on Lark Road and go1.4 miles to the parking area on the right (east).

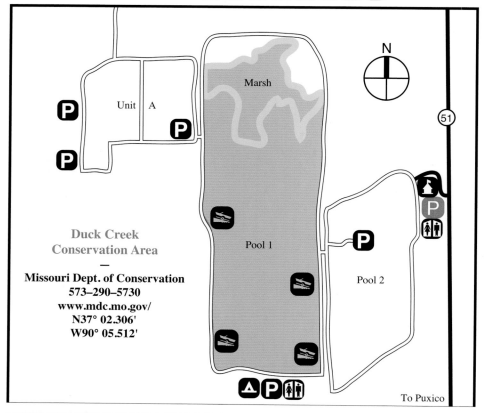

DUCK CREEK CONSERVATION AREA, with its 6,234 acres, provides a diversity of wetland habitats that attract a variety of songbirds, raptors, waterfowl, and mammals so you are bound to see wildlife in some form with every visit. There are few natural wetlands left in Missouri so national wildlife refuges and wetland management areas help to provide food, water, shelter and resting areas for numerous species of animals. One of the best places to observe wildlife is at Pool 1. Take the one way 9-mile drive around the 1,800-acre wetland especially in November and March and you will see thousands of geese and ducks using the area on the way to and from their winter home further south. (Note: The road around Pool 1 is closed during waterfowl hunting season which begins October 15 and closes in late December.) About 0.5 mile from the start of the drive, you will see a sign on the right (west) side of the road with a symbol for binoculars. Look across the pool and a large nest in a bald cypress tree will become evident. In the spring, using a pair of binoculars you may see a head sticking out of the nest and that will be an American bald eagle incubating eggs. Later in the spring, you may see one or two hatchlings peering out of the nest. This nest has been active for many years so you have a good chance of seeing eagle activity in the area whether perching in a nearby tree or soaring overhead. It was a little over 20 years ago that there were no bald eagle nests in the state but after restoration efforts the total is now over 200 annually!

If the entrance gate is open, be sure to take the 4.5-mile loop drive around Unit A. About a mile into the drive there will be a wetland area and if it is holding water in March, you will see birds including snow geese, ducks, American bitterns, black-necked

The placid water reflects a stand of bald cypress trees at sunrise.

stilts, rails, marsh wrens, white-faced ibis and many shorebirds. You may even witness a peregrine falcon diving at the shorebirds and ducks. Also in early spring, along the north end of the drive around Pool 1, watch for lots of double-crested cormorants resting in bald cypress trees. For a bird list of the area, go to: www.mobirds.org/CACHE/mdc-checklists1.asp/locID=118.

Directions: From Hwy. 60, take Hwy. 51 for 12 miles north to Puxico. Continue on Hwy. 51 about another 10 miles to the entrance to Duck Creek Conservation Area on the left. Proceed on the road past the headquarters and follow it to Pool 1.

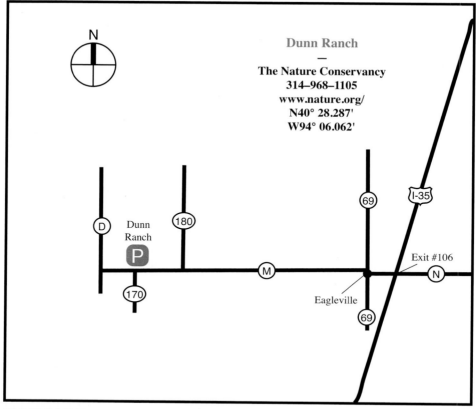

DUNN RANCH, with 3,680 acres, is the largest contiguous prairie north of the Missouri River. (Prairie State Park, with 3,702 acres would be the largest south of the river.) From the parking lot, there is a path leading north up a hill that offers a great view of the surrounding prairie landscape. The Nature Conservancy purchased the former ranch in 1999 and management efforts have been progressing to restore this impressive landscape to a more diverse and healthy tallgrass prairie. Other than the short path going up the hill, there are no additional paths at this time. Wandering around on the prairie is allowed but some units may be closed due to restoration efforts. You can call the Dunn Ranch office at 660-867-3866 or the St. Louis office at 314-968-1105 prior to your visit for more information.

While exploring this prairie landscape, you may be fortunate enough to flush out a greater prairie-chicken. When settlers first came to Missouri there were millions of prairie-chickens in the northern and western parts of the state. Today, there are less than 500 birds. Overgrazing, excessive hunting, loss of prairie, predators, and lack of burning prairies have all taken their toll. Restoration efforts are ongoing to introduce prairie-chickens from Kansas and Nebraska to a select number of prairies with the goal of establishing a stronger population of birds. Although Dunn Ranch has a few prairie-chickens remaining, more are being released to help increase the population. Prairie-chicken viewing was established at Dunn Ranch a few years ago. From mid-March to late April, you can reserve a predawn seat in a viewing blind, accompanied by a guide, that looks out over the "lek" (booming grounds). Here, you can easily observe the male's courtship displays they use to attract hens. Unfortunately, due to the low number of birds, the 2009 event

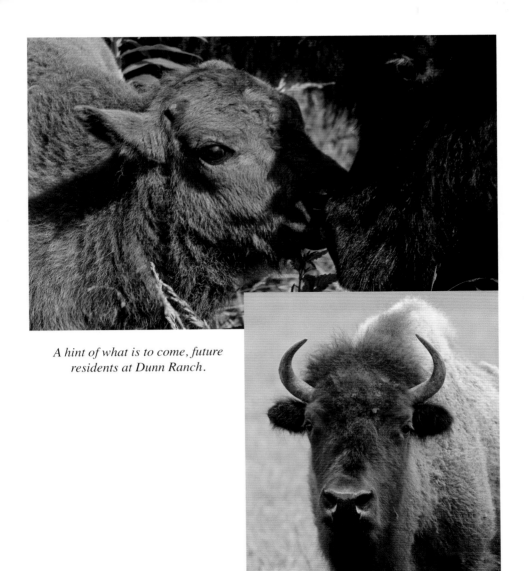

A hint of what is to come, future residents at Dunn Ranch.

was cancelled. Contact the Missouri Department of Conservation Northwest Regional Office at 816-271-3100 for details about future viewing opportunities.

Other birds found here include: bobolink, western meadowlark, upland sandpiper, dickcissel, grasshopper sparrow, Henslow's sparrow, sedge wren, northern harrier, short-eared owl, prairie falcon, and loggerhead shrike to name a few so be sure to bring binoculars!

As a former ranch, cattle once dominated this prairie landscape, but The Nature Conservancy has been working to reintroduce the former grazers, American bison, by constructing over five miles of special fencing around 1,200 acres of prairie. By the time that you are reading this, you should be able to look out over Dunn Ranch and see another piece of the puzzle that has been missing here for over 150 years!

Directions: Take I-35 to Eagleville exit 106, turn west on Hwy. N and proceed 0.5 mile through Eagleville to Hwy. 69, turn right (north) go 0.2 mile and turn left (west) on Hwy M. Follow Hwy. M for 6 miles to the parking area on the right (north).

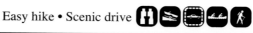

Champion Burr Oak Tree

Burr Oak Road

Perche Creek

Missouri River

Star School Road

Katy Trail State Park

Overlook

Wetland

Wetland

K

KK

N

**Eagle Bluffs
Conservation Area
—
Missouri Dept. of Conservation
573–884–6861
www.mdc.mo.gov/
N38° 51.869'
W92° 27.083'**

EAGLE BLUFFS CONSERVATION AREA is the largest wetland area in the United States that uses treated municipal wastewater from the City of Columbia to supplement its water needs; as much as 20 million gallons of treated water flows through the area daily. Here, over the 4,286-acre complex, you can see a diverse array of wildlife while driving, hiking or canoeing along a series of pools and canals. There are 13 wetland pools that are flooded to create 800 acres of seasonal marshes and 450 acres of more permanent marshes. These wetlands provide year-round habitat for migrating and wintering birds and permanent resident wildlife including a nesting pair of bald eagles for which the area was named.

The water attracts a wide variety of waterfowl and shorebirds during migration along with warblers and other songbirds that nest in the trees along the river and the bluffs. Look for egrets, herons, especially black-crowned night herons, and American and least bitterns wading in the shallow water looking for food. Eagle Bluffs has been designated as an Important Bird Area by the Missouri Audubon Society. A bird list is available at the field office (573-445-3882) just before you enter McBaine or you can go online to download a checklist of the birds that have been observed in the conservation area. Go to: www.mobirds.org/CACHE/mdcchecklists1.asp?locID=137

A side road leads to a boat access to the Missouri River with a nice panoramic view of the river and the towering bluffs on the other side. Most of the gravel roads are open during the year except for waterfowl hunting season that occurs from October 15 to around the end of December.

American coots feast on duckweed that has been windblown to one end of the wetland.

You may have noticed crossing over an abandoned railroad track just before McBaine. This is the Katy Trail State Park. Here a parking lot, restrooms and interpretive displays are provided. If you have a bike or just want to hike, there is an overlook with steps and a deck on the bluff just off of the Katy Trail 2.5 miles to the east that gives you a great view of the Eagle Bluffs wetlands. Another side trip takes you to the state champion bur oak that is also a co-national champion. From the intersection of Bur Oak Road and Star School Road, continue on Bur Oak Road another 1.2 miles and park near the majestic tree for a close-up view.

Directions: From Hwy. 63, take the Stadium Boulevard (Hwy. 740 exit), go west on Stadium Boulevard for 2.2 miles and turn left (south) on Providence Road. Continue south for 4.3 miles where Providence Road becomes Hwy. K. Follow Hwy. K for 7.8 miles through McBaine, where it becomes Burr Oak Road and in about 0.6 mile turn left onto Star School Road. Follow it for 2 miles to the entrance to Eagle Bluffs Conservation Area.

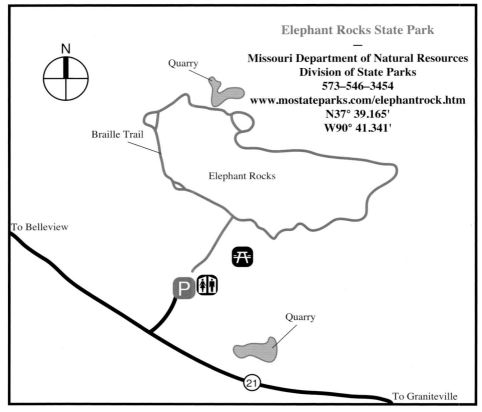

Elephant Rocks State Park
—
Missouri Department of Natural Resources
Division of State Parks
573–546–3454
www.mostateparks.com/elephantrock.htm
N37° 39.165'
W90° 41.341'

N

Quarry

Braille Trail

Elephant Rocks

To Belleview

Quarry

(21)

To Graniteville

ELEPHANT ROCKS STATE PARK has one of the most remarkable geologic features in the United States. Here, you can walk amongst large, rounded, red granite boulders that resemble elephants. These extraordinary rocks were formed about 1.5 billion years ago when molten rock (magma) pushed upward to just below the surface and slowly cooled to form granite. As the Ozark Mountains were being uplifted, fracture lines, called joints, were formed from the stress. These fracture lines run northeast and northwest, and, where they crossed, the granite separated into huge oblong blocks. Underground water movement and chemical weathering began eroding the edges of the blocks and when they were eventually exposed by surface weathering and the effects of freezing and thawing, the wind and rain smoothed and rounded the elephant-shaped rocks to what you see today. The granite is incredibly dense with one cubic foot weighing 160 pounds. One particular elephant rock named "Dumbo," weighs about 680 tons, stands 27 feet tall, and measures 35 feet long and 17 feet wide. See if you can find it!

A 7-acre portion of the 132-acre park was designated a state geological natural area in 1978 for displaying the best-known examples of massive spheroidal granite boulders. A one-mile interpretive trail called the "Braille Trail," wanders through the elephant herd with a spur trail, about halfway, that takes you to the top of the granite outcrop. Along some of the boulders, you will see where some of the early quarry workers carved their names; a tradition performed when they became master stonecutters. Be sure to hike to the highest point and there you will find "tinajitas" (pronounced "tin ya heetas"). These natural depressions are little watering holes where, in spring-

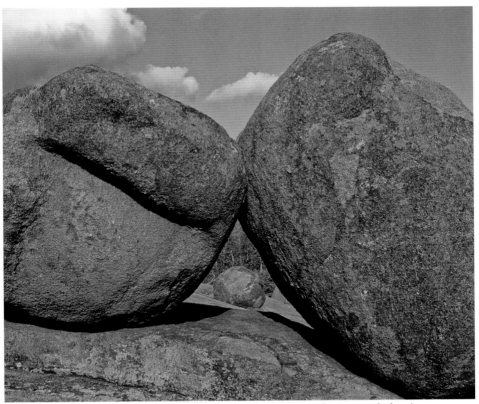

Resting "elephants" with a young pachyderm playing peekaboo!

time, you can find tadpoles and other aquatic life. An audio tour of the Braille Trail can be downloaded from the Elephant Rocks State Park webpage. Be sure to stop and read the interpretive signs at the entrance to the trail and especially how the "elephants" were saved from being quarried away.

Directions: From Potosi, take Hwy. 21 south for about 21 miles to the entrance or from the intersection of Hwy. 21 and Hwy. W, north of Pilot Knob/Ironton, go west 1.2 miles and turn right (north) at the entrance. Park hours: November through March, 8 am to 5 pm; April through October, 8 am to 8 pm.

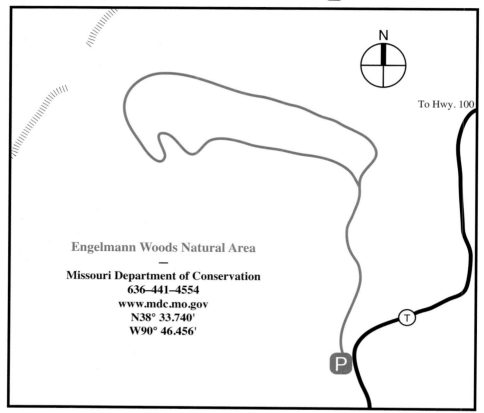

Engelmann Woods Natural Area

—

Missouri Department of Conservation
636–441–4554
www.mdc.mo.gov
N38° 33.740'
W90° 46.456'

To Hwy. 100

ENGELMANN WOODS NATURAL AREA has an impressive stand of mesic old growth forest. Here you will find towering red oak, white oak, white ash, and sugar maple, many of which are over 100 years old with several closer to 200 years old. Using an increment borer, I once aged a typical dominant red oak on a west facing slope and counted 180 annual growth rings. Woods with large trees like this are much less common today but this area has been protected for many years. It was donated by Mrs. Oscar Johnson in 1942 to the Missouri Botanical Garden. In the early 1980s, the forest was purchased by the Missouri Department of Conservation and dedicated in 1983 as a state natural area for its old-growth forest. The rich loess soil on the more protected north- and west-facing slopes accounts for the remarkable growth of the trees and, on the lower slopes, there are large displays of spring wildflowers and ferns such as celandine poppy, white trillium, puttyroot orchid, maidenhair ferns, and Christmas fern.

The area is named in honor of George Engelmann (1809-1884), who came from Germany and established a medical practice in St. Louis. In his later years, he travelled much in the West and found many new species of plants; especially cacti. He is known to have encouraged the wealthy St. Louis businessman Henry Shaw to develop his gardens for scientific and public use. His "Shaw's Gardens" later became the internationally known Missouri Botanical Garden.

The 1.5-mile loop trail is best taken clockwise at the point where the trail divides unless you want more of a workout. Part of the trail follows an old road that eventually continues off of the property. As the trail splits, note the differences in size and types of trees and other vegetation as you go from dry upland forest, to dry-mesic to mesic upland

Celandine poppy (above) and Jacob's ladder (below) are two of the many wildflowers that put on a showy display during April and May.

forest. If you happen to notice some American beech along the trail near the parking area, the trees are about 160 miles from their natural range in southeastern Missouri. I suspect that they were once planted as a horticultural novelty.

Directions: From the intersection of Hwy. 109 and Hwy. 100, west of Ellisville, go west on Hwy. 100 for three miles, turn right on Hwy. T, and proceed 6 miles to the parking lot on the right. It is at the top of a hill after the St. Alban's west entrance. There is parking space for three or four cars. The trail begins at the metal road gate.

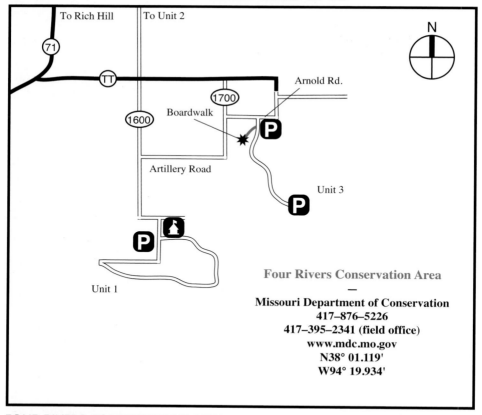

To Rich Hill — To Unit 2

Arnold Rd.

1700

Boardwalk

1600

Artillery Road

Unit 3

Unit 1

Four Rivers Conservation Area
—
Missouri Department of Conservation
417–876–5226
417–395–2341 (field office)
www.mdc.mo.gov
N38° 01.119'
W94° 19.934'

FOUR RIVERS CONSERVATION AREA, which is more formerly known as the August A. Busch Jr. Memorial Wetlands at Four Rivers Conservation Area, is a vast bottomland complex featuring wetlands, lakes, ponds, forests, established prairie, rivers, grasslands, and old fields. The 14,000-acre complex provides valuable migratory and resident wildlife habitat and is the largest state owned wetland management area in the state. The area is too vast to cover here but I can provide two areas for you to visit that will give you an opportunity to see a variety of wetland wildlife plus an active bald eagle nest. For a current list of birds that have been identified using the area, go to: http://www.mobirds.org/CACHE/mdcchecklists1.asp?locID=81

The area name comes from the four streams that influence the wildlife area. They are: Little Osage, Marmaton, Marais Des Cygnes (river of swans), and Muddy Creek. Water from these streams is used to flood the pools at certain times of the year but during periods of extended rain they can also overflow their banks and flood the lakes, pools, and roads that access them. However, flooding in wetlands is a normal process and helps to bring in nutrients and distribute excess water that would likely flood homes and farmland downstream.

A drive through Unit 1 begins just south of the headquarters. Be sure to pick up an area map at the front entrance of the former landowner's home. Then take the first road to the left and start the drive. In 0.1 mile you'll see the August A. Busch Jr. Memorial Wetlands monument. The drive continues in a 4.3-mile loop through Unit 1. As you head west on the long drive between pools 2 and 3, look ahead to the tree line and you should

A great blue heron from a nearby rookery is caught searching for nesting material.

see a large nest in one of the trees. That is the bald eagle nest that is active from February into June.

For the second drive, go north past the headquarters on CR 1600 for 0.7 mile and turn right (east) on Artillery Road for 1 mile, then turn left (north) on CR 1700, go 0.5 mile, turn right (east) on Arnold Road for 0.3 mile and turn right (south) to begin the drive at Unit 3. In 0.1 mile there is a parking area, monument, and view of Pool 3. In 0.1 mile a wheelchair accessible boardwalk takes you to a viewing blind. The road continues for 0.9 mile to a turn around with a hiking trail to Pool 14 for those that would like to do some wildlife watching on foot. Although closed from October 15 to February 15 for waterfowl hunting both units can be viewed during that period from overlooks at the start of each drive.

Directions: At the intersection of Hwy. 71 and Hwy. TT, 3 miles south of Rich Hill, go east 1.1 mile on Hwy. TT to CR 1600, turn right (south) and proceed 2.1 miles to the headquarters.

Scenic drive

GLADE TOP TRAIL is Missouri's only National Scenic Byway. The 23-mile road, which was built by the Civilian Conservation Corps back in the 1930s, was designed to optimize the far reaching scenic views that even extend into Arkansas. Along the route, there are opportunities to exit your vehicle and examine the large dolomite glades that are characteristic of this region. Because of the brilliant fall colors on the glades and forests along the drive, the Glade Top Trail Festival was established to celebrate this showy natural event. Typically, the festival is held the third Sunday in October in the nearby town of Ava and at the Caney Picnic Area, which is about halfway along the Glade Top Trail drive. At the picnic area, live music and a barbeque are provided. You can download a map of the Glade Top Trail at the Ozark Mountains link that I have provided or by stopping by the Ava Ranger District Office on the south side of Ava along Missouri Business Route 5.

The best times to travel the scenic byway are in the spring and fall. In April, the forests are highlighted with blooming serviceberry, redbud, wild plum, and flowering dogwood. Also in April, the glades become alive with showy wild flowers including Indian paintbrush, downy phlox, blue indigo, and yellow star grass. These give way to Missouri primrose, glade coneflower, butterfly weed and others in May and June. Yellow is the dominant color through summer as various sunflowers and goldenrods brighten the scene. Fall brings varied hues of asters and the striking rust-red color of the grasses set against the brightly-colored leaves of smoke tree, sumac, and flowering dogwood. In late October, the forested ridges peak with an array of yellows, reds, and purples that offer a truly amazing experience.

Vibrant fall colors make for a spectacular scenic drive in mid to late October.

Directions: From Ava, at the intersection of Hwy. 5 and Hwy. 14, travel south on Hwy. 5 for 6 miles and turn right (west) on Hwy. A. Proceed 3.5 miles and turn left (south) on County Road A409 for 3 miles and continue on Forest Service Road 147, which begins the Glade Top Trail. (Note: There is an intersection at about 2/3rds of the drive, where a side route called Skyline Drive (Forest Service Road 149), heads right and goes southwest providing additional scenic views ending at Hwy. 125 near Hercules Glades Wilderness Area.) The southern part of the Glade Top Trail crosses both public and private land. Please access private land only with permission. The drive ends at the small community of Longrun. At the three-way intersection in Longrun, turn east and proceed 0.1 mile to access Hwy. 95.

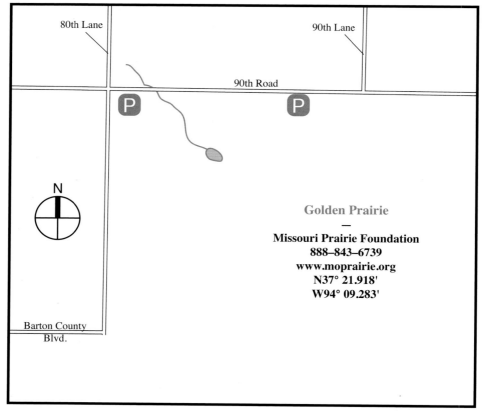

80th Lane

90th Lane

90th Road

N

Golden Prairie
—
Missouri Prairie Foundation
888–843–6739
www.moprairie.org
N37° 21.918'
W94° 09.283'

Barton County
Blvd.

GOLDEN PRAIRIE is a large, very diverse prairie. It was named for the nearby town of Golden City. Two units were purchased in 1970 and 1975 for a total of 320 acres (301 acres prairie; 19 being restored) by the Missouri Prairie Foundation. In May 1975, the prairie was declared a National Natural Landmark by the National Park Service. This national program was established in 1962 to recognize the best examples of biologic and geologic features in both public and private ownership. Today, there are 587 National Natural Landmarks in the program with 16 designated sites occurring in Missouri.

Golden Prairie is one half mile wide and one mile long so there is plenty of opportunity to just wander around, appreciate the diversity of plant and animal life and get a sense of what a prairie landscape must have been like. Heading south from the parking lot, you soon come up on a broad ridge that shows the prairie sloping to the north and south. Along the way, take note of some of the 345 species of plants (a high amount for any prairie) that have been recorded on this area. Of particular interest are royal catchfly, blue false indigo, and prairie hyacinth. Animals to watch for include ornate box turtle, slender glass lizard, loggerhead shrike, scissor-tailed flycatcher, upland sandpiper, and greater prairie-chicken.

Directions: At the intersection of Hwy. 160 and Hwy. 37 at Golden City, take Hwy. 37 south about 2 miles to County Road SE 90th Road, turn right (west) and proceed 2.5 miles. There are two parking areas with the main lot on the northwest corner of the prairie. (Note: On some visits you may encounter a few head of cattle in this prairie. They are being used as a management tool like prescribed fire and occasional haying so feel free to access the prairie but be sure to close the gate.)

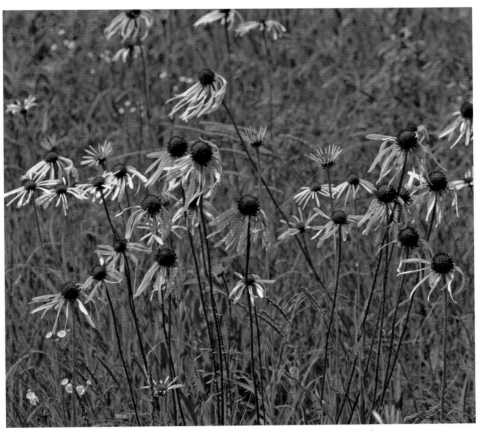

Pale purple coneflowers dance in the prairie wind. (above)
Spiderwort is one of the brighter gems on the prairie. (below)

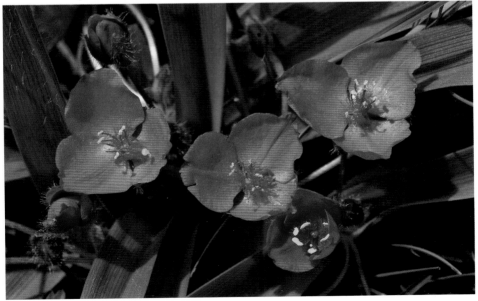

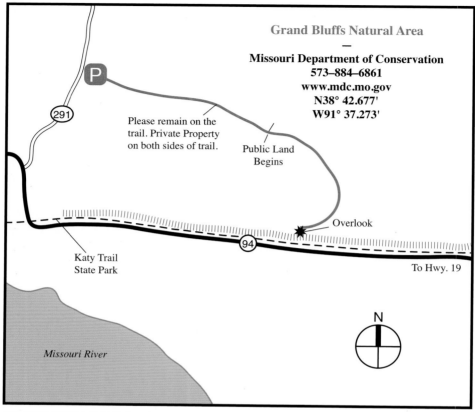

Grand Bluffs Natural Area
—
Missouri Department of Conservation
573–884–6861
www.mdc.mo.gov
N38° 42.677'
W91° 37.273'

Please remain on the
trail. Private Property
on both sides of trail.

Public Land
Begins

Overlook

To Hwy. 19

Katy Trail
State Park

Missouri River

N

GRAND BLUFFS NATURAL AREA is located along a 3-mile stretch of bluffs towering 300 feet above the Missouri River valley. This is the most dramatic exposure of bluffs along the Missouri River in Missouri. A section of the bluffs was purchased in 1991 and designated a state natural area. The dry, fluted dolomite cliffs can be viewed along Hwy. 94 and the Katy Trail. Most cliffs along either side of the Missouri River valley were damaged when railroad tracks were built on each side of the river. In order to elevate the track above the river floodplain many cliff faces were blasted to provide enough fill material to raise the railroad bed. Along the Grand Bluffs, the old railroad bed, which is now the Katy Trail was built far enough away from the cliff that blasting of the cliff was not needed for fill material. So this stretch of towering dolomite cliffs remains much the same as it did when Lewis and Clark made their journey upstream passing by here on May 29, 1804.

A natural surface trail leads from the parking lot up a forested slope to the ridge above the cliff. Along the way, you'll see young to mature second growth white oak, black oak, post oak, sugar maple, red oak, and mockernut hickory. On the ridge there is an old field that is succeeding to persimmon, smooth sumac, and gray dogwood with patches of big bluestem grass, asters and goldenrods. You enter the woods again and start down a slope passing a zone of some large rock boulders and rock slabs of sandstone covered with patches of gray-colored boulder lichen. Below that, Jefferson City dolomite becomes the dominant bedrock that forms the cliff. The first opening on the slope is a small hill prairie with Indian grass, little bluestem grass, partridge pea, and woodland sunflower. Missouri

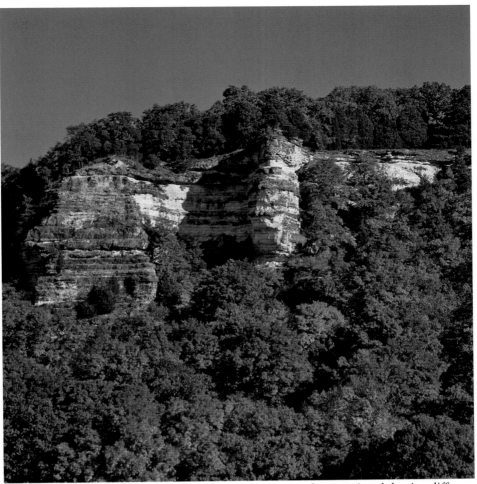

Sugar maple trees show off their fall colors against the towering dolomite cliffs.

Department of Conservation staff are working to preserve this small prairie remnant by cutting some of the smaller trees and by conducting prescribed burns. The trail soon leads to a platform and offers an incredible view of the Missouri River valley. Notice the small dolomite glade around the platform. Here you will find drought-adapted plants that can survive living in thin soils over bedrock. They include sideoats grama grass, big bluestem grass, little bluestem grass, glade coneflower, Missouri coneflower, and cliff goldenrod.

Directions: From the intersection of Hwy. 94 and Hwy. 19, just north of Hermann, take Hwy. 94 west for 7 miles. At the end of the 3-mile long bluff, there is a sharp turn at Bluffton, a town settled in 1847 and now abandoned. Proceed north a short distance and turn onto County Road 291, Bluffton Road, go 0.3 mile to the parking lot on the right. (Note: Please remain on the trail for at least the first half of the hike because it is an easement through private property on both sides of the trail.)

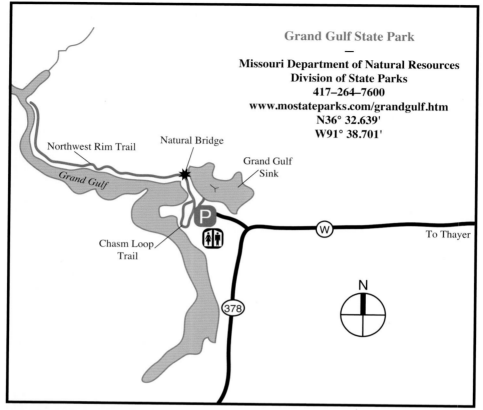

Grand Gulf State Park
—
Missouri Department of Natural Resources
Division of State Parks
417–264–7600
www.mostateparks.com/grandgulf.htm
N36° 32.639'
W91° 38.701'

Natural Bridge

Northwest Rim Trail

Grand Gulf
Sink

Grand Gulf

P

Chasm Loop
Trail

W

To Thayer

378

N

GRAND GULF STATE PARK is considered one of the most spectacular geologic features in Missouri. The major feature of the 322-acre park is the collapsed remains of a major cave system, with a sinkhole, cave, natural bridge, and a gulf that is often called Missouri's "Little Grand Canyon." The gulf was formed by the roof collapse of a large cavern estimated to have taken place around 10,000 years ago. A part that did not collapse remains as one of the largest natural bridges in the state measuring 200 feet long with an opening 75 feet high and 50 feet wide. The canyon, which is three quarters of a mile long, has vertical sides about 130 feet high that makes the chasm deeper than it is wide.

There are interpretive signs along the trails that explain how the grand gulf was created and four overlook decks where you can peer down into the canyon which may be flooded up to 100 feet deep one visit and bone dry another. This is an unusual feature created by Bussell Branch, a creek that previously flowed through the once intact cave system and now flows through the canyon and into a part of the cave that did not collapse. The once open cave is now plugged with debris so water drains through slowly causing the gulf to form a deep lake. The water eventually reappears at Mammoth Spring in Arkansas, 7 miles away. Since you are in the vicinity, head south on Hwy. 63, south of Thayer and just into Arkansas to visit Mammoth Spring, which, at an average daily flow of 234 million gallons of water, is the largest spring in Arkansas, the 6th largest in the United States and the 10th largest in the world.

The Chasm Loop Trail offers several overlooks with interpretive signs in the immediate vicinity of the parking lot. The Northwest Rim Trail follows along one side of

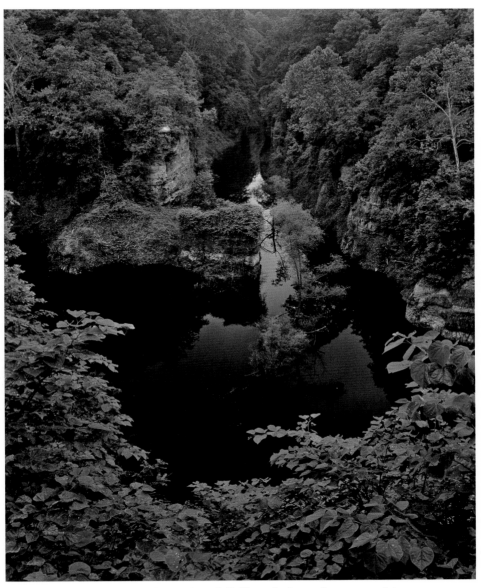

*Wearing two faces. Grand Gulf can be bone dry on one visit
and brimming with water the next.*

Grand Gulf and provides views into the canyon that are best seen when the leaves are off the trees. Towards the end of the trail, there is a view of a wet-weather waterfall that is activated by heavy rains draining an area over 20 square miles in size. This is a good place to turn around and head back because the trail dead ends shortly beyond this point.

Directions: At Hwy. 160 and Hwy. 19, north of Thayer, follow Hwy. 19 south one mile and turn right (west) on Hwy. W and proceed 6 miles to the entrance to Grand Gulf State Park. The park is open daily from 8 am to dusk. Park gates open and close at these times.

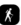

GRASSHOPPER HOLLOW NATURAL AREA contains the largest fen complex in un-glaciated North America. That is quite a statement but it is true. Fens are a type of wet-land more associated with northern and northeastern states and Canada in areas that were glaciated. Although rare, there are more fens in the Ozarks of Missouri than anywhere else in unglaciated North America. And, in the Ozarks, Grasshopper Hollow has the high-est concentration with at least 15 fens. When water filters down through the fragmented dolomite bedrock of the surrounding ancient hills, it eventually emerges on the lower slopes and valley bottom as cool, ever-flowing seeps. It is here you will find plants that favor growing in these fens with their permanently saturated soil. This 593-acre, state designated natural area, is owned by The Nature Conservancy, Mark Twain National For-est, and Doe Run Mineral Corporation.

In preparation for the hike, you may want to wear boots or shoes that you don't mind getting wet. The trail is mostly dry but there are occasional seeps that cross over the old road. The Nature Conservancy does have an informative trail brochure with numbered stops along the way but I usually find the box about 500 feet down the trail empty. For a trail guide call the Lower Ozark Project office at 573-323-8790 or the main office at 314-969-1105. About halfway down the trail, you will notice an old beaver pond lined with alder. At the end of the trail, a deck overlooks a 40-acre prairie fen. This is the larg-est of the four types of fens that occupy the valley. It is called a prairie fen because plants more commonly found growing in prairies such as prairie cordgrass, big bluestem, Indian grass, New England aster, and rough-leaf goldenrod can be found here.

The uncommon marsh fern stands amongst Indian paintbrush and ragwort.

You may notice some logging in the hills. The hills are mainly oak but prior to extensive logging and fire suppression, beginning in the late 1800s, the hills were dominated by shortleaf pine. A management goal is to convert the hills back to mostly pine because they transpire less water than oaks which will allow more water to percolate into the hills which will feed the fens.

Directions: On Hwy. 21, south of Centerville, take Hwy. 72 west 12 miles to County Road 860 on the right (north) and follow the gravel road 0.6 mile to the parking lot. Or, from Hwy. TT, go east on Hwy. 72, 1.1 miles to County Road 860 on the left (north) and follow the gravel road 0.6 mile to parking lot. (Note: at 0.4 mile on the gravel road you cross the Karkaghne Section of the Ozark Trail.)

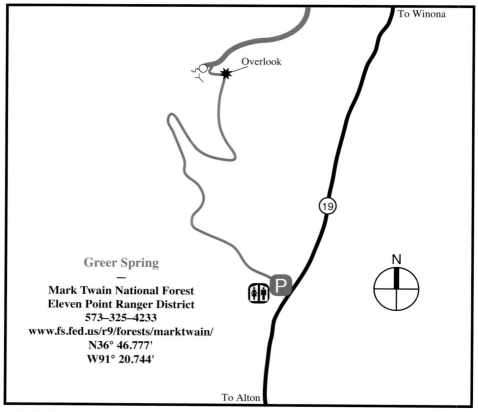

GREER SPRING, with a flow of 220 million gallons per day, is the second largest spring in Missouri. Amazingly, there is such a large volume of flow that when the spring water ends its 1.25-mile run, it doubles the size of the waiting Eleven Point River. To amass such a large volume of water, studies have found that the spring is fed from a recharge area that encompasses 330 square miles of land. Greer Spring has much wild beauty, having long since recovered from dams, mills, and other structures abandoned before 1921. The trail begins in the northwest corner of the parking lot. The trail is moderately strenuous but there are switchbacks and some benches along the way to make it easier. As you get closer to your destination, the faint sound of rushing water gets louder. Before long, you arrive at a stone overlook within sight of Greer Spring's two openings. To your right is the spring boil that emits the largest volume of water of the two openings. Notice how the width of the spring run doubles below the boil. Upstream about 60 yards to your left, the second flow emerges from Greer Spring Cave. At one time in the past, the cave opening probably carried the total volume of water but an underground conduit broke through 300 feet downstream from the cave and pirated much of the water. In spite of the boil's powerful current, divers have been successful in entering this opening to a depth of 100 feet.

You can get a closer look at the spring boil by carefully walking down the steps to the left and taking the narrow foot trail to the right. Once at the spring boil, you will see that the trail continues and eventually ends at the Eleven Point River. Hiking beyond the spring boil is not recommended because the trail is rugged and not maintained.

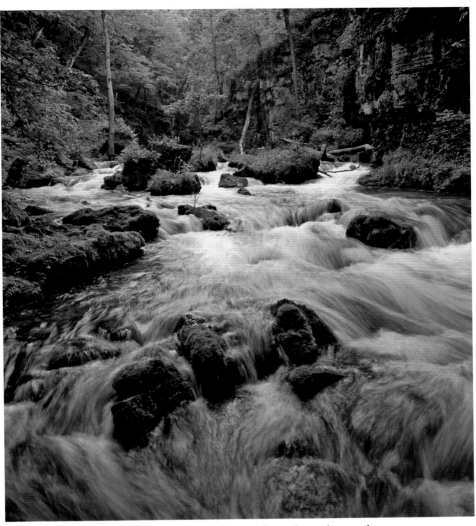

*The second largest spring in Missouri flows through a verdant canyon
on its way to the Eleven Point River.*

This spring fed stream is incredibly fast. It drops 62 feet over its 1.25-mile run to the Eleven Point River, making it one of the steepest gradients of a major stream in the state. The water is so powerful that wading, swimming and boating are prohibited. One canoeist attempted the run and lost his life while the son of a former owner accidentally fell in and was pounded to death by the rocks in the rushing water. Also, entry into the cave is discouraged due to hazards presented by strong currents, slippery footing, and possible damage to cave life, including the habitat of a population of the rare Salem cave crayfish.

Directions: Take Hwy. 19 and go 18 miles south of Winona or 8.5 miles north of Alton to the entrance and parking area on the west side of the road. The area is open from dawn to dusk.

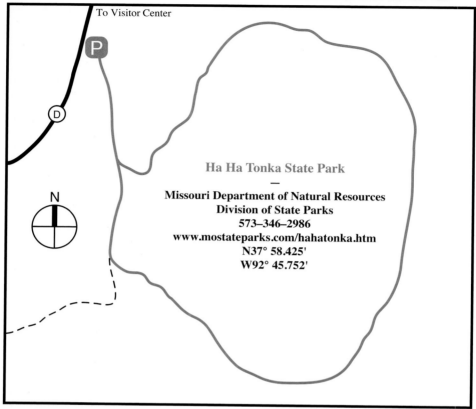

To Visitor Center

N

Ha Ha Tonka State Park
—
**Missouri Department of Natural Resources
Division of State Parks
573–346–2986
www.mostateparks.com/hahatonka.htm
N37° 58.425'
W92° 45.752'**

HA HA TONKA STATE PARK is rich with many interesting features spread across its 3,680 acres. Here, you have an opportunity to visit a large spring (the 12th largest in the state), a natural bridge, glades, woodlands, bluffs, caves, sinkholes, castle ruins, the Niangua Branch of the Lake of the Ozarks and 15 miles of trails. To learn more about these special features, a stop at the visitor center is recommended to pick up a park trail and natural area guide. Also, adjacent to the building, there is an outdoor interpretive exhibit that provides a good orientation to the park's features and history.

One of my favorite stops is at the Ha Ha Tonka Woodland (formerly named "Savanna") Natural Area, a 953-acre natural area that was designated in 1990. Here you will find one of the largest publicly-owned woodland and glade landscapes left in the state. The glades are of particular interest to me because they contain a high diversity of wildflowers and engaging rock outcrops. These rock outcrops are quite porous or spongy in character and identify a certain type of dolomite classified as Gasconade dolomite, the main bedrock in the park. Of the several types of dolomite in Missouri, Gasconade dolomite and Eminence dolomite, outcroppings further southeast from here, have the most interesting shapes due to their spongy looking surface.

I recommend taking the Acorn Trail because it provides an excellent opportunity to see a glade and woodland landscape that changes in character as you walk the path encircling the hill. Note the differences in vegetation on the south and southwest face of the hill compared to the east and north side of the hill. To reach the Acorn Trail, begin at the visitor center entrance and drive 0.7 mile south on Hwy. D to the Turkey Pen Parking Lot

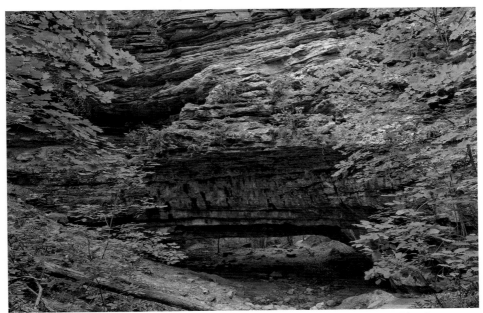

The colorful and weathered Gunter Sandstone enhances the natural bridge.

June is the month to see an abundance of yellow coneflowers along the Acorn Trail.

on the left (east) side of the road. Here, you can obtain an Acorn Savanna Self-guiding Trail booklet as well as a map showing all of the trails in the park. You can also obtain these brochures at the visitor center. Beginning at the parking lot, you will find a 450-foot wheelchair accessible Oak Woodland Interpretive Trail. This is also the start of the 7-mile Turkey Pen Hollow Woodland Trail. Take the trail south up a rather steep hill and follow the green arrows which identify the 0.75-mile Acorn Trail.

Directions: From Camdenton, go west on Hwy. 54 for 2 miles and turn left (south) on Hwy. D; proceed 1.5 miles to the visitor center on the right. The park and visitor center are open daily from November 4 through March 10, from 8 am to sunset; and from March 11 through November 3, the park and visitor center are open daily from 7 am to sunset.

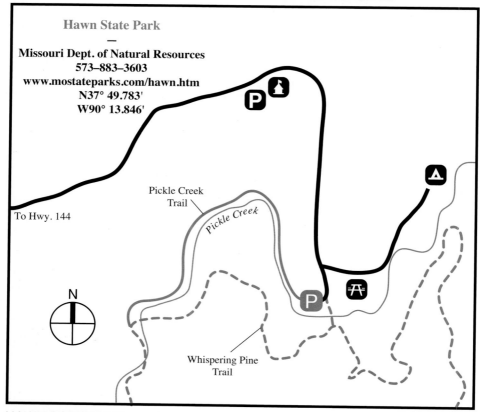

Hawn State Park
—
Missouri Dept. of Natural Resources
573–883–3603
www.mostateparks.com/hawn.htm
N37° 49.783'
W90° 13.846'

Pickle Creek Trail

To Hwy. 144

Pickle Creek

N

Whispering Pine Trail

HAWN STATE PARK contains some of the most unique and appealing natural features of any park in the state. Immediately, upon the drive past the entrance, you will notice broad sweeping hills dominated by tall unswerving pine trees rising above a far reaching open understory. A stop at the 0.25-mile paved Pinewoods Grove Trail and Overlook with its interpretive signs explains what you are looking at and how it came to be. This trail is wheelchair accessible. Along with the special pine woodlands, the park also contains clear water streams, shut-ins, granite outcrops, and sandstone features including weather-sculpted outcrops, overhangs, majestic bluffs, narrow canyons, and hilltops that offer far-reaching views.

You can pick up a trail brochure at the office. I would recommend the Pickle Creek Trail because it contains a variety of features in such a short distance. This 1.5-mile round-trip hike, marked with green arrows, begins on the west side of the picnic area. Notice the large stand of towering pines, many of which are over 200 years old. The trail enters the Pickle Creek Natural Area. This 58-acre area was designated as a state natural area in 1979. Over much of the hike, the trail parallels Pickle Creek, which was selected as an outstanding water resource. This high quality stream contains more than 20 species of fish that live among a series of small rapids, extended pools and miniature waterfalls. A granite shut-ins is another neat feature along the trail. The trail is a bit more rigorous here so take your time. At about 0.6 mile, the trail crosses over Pickle Creek. Here, you can either return back the same way you came or continue on an upland route that becomes the Whispering Pines Trail that is marked with red arrows. After a hike up a steep hill, you

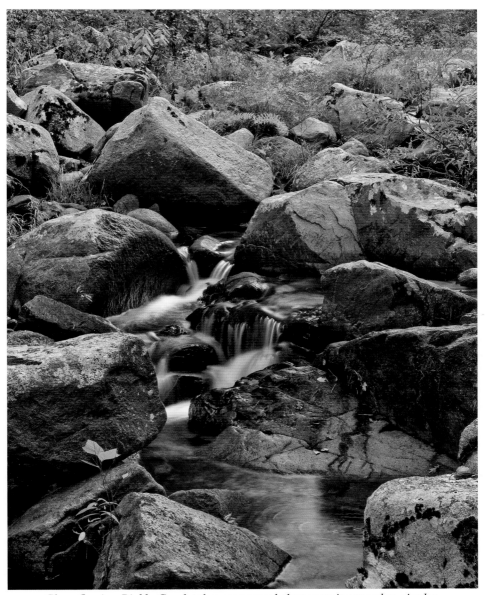

*Clear flowing Pickle Creek takes on several shapes as it cascades, ripples,
and pools its way through the park.*

are rewarded with a great view of the surrounding landscape. The trail continues along a
north slope and down a hill to a left turn that leads back to the picnic area.

Directions: From Ste. Genevieve, at the intersection of I-55 (exit 150) and Hwy. 32,
take Hwy. 32 west for 11 miles and turn left (south) onto Hwy. 144. Proceed 3 miles to
the park entrance. The gates are open from 7:30 am to 9:00 pm. Follow the directional
signs down to the picnic area. There you will find the Pickle Creek Trailhead, which is
west of the Whispering Pine Trailhead.

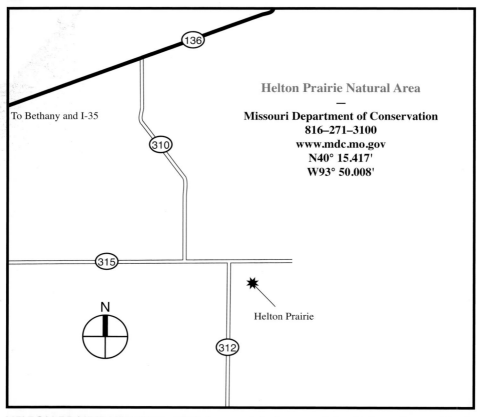

Helton Prairie Natural Area

—

Missouri Department of Conservation
816–271–3100
www.mdc.mo.gov
N40° 15.417'
W93° 50.008'

To Bethany and I-35

Helton Prairie

HELTON PRAIRIE NATURAL AREA is one of the last remaining high quality prairies in northern Missouri. This 30-acre prairie was designated as a state natural area in 1989. Although small in acreage, when compared to prairies in the southwestern part of the state, it more than makes up for its size with showy wildflower displays from May through September. Prairies north of the Missouri River once dominated the landscape in this glaciated portion of the state. Here, past glaciers reworked the soil and deposited new material which later made for easier plowing. Compare this with the southwestern part of the state, where glaciers never reached. The soil is thinner, rockier making tilling impossible in most places. Here, prairies are used for pasture and for haying. There was once an estimated 15 million acres of prairie in the state prior to European settlement. Of the 70,000 acres of prairie remaining, 98% of it occurs in areas of thin-soil in the southwestern part of the state. This makes Helton Prairie, with its tillable soil, even more special.

As you walk through the prairie, notice how dense and plush the vegetation appears. This is because of its rich, silt loam soil. Classified as a mesic (moist) prairie it is one of the rarest types of prairie because most have been plowed and converted to cropland. Helton Prairie is in its showiest floral display from May through June but you can always find something in flower here through September. Look for pale purple coneflower, compass plant, bunchflower, Michigan lily, prairie phlox, rattlesnake master, alum root, lead plant to name a few, along with grasses such as prairie dropseed, big bluestem, switch grass, gama grass and Indian grass. In the draws, you will find conditions where moisture is held a little longer and that is referred to as wet-mesic prairie, a condition between wet

With deep, rich soils, northern prairies such as Helton contain an abundance of showy prairie wildflowers.

and mesic. Look for large pockets of sawtooth sunflower with their 8 to 10 foot stems waving in the sky. Unfortunately, poor farming practices north of the prairie, has caused extensive erosion in the main draw that runs through the prairie due to increased water drainage. A series of rock dams held together with fencing is helping to stabilize the draw that would eventually destroy the prairie if left unchecked. Be sure to check out the 15-acre unit to the east of the prairie. Formerly in row crops, it is being restored to mesic prairie by adding seeds collected from prairie plants growing in the adjoining natural area. Notice also how Helton Prairie is slowly spreading on its own eastward into the restored prairie.

Directions: From Bethany and I-35, proceed on Hwy. 136 east for 7 miles and turn right (south) on County Road 310, go south 1.6 miles and turn left (east) on Country Road 315 and after 0.3 mile, park along the road near the large sign and enter the prairie.

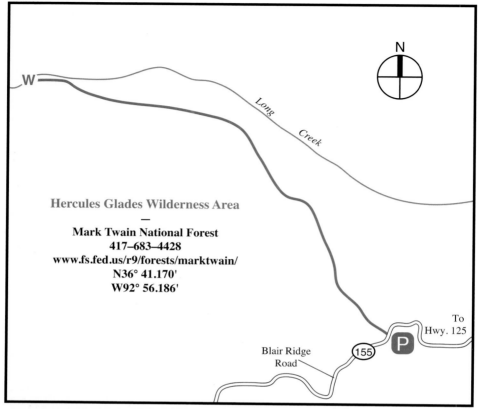

HERCULES GLADES WILDERNESS AREA is a huge complex of open glades, knobs, rocky hillsides and narrow drainages that give you a sense that you are in true wilderness. Designated as a wilderness in October 1976, Hercules Glades are a window back in time to what the landscape was once like when settlers first appeared in the White River Hills. Here you will find numerous dolomite glades on slopes and knobs, many of which are interconnected by trails. Glades are like miniature deserts where you can find roadrunners, collared lizards, tarantulas, scorpions, and pygmy rattlesnakes. Also, plants specialized in tolerating the heat, drought, and thin soils like Indian paintbrush, prickly pear cactus, glade coneflower, Missouri primrose, blue false indigo, and Missouri coneflower, to name a few. The glades display their best flowering from April through June, while the yellows of sunflowers and goldenrods dominate the summer.

There are three public trailheads that give you access to six trails totaling 42 miles that traverse across the area's 12,315 acres. The trail to Long Creek Falls provides a good selection of features that represent the White River Hills. Wander around the glades inspecting the variety of plant life and enjoy the scenic views of the surrounding hills. My only disappointment here is that the wilderness area has had few prescribed fires which are needed to set back the woody encroachment, especially from that of eastern red cedar. The trail is 5.4 miles roundtrip with easy hiking until the last half mile when the trail goes downhill to Long Creek. It is the return trip where you need to take your time. To see the impressive falls, take the trail to the left at a "Y" intersection towards the base of the hill. Follow the trail as it parallels the creek, crossing a small side branch, continue on the

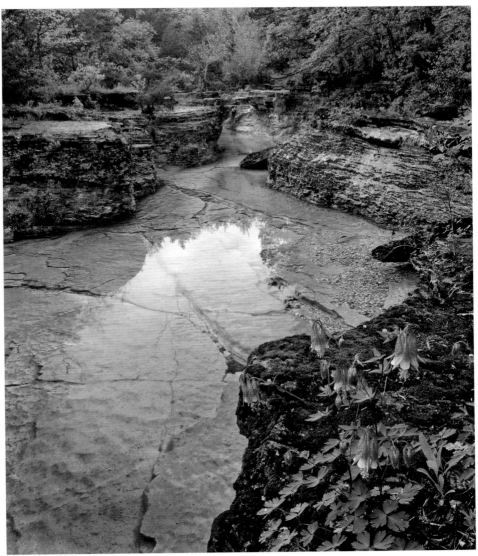

A wild columbine overlooks the tranquil water of Long Creek.

trail up and down a small hill along Long Creek eventually to a small cedar grove with a campfire ring and from there walk straight over to the falls. Or, simply wade/walk along the creek until you reach the falls. Long Creek Falls is definitely one of the main features in the wilderness area. Mainly active after substantial rains, water cascades over ledges 6 to 10 feet high, plunging into a large pool. Unfortunately, there are few waterfalls in the state of much note but the scenic quality of the water-sculpted dolomite bedrock makes Long Creek Falls well worth the hike just to see it.

Directions: From Forsyth, take Hwy. 160 east 21 miles and turn left (north) on Hwy. 125, proceed 6.3 miles and turn left (west) on Blair Ridge Road, CR 155, and go 2.3 miles to the parking area on the left. The trail begins on the opposite side of the road. If you miss the CR 155 turn, proceed another mile to the Hercules Glades Wilderness Lookout Tower entrance where you can turn around.

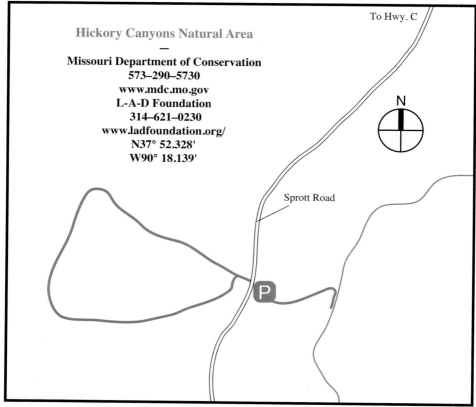

HICKORY CANYONS NATURAL AREA offers close-up views of scenic box canyons and cliffs draped with ferns and mosses. The cliffs are composed of ancient LaMotte sandstone that was formed over 500 million years ago. That makes it the oldest sedimentary rock in Missouri. Of all the various sandstone, limestone, and dolomite cliffs and canyons in the state, LaMotte sandstone is the most impressive. The shaded, cool, moist canyons provide habitat for plants that were once more common here during the Ice Age. As the last Ice Age ended over 12,000 years ago, the landscape changed to a warmer, drier environment. The cool, moist loving plants migrated north with the retreat of the glaciers, while some found these narrow canyons suitable to continue thriving. These are called relict plants because they are remnants (left behind) from larger populations of plants and have managed to survive in the microenvironment that these canyons provide. Here you will find the rare shining club moss, partridge berry, northern white violet, rattlesnake orchid, and others. The long fronds of the rare hay-scented fern can be seen arching over cliff ledges in a few areas. The name comes from the smell of the fronds when crushed to that of newly mowed hay.

As you walk the trails, notice the drier upper slopes dominated by shortleaf pine, black oak, blackjack oak, white oak and highbush blueberry. As you drop into the canyons, where the moisture is greater, red oak, white oak and sugar maple dominate with an understory of pawpaw, spice bush, deciduous holly, and wild azalea.

Hickory Canyons was dedicated as a natural area in 1974 with an addition in 1979. The 280-acre natural area is owned by the L-A-D Foundation and managed by the Mis-

Autumn comes to the canyon with its lichen capped rim.

souri Department of Conservation. There are two trails, one on either side of the road. The 0.5-mile roundtrip trail begins at the parking area. It follows a slope into a box canyon with spectacular views of cliffs, ledges, overhangs, and a waterfall when there is sufficient rain. Across the road from the parking area you'll find the 1.0 mile loop trail. After a short distance on this trail, you have a choice of either going left or right. If you go left, you eventually come to some stairs that descend into a small box canyon. At the other end of the trail, the hike out of the valley is a little steeper for a short distance. If you go right, you go down the steeper slope and eventually enter the box canyon from the mouth of the canyon, which makes for a more impressive view. So it's your choice. While walking the valley floor, the trail crosses a small wet-weather creek four times. Expect to get your boots a little muddy along this stretch. At the beginning of each trail there are caution signs about the cliffs ahead so if children are along watch that they don't get ahead of you or wander off the trail.

Directions: From the intersection of I-55 and Hwy. 32 (exit 150) near Ste. Genevieve, take Hwy. 32 west, 8 miles and turn right (north) on Hwy. C, proceed 3.2 miles, turn left (west) on Sprott Road, and go 1.7 miles to the signed parking area on the left.

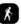

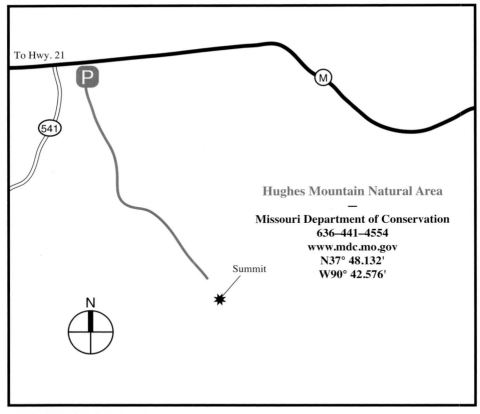

To Hwy. 21

P

541

M

Summit

Hughes Mountain Natural Area
—
Missouri Department of Conservation
636–441–4554
www.mdc.mo.gov
N37° 48.132'
W90° 42.576'

N

HUGHES MOUNTAIN NATURAL AREA has a unique geologic feature that is found in only a few places in the world called Devil's Honeycomb. The large hill before you is composed of once-molten rock that dates back 1.5 million years. As some of the molten rock cooled at the very top, it formed polygonal columns resembling fence posts. These columns have four to six sides that measure 8 to 10 inches in diameter and 3 to 4 feet in height. Granted, they are shorter than typical fence posts but if you stand on the surface and look down on the polygonal shapes, a honeycomb pattern comes to mind. Similar igneous features make up Devils Tower National Monument in Wyoming, Devils Post Pile National Monument in California, and the Giant's Causeway in Ireland.

The natural area, which was designated in 1982, was named for John Hughes, the first European settler in the area who arrived in 1810. The land stayed in the Hughes family until it was purchased by the Missouri Department of Conservation. On the south side of the parking lot, the Devil's Honeycomb Trail begins. The trail heads up the northern flank through a forest dominated by red oak, white oak, sugar maple, red maple, mockernut hickory, and flowering dogwood. The higher you go, notice the change to dry woodland with trees more open grown, knarled, and stunted due to the drier conditions. Here, you find black jack oak, post oak, eastern red cedar, and black hickory along with small openings of bare rock and thin soil. The height and diameter of these trees is much smaller than the trees you encountered on the lower north slope but they are very close to the same age or even older. Exposure, slope, soil depth, and moisture availability all greatly influence the size, vigor and types of plants that grow in any one area. After a somewhat

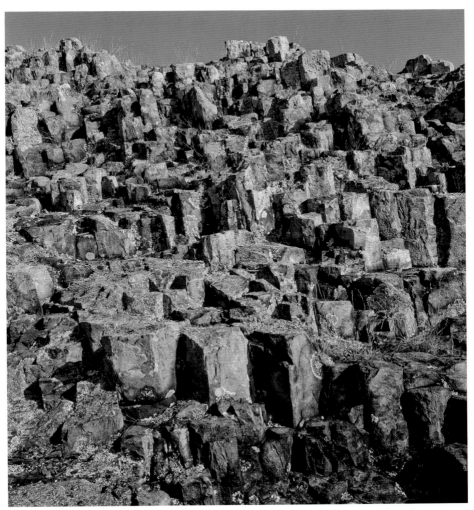

*Rock columns such as these on top of Hughes Mountain are found
in only a few places in the world.*

strenuous hike about halfway up the hill there is a small rocky opening that offers a nice view looking northeast. The trail eventually comes to a huge opening near the top. Notice the tall metal post, use this as a reference for your return trip down the hill. It is easy to get disoriented while wandering around on the large igneous glade before you. This desert-like area is composed of a very hard bedrock surface with scattered rock fragments and pockets of thin soil. Here, you will find mosses and lichens living on the bare rock. And, in the thin soil, little bluestem and broomsedge grasses mixed with prickly pear cactus, fame flower, pine weed, Ohio spiderwort, yellow star grass, wild hyacinth and other wildflowers. Proceed to the very top of the hill and there you will find the Devil's Honeycomb. The view is almost 360 degrees and on a clear day you can see three counties. Watch your footing; there may be loose rocks and sharp edges. The best examples of the fence posts can be seen by dropping down a bit on the knob's south face.

Directions: From Potosi at the junction of Hwy. 8 and Hwy. 21, take Hwy, 21 south 11 miles to Hwy. M, turn left (east) then proceed 3 miles to the parking area on the right (south).

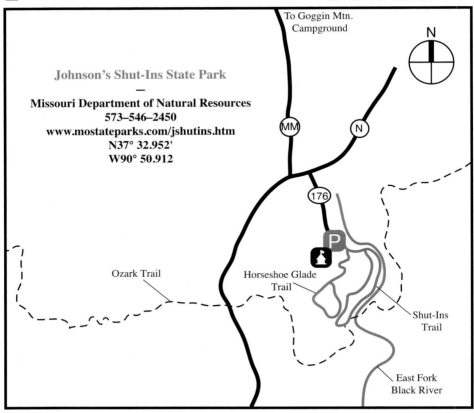

JOHNSON'S SHUT-INS STATE PARK contains one of the top shut-ins in the state. This spectacular canyon gorge, with its cascades, chutes, waterfalls, potholes, and pools, is very popular with nature enthusiasts, photographers, and swimmers alike. Yes, swimming is allowed in the shut-ins during normal river flows. The shut-in was formed by the East Fork Black River cutting through igneous rock once deposited by volcanic action about 1.5 billion years ago. The striking blue-gray rock outcrops have been smoothed and polished from eons of water, sand, and gravel, tumbling through cracks in the bedrock and sculpting out a maze of channels and plunge pools. How can a swimmer resist!

The 8,549-acre state park offers two trails that provide access to some very interesting geologic features and diverse natural communities that are part of the 180-acre Johnson's Shut-Ins Natural Area. Designated in 1978, the natural area contains significant natural features including gravel bars, igneous shut-in, dry igneous woodlands, igneous glades, and talus slopes. The 3.1-mile Shut-Ins Trail, which intersects all of these features, begins at the end of the parking lot near the store. The first part is wheelchair accessible and goes to a deck overlooking the shut-ins, a distance of 0.3 mile. From there, stairs take you to two more overlooks. The trail beyond this point is being reworked and will be open again by the time this book is published. When you visit the park, you will learn about the disaster that has affected the park. On Dec. 14, 2006, the upper reservoir of AmerenUE's Taum Sauk hydroelectric facility ruptured and released more than a billion gallons of water that ripped out the heart of the state park. Cleanup and construction has been ongoing since then and the park will be up and operating 100% in the summer of

The East Fork Black River, as it courses through the igneous shut-in, provides plenty of appeal for the bather and photographer alike.

2009. Interpretive displays explaining the flood events and the park's exceptional natural features are already in place along the Shut-Ins Trail.

The 2.2-mile Horseshoe Glade Trail is accessed just beyond the beginning of the Shut-Ins Trail. The trail weaves its way up a wooded slope to a large igneous glade with some great views of distant hills. Also under repair is part of the 33-mile Taum Sauk Section of the Ozark Trail that passes about midway through the park. Check with the park's website for more details.

Directions: North of Ironton at the junction of Hwy. 21 and N, go west 0.5 mile and turn left (south) on Hwy. N, proceed 13 miles to the park entrance. Visit the website for information about park hours and camping. And, be sure to check out the new trail across the river that interprets the geologic features that were exposed as the reservoir's floodwaters scoured out the hillside.

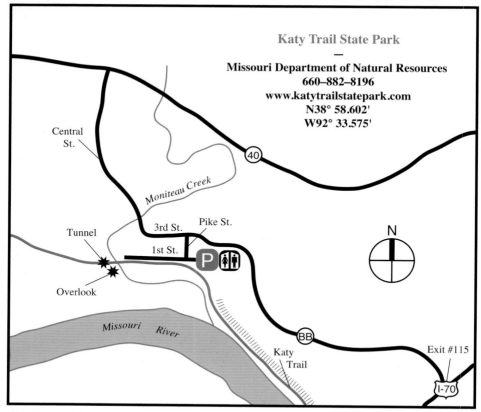

Katy Trail State Park
—
Missouri Department of Natural Resources
660–882–8196
www.katytrailstatepark.com
N38° 58.602'
W92° 33.575'

KATY TRAIL STATE PARK is a 225-mile hiking and biking trail that runs from St. Charles to Clinton with the section from St. Charles to Boonville designated as an official segment of the Lewis and Clark National Historic Trail. Formerly the Missouri-Kansas-Texas Railroad (MKT or Katy), it is the longest developed rail to trail in the United States. Although the Katy Trail has 26 trailheads, I think the one at Rocheport provides an excellent opportunity to view the bluff and river setting, as well as experience the river/railroad settlement past.

At the Rocheport Trail Head/Parking Lot take the time to go over the informative displays about the local history and settlement of the area. Then hike or bike west towards the only tunnel on the 225-mile trail. In about 0.5 mile cross over Moniteau Creek ("Creek of the Great Spirit") and examine the MKT Tunnel. Feel free to walk through the 243-foot long tunnel and continue to walk or bike along the Katy Trail as it parallels the Diana Bend Conservation Area or return to the tunnel entrance and follow the signs to the Diana Bend Overlook. This wheelchair-accessible walkway leads to a viewing platform and a wildlife viewing blind that overlooks a 100-acre semi-permanent marsh. For a commanding view of the 1,016-acre conservation area, you can take a rigorous hike up the steep hill to a viewing platform at the edge of a cliff. The hike is just like climbing steps and if you take your time, it isn't all that much trouble. The view is best when there are no leaves on the trees if routine maintenance has not kept their growth in check.

Return to the Rocheport Trail Head/Parking Lot and head the opposite direction. You'll soon come across a great view of the Missouri River and the Burlington limestone cliffs that tower 150 feet above the trail. This view of the river and the cliffs continues for

The long abandoned MKT railroad tunnel is now an interesting historic feature to be experienced by those travelling on foot or by bicycle along the Katy Trail.
(right)

Spectacular views of both the Missouri River and the lofty dolomite cliffs can be found along this stretch of the Katy Trail.
(below)

another 5 miles before the trail heads more inland. After about 0.5 mile along this cliff/ river view, note a small spring emerging from the base of the limestone cliff. In about another 0.5 mile, the trail crosses under I-70 and in another 2 miles you'll see Torbett Spring as it emerges out of Lewis and Clark Cave, which is located on private property. If you look up above the cave entrance about 40 feet and 30 feet to the left, you'll see some faded North American Indian pictographs.

Directions: From Columbia, take I-70 west for 2 miles and exit 115, then go north on Hwy. BB for 2 miles into Rocheport, turn left (south) on Pike St., go two blocks to First St., turn left (east) and go one block to the trailhead parking area.

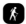
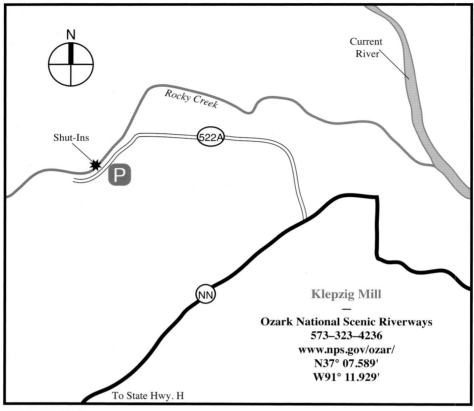

N

Current
River

Rocky Creek

Shut-Ins

522A

P

NN

Klepzig Mill
—
Ozark National Scenic Riverways
573–323–4236
www.nps.gov/ozar/
N37° 07.589'
W91° 11.929'

To State Hwy. H

KLEPZIG MILL shut-ins is small compared to Johnson's Shut-ins, Castor River Shut-Ins, and St. Francis River Shut-Ins but its attractive reddish tan bedrock and cascading waterfalls make up for its size. The size and roar of the shut-ins varies as Rocky Creek responds to varying amounts of rainfall throughout the year. Since it is a permanent stream, you can expect to see some water moving most of the time except for maybe really cold winters when ice locks the moisture in place.

The National Park Service has provided an interpretive sign that explains the historic aspects of the old mill site. Most of the shut-in has reclaimed its original character but you can still see remnants of the concrete dam that once extended completely across the creek. Above the dam, a large pool was maintained and water was diverted through a concrete flume to a large concrete well that turned a horizontally mounted turbine before the water rejoined the creek. The mill, built by Walter Klepzig, the son of a Prussian German immigrant, also constructed a small spring house for storing perishable goods. That is the structure you pass on the way to the shut-ins.

All of the hills around you are ancient volcanoes and lava flows that span an area about 8 miles from east to west and 12 miles from north to south. This region is an outlier of the much larger St. Francois Mountains whose western boundary begins about 30 miles to the northeast. This once active volcanic region dates back to the Precambrian System, which occurred over 1.5 billion years ago. So feel free to wander around on these ancient rocks and even take a dip in the plunge pool on a hot summer day but be careful, the smooth, polished rock is slippery when wet and avoid getting in Rocky Creek during

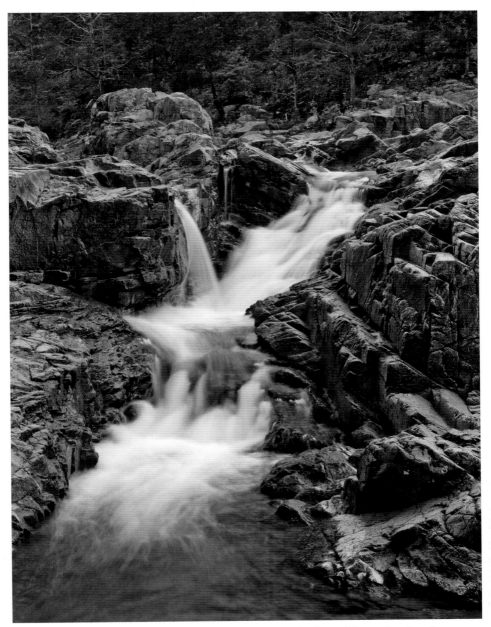

*Klepzig Mill, with its colorful purple rocks, is the last of three shut-ins that
Rocky Creek flows through before entering the Current River.*

high water. You may find yourself sharing the area with hikers because Klepzig Mill is
right along the Ozark Trail.

 Directions: At the intersection of Hwy. 19 and Hwy. 106 in Eminence, go east on
Hwy. 106 for 7 miles, turn right (south) on Hwy. H for 4.4 miles, then turn left (east) on
Hwy. NN and proceed 4.5 miles to Shannon County Road 522-A, follow the gravel road
1.3 miles to a parking area on the left.

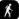
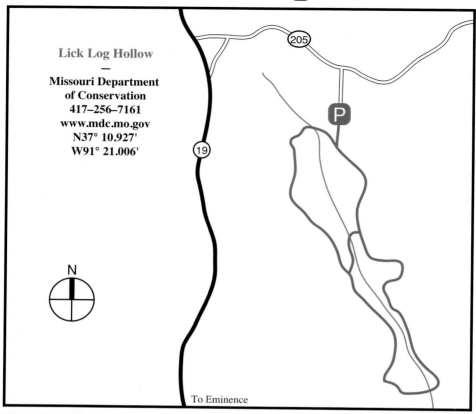

Lick Log Hollow

—

**Missouri Department
of Conservation
417–256–7161
www.mdc.mo.gov
N37° 10.927'
W91° 21.006'**

To Eminence

LICK LOG HOLLOW provides an opportunity to view several different types of habitats and geologic features that are representative of the Ozarks. An easy, well-maintained hiking trail leads to a dolomite glade, an igneous glade, a miniature shut-ins, a fen and an oak-pine forest. All of these features and more are interpreted in a trail brochure that is found in a box at the trailhead. If the box is empty, you can get a copy at the nearby Missouri Department of Conservation district office. The Eminence District Office is located 2.2 miles north of Eminence on Hwy. 19 or from the intersection of Hwy. 19 and Shannon County Road 205 go 0.6 mile south on Hwy. 19 and turn left (east).

Lick Log Hollow is part of the 37,170-acre Angeline Conservation Area. "Lick Log Hollow" is the historic name referenced on the topographic map for the region. The origin of the name is not known but the term "lick log" is a name given by a settler to the place where saltlicks were left for cattle or deer. Typically, a tree was felled and a trough was cut out and filled with salt.

Directions: From Eminence, go 2.4 miles north on Hwy. 19 and turn right (east) on Shannon County Road 205, continue 0.3 mile, turn right (south) and go 0.2 mile to the parking area.

Halfway down the Lick Log Trail, you cross over a colorful miniature shut-in.

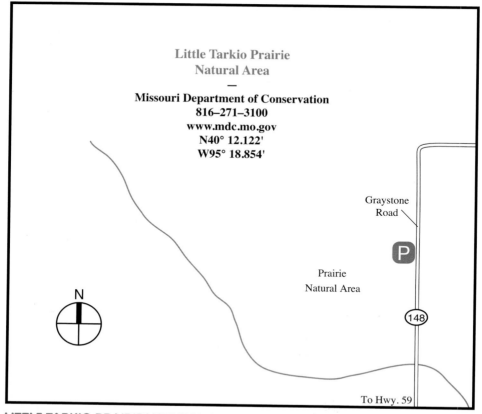

Little Tarkio Prairie Natural Area
—
Missouri Department of Conservation
816–271–3100
www.mdc.mo.gov
N40° 12.122'
W95° 18.854'

Graystone Road

P

Prairie Natural Area

N

148

To Hwy. 59

LITTLE TARKIO PRAIRIE NATURAL AREA is a small 15-acre prairie, but it is very special because of its location. According to the original government land surveyor notes, recorded in the early 1800s, prairie north of the Missouri River once totaled over 5 million acres. Now, less than 300 acres remains. Most of it was converted to cropland or pasture or, with fire suppression, allowed to change into forest. Purchased in 1999, the 129-acre tract contains 15 acres of prairie with the remaining 114 acres being restored to prairie with seed collected from the natural area. The area is named Little Tarkio because it is in the headwaters of Little Tarkio Creek and Tarkio is the Osage Indian word for walnut.

Although small in size, Little Tarkio Prairie is a high quality prairie with a diversity of forbs (wildflowers) that bloom from late April through October. As is typical with other prairies, if you visit every 2 or 3 weeks, you will see a whole new array of plants in bloom. Here, you will find big and little bluestem grasses, prairie dropseed, porcupine grass, and June grass providing cover along with lead plant, white and purple prairie clovers, round-headed bush clover, downy phlox, white wild indigo, pale purple coneflower, rosinweed, New Jersey tea, fringed loosestrife, azure aster, along with 80 other showy forbs. Feel free to walk around and admire one of the rarest prairies of its type in the state.

Directions: Take I-29 to exit 84, Mound City, turn right (east) and go to the first intersection, turn left (north) on Hwy. 59 and proceed about 5.6 miles, then turn right (east) on CR 148 (Graystone Road); go 1.3 miles to the parking lot on the left.

Starry campion, with its deeply split petals, can be found along the wooded draw. (right)

A hover fly searches for nectar on a purple prairie clover. (middle left)

Tall blazing star often occurs in dense stands making for a beautiful sea of purple wands waving in the prairie breeze. (middle right)

Butterfly weed and black-eyed Susan are just a few of the showy forbs you'll find here.

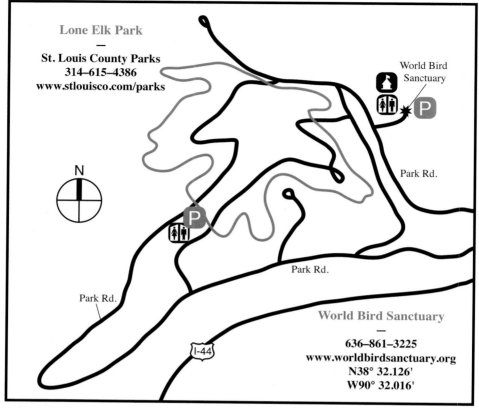

Lone Elk Park
—
St. Louis County Parks
314–615–4386
www.stlouisco.com/parks

World Bird Sanctuary

N

Park Rd.

Park Rd.

Park Rd.

I-44

World Bird Sanctuary
—
636–861–3225
www.worldbirdsanctuary.org
N38° 32.126'
W90° 32.016'

LONE ELK PARK is the only public area in the state where you are guaranteed to see bison and elk on just about every visit and you don't even have to leave your car! Once used for ammunition testing and as a storage site during World War II and the Korean Conflict, the U.S. Army sold the land to the county in the 1960s. In the early 50s, elk were maintained on the area but the Army decided to eliminate them. One lone male elk survived by hiding out in the hills for 10 years before being noticed by a park employee, hence the origin of the park's name. There is a 3.25-mile trail that loops around the park. The White Bison Trail begins at the park restroom area in the valley. Look for a brown trailhead sign marked with a white bison emblem and the word "trail." Along the trail, you can observe elk, bison, white-tailed deer, wild turkeys and other wildlife. Don't forget the tick spray.

WORLD BIRD SANCTUARY is a private organization dedicated to rescuing, rehabilitating and breeding threatened bird species from around the world. They also provide education programs and conduct field studies. This is a great opportunity to see a variety of eagles, hawks, falcons, and owls, also sandhill cranes, greater prairie-chickens, white pelicans, turkey vultures, thick-billed parrots and more. These birds can be viewed along a trail that begins at the east end of the parking lot. This is part of a 1-mile trail that continues past the bird exhibits and down a wooded slope to the Meramec River. Along the way you pass bird feeding stations and a bird photography blind. The trail joins a gravel road that heads back to the sanctuary entrance. While at the sanctuary, be sure to visit the wheelchair accessible gift shop where you can buy nature-related items. Also be sure to see the living bird displays outside the back of the building. The World Bird Sanctuary is a nonprofit organization so they gladly accept donations and check out their membership information.

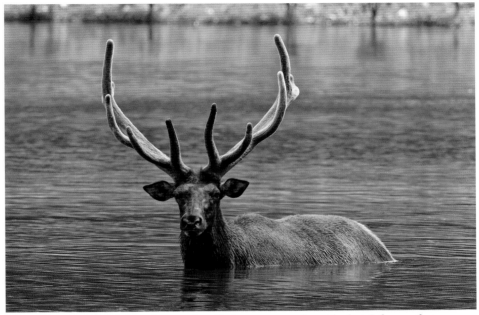

A bull elk with its velvet antlers finds an escape from the hot July weather.

A red-shouldered hawk (left) and American bald eagle (right) are two of the many raptors on display at the World Bird Sanctuary.

Directions: From St. Louis, take I-44 west to exit 272, turn north on Hwy. 141 and move immediately to the first right turn, which leads to North Outer Road, turn left on North Outer Road and go west about 2 miles to the entrance to Lone Elk Park. The park is open year round. The World Bird Sanctuary is open year round except for Thanksgiving and Christmas.

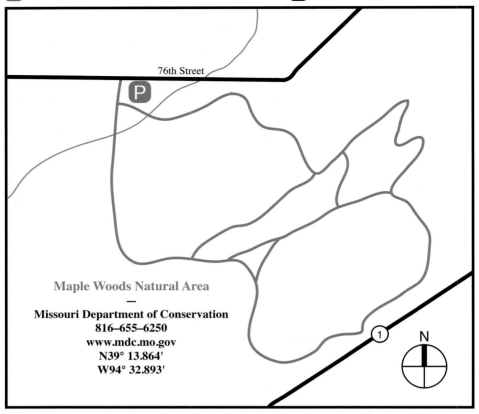

76th Street

Maple Woods Natural Area
—
Missouri Department of Conservation
816–655–6250
www.mdc.mo.gov
N39° 13.864'
W94° 32.893'

N

MAPLE WOODS NATURAL AREA is an oasis of old growth forest surrounded by intense urban development. Located within the City of Gladstone, the 39-acre forest offers visitors a place to unwind and experience nature as it looked hundreds of years ago. There are a series of trails, totaling 1.4 miles, which take you across north slopes, south slopes and a ridge where you can observe how various exposures and slopes affect what types of vegetation grow there. An 18-acre natural area, which was designated in 1978, occurs in the northeast part of the forest. Here you will find old growth sugar maple, red oak, and white oak with an understory dominated by pawpaw. Be sure to include a spring trip because you'll find a nice display of wildflowers and ferns, including wild ginger, spring beauty, Dutchman's breeches, yellow violet, showy orchis, putty root orchid, woodsia fern, maindenhair fern, and rattlesnake fern. Late October is a must visit. The shades of oranges and yellows of the sugar maples are outstanding. Be sure to bring your camera!

Maple Woods Natural Area has a national distinction as it was declared a National Natural Landmark by the National Park Service in 1980. The area is recognized as a best example of a biological feature in public ownership. There are 16 designated sites in Missouri.

Begin the hike by crossing the bridge at the edge of the parking area. The creek below is a side branch that flows into Shoal Creek about one-quarter mile downstream. Immediately turn left and follow the path east as it parallels the creek. This first section of the natural surface trail can be a bit slippery and muddy at times so proceed cautiously. The trail is unsigned but the paths are well worn so feel free to wander around taking different routes.

Maple trees put on their best show in late October at the natural area.

Directions: At the intersection of I-435 and Hwy. 152 (exit 49), which is 2.5 miles north of Claycomo, take Hwy. 152 west for 1.5 miles, then take Hwy. 1 (North Indiana Ave.) south and at 0.5 mile, turn right (west) on 80th St. (Maplewoods Parkway) then after 0.5 mile, turn left (south) on North Agnes Ave. for 0.5 mile, which becomes 76th St., proceed 0.3 mile and turn left (south) to the parking area.

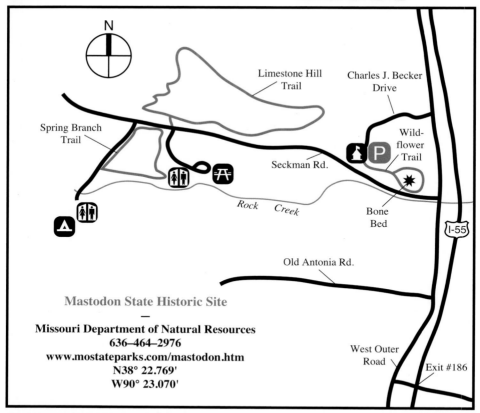

MASTODON STATE HISTORIC SITE has drawn worldwide attention because it contains one of the most extensive ice age deposits of now extinct animals in the United States. Archaeological history was made in 1979 when scientists excavated a stone spear point in association with mastodon bones that provided the first solid evidence that early hunters interacted with these prehistoric beasts over 10,000 years ago. This important site was first discovered in the early 1800s with additional excavations occurring over the years until a group, concerned about future destruction of the site from more recent private excavations and proposed urban developments, organized the Mastodon Park Committee to bring awareness of the site's need for protection. Through fund raising efforts and grants, 418 acres, containing the bone bed, was purchased in 1976. The Kimmswick Bone Bed was placed on the National Register of Historic Places in 1987.

A museum was established to showcase human and animal artifacts and interpretive displays describe what conditions were like in the area over 10,000 years ago. A small entry fee is requested to enter the museum and it is well worth it. There are three trails on the historic site. The 0.5-mile Wildflower Trail begins at the museum and goes down a series of 130 steps to the bone bed. An interpretive display at the bottom describes the excavation site. Along the way, you get an excellent view of the Kimmswick limestone cliff that rises some 80 feet over the fossil bed. The other two trails are accessed from the picnic area off of Seckman Road. The Spring Branch Trail is an easy walk along a spring, spring branch and bottomland forest to Rock Creek. The Limestone Hill Trail crosses Seckman Road and enters an upland forest. The trail winds up a steep hill, across

*Impressive displays of now extinct giants like this mastodon
can be viewed at the museum.*

an upland slope and past an old quarry. Taking the trail to the left gets you up the trail faster using switchbacks while taking the trail to the right, gives you a longer steep grade to hike.

Directions: Along I-55, at the Imperial/Kimmswick exit 186, turn west onto Imperial Main Street, then the first right (north) on West Outer 55 Road, go 0.5 mile and turn left (west) on Seckman Road to the picnic area or go another 0.2 mile and turn left (west) on Charles J. Becker Drive and proceed to the museum. Check with the website for museum and historic site hours.

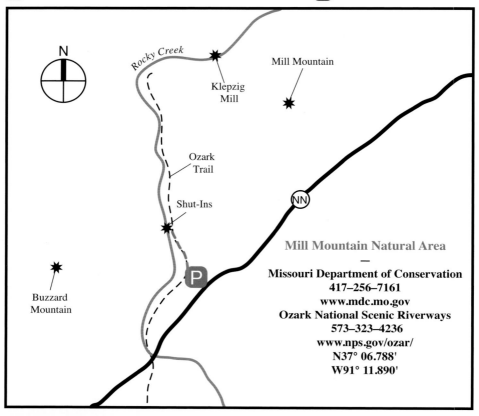

MILL MOUNTAIN NATURAL AREA contains one of three shut-ins along Rocky Creek with the others being Rocky Falls and Klepzig Mill, and all three can be visited in the same day. Mill Mountain Natural Area is a bit more remote but that adds interest because you get to see more of the igneous landscape. Mill Mountain was designated a state natural area in 1973 with an addition in 1983 by the National Park Service, for a total of 140 acres. The shut-in was created when Rocky Creek found a path between Buzzard Mountain and Mill Mountain and, as the stream eroded deeper into the bedrock, it became shut-in and had nowhere else to go. Mill Mountain is named because there was once a mill, known as Klepzig Mill, that was used to harness the creek's energy to turn a grist mill, which was used for grinding grain into flour. Buzzard Mountain may have been named for someone noticing vultures either nesting, roosting, or circling over the hill.

The trail leads through an old field and soon enters a section of woods that is also part of the Ozark Trail. The woods are dominated by red oak, white oak, shortleaf pine, black gum, red maple, and mockernut hickory. Soon the trail crosses the lower flank of Mill Mountain and you can see a distinct change in the habitat and the vegetation. Here the bedrock is more exposed and covered with lichens and mosses. In small soil pockets you can find stunted trees of black jack oak, eastern redcedar, winged elm, shortleaf pine, and black hickory, with little bluestem grass and various wildflowers growing in the more open areas. This is an igneous glade. The trail then drops down the slope to a mesic forest and then the shut-in. Notice the colorful purple to pinkish rhyolite bedrock and how the water cascades and plunges over it on its way towards the Current River, another 3 miles distance.

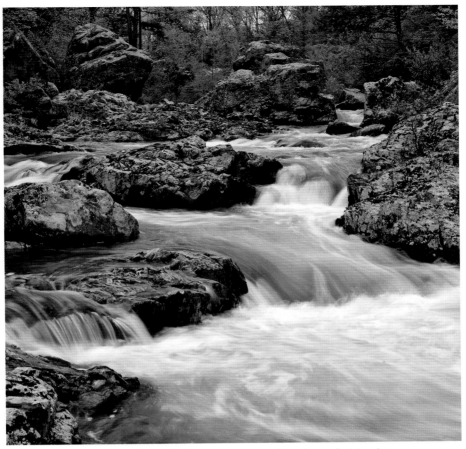

Rocky Creek flows through the most remote of the three shut-ins it traverses on its way to the Current River.

Take a moment to look across the shut-in at the opposite slope. Notice the gray filaments hanging from some of the cedar trees. If you have travelled in the southern part of the United States this may remind you of the bromeliad called Spanish moss. Actually, what you see here is a lichen called old man's beard that seems to prefer growing in trees close to a water source probably because of the available mist or dew. Known to contain powerful antibiotics, Native American Indians used this form of lichen as a compress on severe battle wounds to prevent infection and gangrene.

If you want to see more of the igneous glade, a hike up Mill Mountain will provide that opportunity. There are no trails but there are enough glade openings to make the hike interesting.

Directions: At the intersection of Hwy. 19 and Hwy. 106 in Eminence, go east on Hwy. 106 for 7 miles, turn right (south) on Hwy. H for 4.4 miles, then turn left (east) on Hwy. NN and proceed 2.0 miles passing CR 526 on the right and continue on Hwy. NN another 1.2 miles. (Along this stretch, you actually drive over Rocky Creek as it winds its way to the shut-in.) On the left side of the road, there is a narrow one-car pullover located just before a deer crossing highway sign. The old field road down the hill to the shut-in is rutted and not recommended for travel, especially for low clearance vehicles. It is best to park along the shoulder of the road.

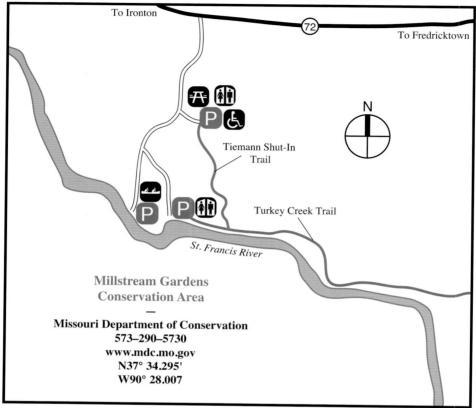

MILLSTREAM GARDENS CONSERVATION AREA contains the largest shut-ins in Missouri. It also has the distinction of containing the only whitewater in the state. Every March, the Missouri Whitewater Championship races are held along this stretch of the St. Francis River as it tumbles and churns over granite boulders the size of cars. The 612-acre conservation area is named for the historic Millstream Gardens, an Ozark theme village established by Elmer Tiemann, a landscape architect from St. Louis. The shut-in also bares his name. The 1.2-mile Tiemann Shut-in and a buffer zone on either side of the St. Francis River was designated as the St. Francis River Natural Area in 1983 for the significant geologic feature.

There are two trails in the area. The Tiemann Shut-In Trail is a 1.0-mile roundtrip wheelchair accessible paved trail that winds through an upland forest and down to the Cat's Paw viewing platform overlooking the shut-in. If you don't need disabled accessibility, I would recommend the 1.0-mile roundtrip Turkey Creek Trail that begins at the second parking lot near the small pavilion. At the southeast corner of the parking lot near the vault toilets, follow the edge of the woods about 100 feet to an opening that turns into an old asphalt roadbed that parallels the river. In about 800 feet, you cross a wooden bridge, just to the right a path leads down to the shut-in. Here you can wander around or just relax on the grey-colored boulders of the Silvermine granite. The Turkey Creek Trail continues to Big Drop Rapids, Cat's Paw, Shark's Fin, Pine Overlook and Double Drop Rapids, all rock features in the shut-in named by whitewater enthusiasts. The trail then enters the Silver Mines Recreation Area, which extends for another two miles. The whitewater part of the shut-in

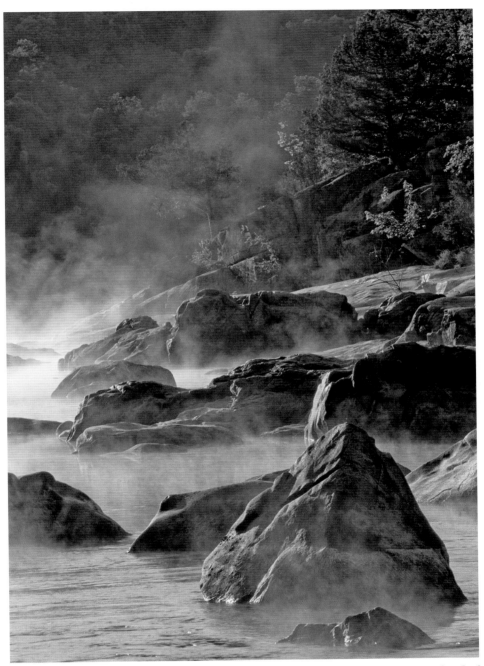

The character of the shut-in changes with each visit due to the fluctuating water level of the St. Francis River as it flows through the natural area.

is within the Millstream Garden Conservation Area. (Note: Paddlers attempting to float the shut-in should have adequate experience and whitewater equipment.)

Directions: From the intersection of Hwy. 67 and Hwy. 72 at Fredericktown, take Hwy. 72 west 8.5 miles and turn left (south) at the gravel road and follow the signs to the area.

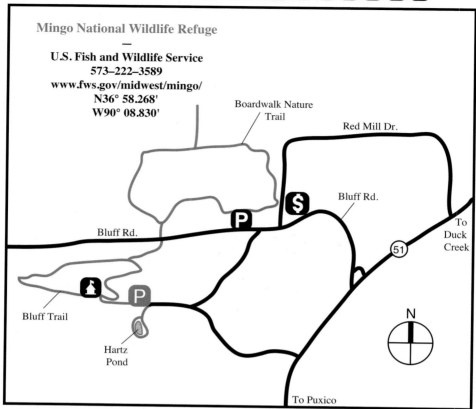

Mingo National Wildlife Refuge
—
U.S. Fish and Wildlife Service
573–222–3589
www.fws.gov/midwest/mingo/
N36° 58.268'
W90° 08.830'

Boardwalk Nature Trail

Red Mill Dr.

Bluff Rd.

Bluff Rd.

To Duck Creek

51

Bluff Trail

Hartz Pond

N

To Puxico

MINGO NATIONAL WILDLIFE REFUGE is an important feeding and resting stop along the Mississippi Flyway for migrating birds during the spring and fall months. The 21,676 acres also provides important habitat for resident wildlife including four pairs of nesting bald eagles. The refuge also contains the largest remaining bottomland forest (15,000 acres) of the original 2.5 million acres once found across the Bootheel of Missouri. To add further protection, 7,730 acres was designated as a wilderness area in 1976.

There is so much to see and do here so be sure to stop by the visitor center to look at the exhibits and review potential activities. There are two main trails on the refuge. The 0.5-mile Bluff Trail begins at the west end of the visitor center and proceeds to Rockhouse overlook where you can view a bottomland forest, Rockhouse Marsh and the upland hills of the Ozarks to the north. The trail continues, passing through boulders and along the base of a small dolomite cliff. This is a good place to see wildflowers in the spring. At the parking lot, you will notice a trail to Hartz Pond. This short trail is used for nature classroom activities. The 1.0 mile Boardwalk Nature Trail can be reached by driving down the hill from the visitor center parking lot, turning left and then right at the parking area. Go right on the boardwalk and you enter a mesic bottomland forest, which is a foot or so higher in elevation. You soon transition to a wet-mesic bottomland forest and, finally, a swamp at its lowest elevation. You'll notice the change as you go from pin oak, sugarberry, sugar maple, red mulberry sycamore, pawpaw, red buckeye and spice-bush to silver maple, cottonwood, Drummond's red maple, water locust, water elm, and water hickory to the swamp with bald cypress and water tupelo. About halfway around

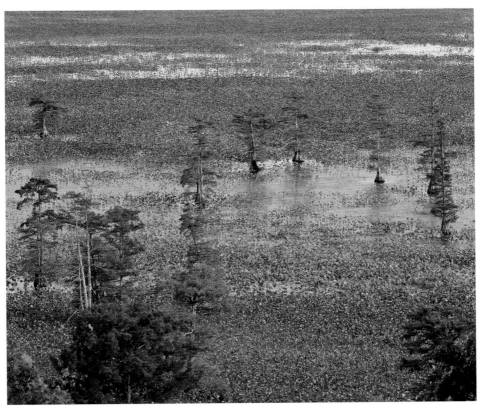

Bald cypress trees take on a bronze cast as autumn peaks.

the trail be sure to take the spur across a levee to an observation tower with a viewing scope overlooking the wetlands. Finally, take the time to drive the 20-mile auto tour route. It is a great opportunity to see a variety of habitats and wildlife with the highlight being a stop at the observation deck overlooking Monopoly Lake. Pick up an auto tour brochure before beginning the journey. Oh, when you get to the Rockhouse Marsh Overlook, don't bother to stop and hike the short trail to the deck because the view is totally blocked by trees.

Although there are at least four active bald eagle nests on the refuge, they are difficult to see. A much better view of a bald eagle nest can be found at nearby Duck Creek Conservation Area. A good time to see and learn more about bald eagles is during the annual eagle day event. Usually held the first weekend in February, the event includes live eagle programs, exhibits, videos, and guides with spotting scopes. Check the Missouri Department of Conservation website to learn when and where the events statewide are being held.

Directions: At the intersection of Hwy. 60 and Hwy. 51, which is east of Poplar Bluff and west of Dexter, take Hwy. 51 north 14 miles through Puxico and turn left (west) at the refuge entrance. The visitor center and hiking trails are free but a daily entrance fee is required for each vehicle entering the refuge. (Note: The Auto Tour Road is open April 1 to May 31 and October 1 to November 30.)

 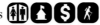

MISSOURI MINES STATE HISTORIC SITE sounds like it doesn't fit the theme of this book but it's what's inside the 19,000 square-foot Powerhouse building that relates---a magnificent collection of Missouri minerals and rock displays. Here you'll view and learn about the various quartz, calcite, barite, iron oxides, and copper minerals, all in interesting and colorful shapes. There is also a fluorescent mineral room featuring specimens that "glow" with brilliant colors under ultraviolet "blacklight." Along with the displays showing the diverse amount of minerals found in the state, there are exhibits of various rock types that have influenced and shaped the Missouri landscape. The geology of Missouri is very diverse ranging from igneous rocks over 2 billion years old to the various types of sedimentary rock including chert, limestone, dolomite, sandstone, and shale. In one section of the museum you learn about Missouri's most important underground resources such as lead, iron (galena), copper, silver, barite, zinc, granite, limestone and coal. The museum also has a gift shop where you can purchase mineral/geology related books, minerals and mineral jewelry.

Missouri Mines State Historic Site lies along the north border of the 8,238-acre St. Joe State Park, the third largest state park in Missouri. There are a wide variety of features and activities that are provided in the park including an 11-mile paved hiking/biking trail. Along the south side of the historic site parking lot, you can take a 1-mile spur trail to access the main trail. Information about the St. Joe State Park trails and other features can be found at the historic site visitor center or by going online at: www.mostateparks.com/stjoe.htm

Mozarkite, Missouri's state rock, shown above in its colorful polished form is one of many rocks, gems, and minerals that can be viewed at the museum.

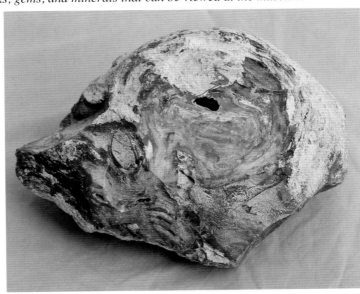

A large 8-inch wide Mozarkite is shown here in its rough stage.

Directions: At the intersection of Hwy. 67 and Hwy. 32 at Park Hills, go west on Hwy. 32 1.7 miles and take the Bus. 67 exit, turn left (south) and follow the signs for 0.7 mile to the entrance. Historic site hours: December through March, open Friday and Saturday from 10 am to 4 pm; Sunday from 12 pm to 5 pm. (Groups can schedule tours in advance seven days a week.) From April through November, open Monday through Saturday from 10 am to 4 pm; Sunday from 12 pm to 6 pm.

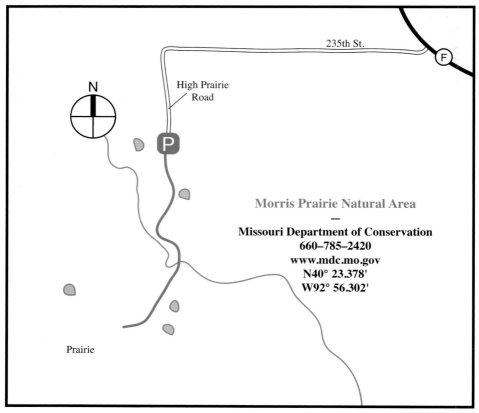

MORRIS PRAIRIE NATURAL AREA is located in the southwest corner of Morris Prairie Conservation Area. It is one of only a few high quality prairies left in northern Missouri. It is hard to imagine but over 70% of the land north of the Missouri River was once prairie. With the soil being suitable for tilling, the prairies were converted to cropland and pasture so any parcel of prairie left is so very special. The former owners, Ken and Marlene Morris recognized that rarity and contacted the Missouri Department of Conservation in the 1980s about their 47-acre prairie. They were interested in seeking management advice and help in protecting this rare gem. Over the years, department staff aided in conducting prescribed burns and reducing the number of small trees and shrubs that were invading the prairie. The owners agreed to have the prairie nominated as a state natural area and it was dedicated as such in 2001. In 2005, wanting to protect the prairie for future generations to enjoy, they sold their land to the department.

As you drive the lane to the parking lot, notice the prairie restoration. There are plans to convert other parts of the conservation area back to prairie. From the parking area you can walk along the service road for about 500 feet to an old barn, and then hike down the hill heading south. There may be a mowed path to guide you, but if not, just find your own way down to the creek, cross it and head up the hill working your way west to a line of trees running north and south. Along that line, there will be an opening that leads to the prairie. There are no paths or trails so feel free to wander about but note where you came in from.

Most of the prairie (28 acres) is dry-mesic and dominated by the grasses big

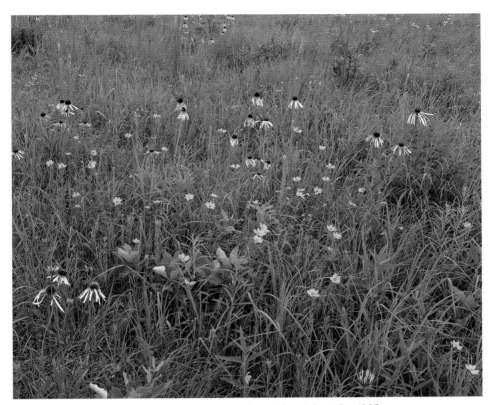

This is a rare northern Missouri prairie, rich with wildflowers,
that has escaped the plow thanks to its conservation-minded former landowners.

bluestem, little bluestem, and Indian grass. There have been over 200 prairie plant species recorded here. You can find prairie wildflowers (forbs) in bloom from early May through October. When first entering the prairie, if you head down the south slope, it takes you to the 2-acre mesic part of the prairie. Here you will find prairie dropseed, big bluestem, compass plant, lead plant culver's root and other plants that prefer a more moist soil. Parts of the prairie have problems with shrubs like hazelnut, prairie willow, New Jersey tea, and dwarf chinkapin oak that will spread if not controlled by fire and mowing so management is critical in helping to maintain the character of one of the finest prairies left in northern Missouri.

Directions: From Unionville, go west on Hwy. 136 for 1 mile and take Hwy. 5 south 3 miles to Hwy. F and turn left (east), proceed 6.8 miles and turn right (west) on 235th Street, go 0.6 mile and turn left (south) on High Prairie Road for 0.2 mile to the parking area.

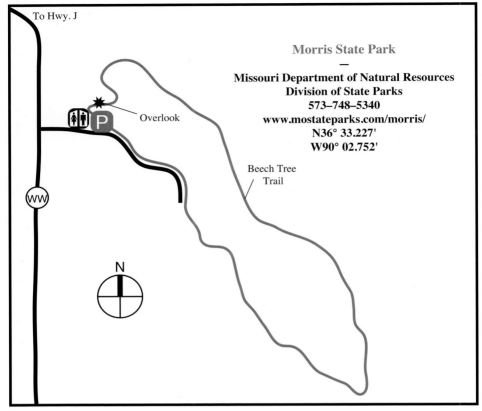

To Hwy. J

Overlook

Morris State Park
—
Missouri Department of Natural Resources
Division of State Parks
573–748–5340
www.mostateparks.com/morris/
N36° 33.227'
W90° 02.752'

Beech Tree
Trail

WW

N

MORRIS STATE PARK is located on Crowley's Ridge, a unique landform that remained after the ancient Mississippi and Ohio Rivers, swollen by glacial melt waters, scoured away the rest of what we now call the "Bootheel." The ridge was once a major transportation route used by Native American Indians, and European explorers and settlers. This 150-mile long ridge runs from what is now Helena, Arkansas, north to just below Cape Girardeau and averages 0.5 to 12 miles wide and 100 to 250 feet high. This upland route kept travelers from having to struggle through the vast swampland of the Mississippi Lowlands. The ridge is named for Benjamin Crowley, one of the first settlers in the early 1800s. The state park's 161 acres was donated by Jim D. Morris, a Springfield businessman, who wanted to preserve the ridge's unique natural and geologic features for future generations to enjoy.

The 2-mile Beech Tree Trail begins at the parking lot. Hiking at each end is a bit strenuous but brief as you descend to the base of the ridge on the north end and then ascend the hill at the south but the trail in between is relatively level. There are over 300 species of plants that have been recorded in the state park. Some of the vegetation here is more similar to the Tennessee Hills in the east than to the Ozark Mountains to the west. This is due to the scouring floodwaters of the ancient rivers that isolated the ridge, which was once connected by land eastward to the Tennessee Hills. Here you can find American beech, tulip tree, and sweet gum flourishing as well as the more common red, white and post oaks. Growing beneath the canopy, you'll find red maple, sassafras, flowering dogwood, red buckeye and devil's walking stick.

The fall color of devil's walking stick accents the winding trail through the state park.

On the return trip, be sure to follow the trail signs because you are on private property on the way back to the parking lot.

Directions: At the intersection of Bus. 25 and Hwy. J in Malden, go 5.5 miles west on Hwy. J to Hwy. WW, turn left (south) and go 1 mile to the park entrance on the left (east).

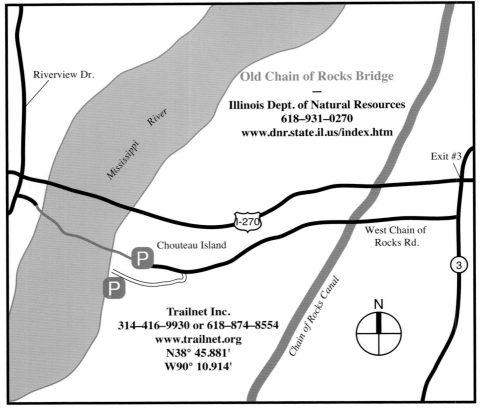

Riverview Dr.

Old Chain of Rocks Bridge
—
Illinois Dept. of Natural Resources
618–931–0270
www.dnr.state.il.us/index.htm

Mississippi River

Exit #3

I-270

Chouteau Island

West Chain of
Rocks Rd.

P

P

Trailnet Inc.
314–416–9930 or 618–874–8554
www.trailnet.org
N38° 45.881'
W90° 10.914'

Chain of Rocks Canal

N

3

OLD CHAIN OF ROCKS BRIDGE provides a unique opportunity to walk or bicycle across the mighty Mississippi River from shoreline to shoreline without having to worry about oncoming traffic or narrow walkways. You essentially have the whole bridge to yourself. Not only is this a great opportunity to view the river at your leisure, it is also a great place to observe wildlife, especially bald eagles that catch fish in the river and rest in the large cottonwood trees lining the shoreline, especially on Chouteau Island where the Illinois side of the bridge is connected.

The Old Chain of Rocks Bridge was completed in 1929 and at 5,353 feet in length, remains as one of the longest truss bridges in the country. The truss part is the interconnected metal beams above the road bed that absorb tension and compression depending on the load. The distinctive 22-degree bend at the middle of the bridge was necessary for navigation on the river around the concrete bridge piers. The bridge's name comes from a rock-ledged reach of river literally described as a chain of rocks, stretching for seven miles starting on the north side of the City of St. Louis and extending upstream. Because the water was so shallow, modern boats and barges needed an alternative route so the 8.4-mile Chain of Rocks Canal was built and completed in 1953. Looking down from the bridge, you'll notice the large falls. This is where the river actually spills over the 2,925-foot low-water River Dam #27, the first permanent rock-filled dam across a major river in the United States. This dam was built in 1960 to insure adequate depths over the lower sill of the old Alton Locks that was 12.5 river miles upstream. If you look closely, you'll see dozens and sometimes hundreds of gulls flying over and diving into the falls in pursuit of small fish. Also notice the two castle-like structures just downstream from the

Ring-billed gulls in a feeding frenzy searching for dazed, disoriented, or injured prey as they tumble through the rapids.

bridge. They serve as water intakes for the Chain of Rocks Water Treatment Facility.

Just before you arrive at the parking lot on the Illinois side, note the gravel road to the left (south). This leads you to a parking lot and a great view of the falls. Here you can see the action up close as the gulls glide over the raging waterfall looking for something to eat. You'll also have better views of bald eagles perching in nearby trees. A good time to see and learn more about bald eagles is during the annual eagle day event. Usually held the third weekend in January, the event includes live eagle programs, exhibits, videos, and guides with spotting scopes. Check the Missouri Department of Conservation website to learn when and where the events statewide are being held.

Directions: At the intersection of I-270 and Riverside Drive, the last exit before the Mississippi River Bridge, take Riverside Drive south about 0.4 mile to an entrance on the left. The parking lot may be closed due to past vandalism. If so, proceed to cross over the river by way of the I-270 bridge and take the Hwy. 3 exit, turn right (south) and in 0.1 mile, turn right at the intersection onto West Chain of Rocks Road. It is a 2.2-mile drive to the parking lot. Along the way, you cross over the Chain of Rocks Canal. Be careful because the bridge road has been narrowed to one lane so drive slowly and be prepared to squeeze past any oncoming vehicles. (Note: Due to recent vandalism, you may not want to leave your vehicle unattended, especially at the bridge parking area.)

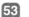

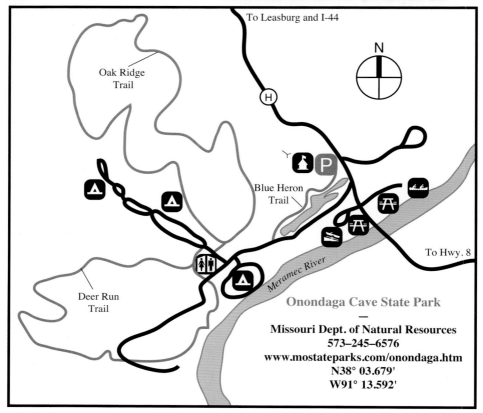

To Leasburg and I-44

N

Oak Ridge Trail

H

Blue Heron Trail

P

Meramec River

Deer Run Trail

To Hwy. 8

Onondaga Cave State Park
—
Missouri Dept. of Natural Resources
573–245–6576
www.mostateparks.com/onondaga.htm
N38° 03.679'
W91° 13.592'

ONONDAGA CAVE STATE PARK is a National Natural Landmark, so distinguished for the quality of its cave formations. On a 0.9-mile guided tour, you can expect to see stalactites, stalagmites, flowstones, columns, draperies, soda straws, cave coral, rimstone dams, and underground streams and pools. Special lighting enhances spectacular cave formations with such intriguing names as Queen's Canopy, Dawn Canyon, Wall of Jericho, Lily Pad Room, Devil's Bathtub and more. Trained guides provide information about the formation of the cave's geologic wonders and the animals that call this subterranean habitat home. The visitor center is where the tours begin. While waiting, you can explore the displays and exhibits that showcase Missouri as the Cave State and explain the significance of Onondaga Cave. By the way, although Missouri declares itself the cave state with over 5,500 caves discovered so far and more found each year, Tennessee manages to stay at least 500 caves ahead!

If you would like to have a more strenuous cave experience while using a lantern as your light source, a tour of nearby Cathedral Cave is available. Check with the visitor center or the website under "cave tours" for more information.

While waiting for a cave tour to begin, you have an opportunity to take a 0.5 mile leisure walk along the Blue Heron Trail. Starting at the southeast corner of the visitor center parking lot, the trail soon splits so bear right. Along the first part of the trail, notice the large rock outcrops with the very porous texture. This is typical of Gasconade dolomite, one of the most porous bedrocks in the state and responsible for many karst formations such as caves, sinkholes, and springs. The trail parallels an oxbow lake, which

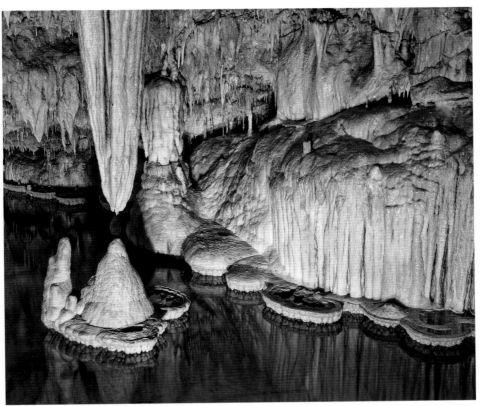

A multitude of spectacular cave formations await visitors at Onondaga Cave.

is an old channel of the Meramec River. You will pass the natural entrance to Onondaga Cave where Onondaga Spring issues out of the opening into a pool. This is also the site of an old mill.

The 2.75-mile Deer Run trail winds through upland forest, by the entrance to Cathedral Cave, a dolomite glade and a bluff line with several views of the Meramec River. And, the 3.25-mile Oak Ridge Trail, goes through an upland forest, a dolomite glade with great views, and along a wet-weather creek with small waterfalls. You can find out more information about the trails at the visitor center.

Directions: Northeast of Cuba along I-44, take exit 214 (Leasburg) then drive south on Hwy. H for 7 miles passing through the town of Leasburg and arrive at the entrance to the state park. Visit the website or call 573-245-6600 to schedule a cave tour.

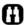
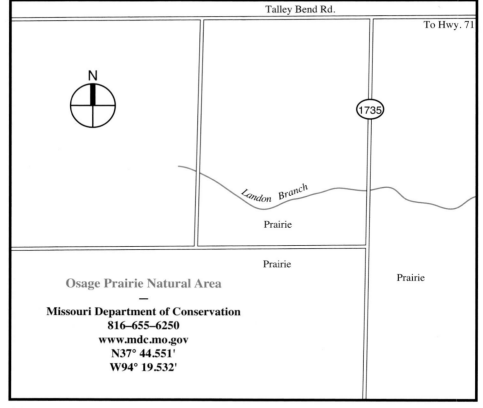

Talley Bend Rd.

To Hwy. 71

N

1735

Landon Branch

Prairie

Prairie

Prairie

Osage Prairie Natural Area

—

Missouri Department of Conservation
816–655–6250
www.mdc.mo.gov
N37° 44.551'
W94° 19.532'

OSAGE PRAIRIE NATURAL AREA, named for the dominant North American Indian tribe in the region, is a high quality prairie with a good diversity of plant and animal life. There are no trails so wandering about this prairie expanse is perfectly acceptable. At 1,466 acres, Osage Prairie is one of the largest prairies in the state. Located in Vernon County, where prairie once amounted to about 400,000 acres or seventy-five percent of the county according to the U.S. General Land Office Survey, which was conducted in the early 1800s.

The south 615 acres of Osage Prairie is a state natural area which is a designation that recognizes that this prairie is one of the best examples of its type and closely resembles what it would have looked like in presettlement times. There are lots of different types of plants that grow and bloom here from mid-April through October. If you were to visit the prairie every two or three weeks during the season, you would find a whole new set of prairie forbs (wildflowers) in bloom.

There is also a variety of animals that can be found on Osage Prairie including coyote, white-tailed deer, northern harrier, greater prairie-chicken, scissor-tailed flycatcher, short-eared owl (in the winter) upland sandpiper, Henslow's sparrow, northern crawfish frog, prairie mole cricket, and regal fritillary butterfly. By the way, the last species is not doing well throughout the tallgrass prairie region except for in Missouri. The attractive regal fritillaries, which closely resemble monarch butterflies, can be found on pale purple coneflowers blooming in June.

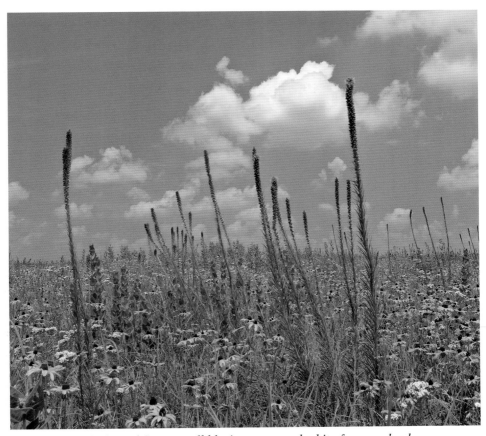

*Black-eyed Susans, tall blazing stars, and a bit of yarrow lead
up the hill and seem to meet the sky.*

Directions: At the intersection of Hwy. 71 and Hwy. 54, go 6 miles south on Hwy. 71 and turn right (west) on Tally Bend Road, which is opposite Hwy. E. Go 0.6 mile west on Talley Bend Road and turn left (south) on County Road 1735, proceed 1.4 miles to the "T" intersection. You can park anywhere along the side of the road going north/south or east/west.

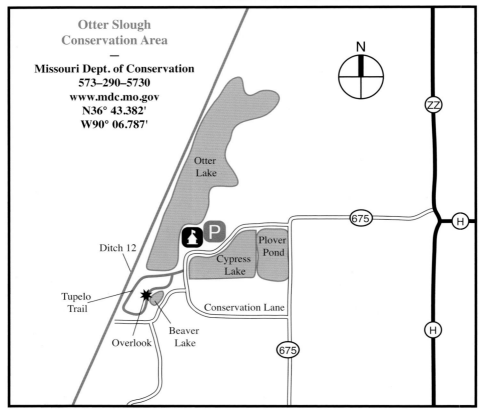

Otter Slough Conservation Area

—

Missouri Dept. of Conservation
573–290–5730
www.mdc.mo.gov
N36° 43.382'
W90° 06.787'

N

ZZ

Otter Lake

675

H

Ditch 12

Plover Pond

Cypress Lake

Tupelo Trail

Conservation Lane

H

Beaver Lake

Overlook

675

OTTER SLOUGH CONSERVATION AREA is a wildlife magnet, attracting migratory and wintering waterfowl, wading birds, shorebirds, bald eagles, along with wetland mammals, amphibians, reptiles, and fish that make this area their home. You won't be disappointed when visiting this area anytime of the year. Once part of the St. Francis River, with its oxbow lakes and swamps, the landscape changed when the New Madrid earthquake of 1811 and 1812 caused Otter Lake, Fish Slough, Lick Creek and the Glades Swamp to combine into a large wetland complex. However, ditching and draining efforts in the 60s and 70s opened up more of this land for farming and reduced the wetlands. Fortunately, the Missouri Department of Conservation was able to purchase most of what remained to form the 4,866-acre conservation area, with its 2,200 acres of wetlands.

There is a two-post information board at the end of Conservation Lane at the "T" intersection. Park there and take the Tupelo Trail that begins right behind the sign. Experience what it was like walking through bottomland forest and cypress/tupelo swamp, much the way early travelers did except you are high and dry on a boardwalk and elevated surface. There is a good mixture of bottomland trees here including American elm, willow oak, overcup oak, persimmon, water locust, silver maple, swamp privet, green ash, sugarberry, Drummond's red maple, swamp privet and green hawthorn. About halfway along the trail, a short spur leads to a deck that overlooks Beaver Lake. Continuing on, the north end of the trail skirts the swamp edge of Otter Slough. Look for bald cypress, water tupelo and buttonbush, all characteristic swamp species. Just north of the two-post information board, a gravel lane goes north to a boat ramp where you can launch a small

Bald cypress trees are silhouetted against a twilight sky.

boat or canoe to explore the 250-acre Otter Slough. At the north end, a 20-acre portion of the swamp has been set aside as a natural area. Otter Slough Natural Area is one of the few remaining examples of swamp communities left in the Bootheel. To visit the natural area, it is best accessed by way of a canoe, which is a great experience paddling through the swamp. Just beyond the boat launch, the road ends at the headquarters. Park and follow the walkway north just a short distance to a deck that extends out over the water for a nice view of the swamp. Be sure to get an area map at the headquarters. There are several roads on the conservation area that take you to various wetlands where you will have additional wildlife viewing opportunities.

Directions: From the intersection of Hwy. 60 and Hwy. 25 at Dexter, go west on Hwy. 60 for 6 miles and turn left (south) on Hwy. ZZ, proceed 8.4 miles, turn right (west) on County Road 675, go 1.0 mile and turn right (west) on Conservation Lane and follow to a "T" intersection. A two-post information board at the edge of the woods is the trailhead for the Tupelo Trail.

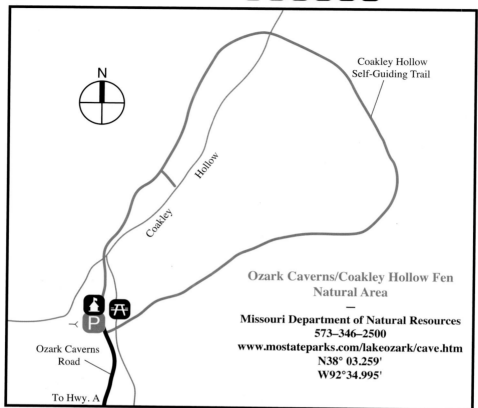

Coakley Hollow Self-Guiding Trail

N

Hollow

Coakley

Ozark Caverns/Coakley Hollow Fen Natural Area

—

Missouri Department of Natural Resources
573–346–2500
www.mostateparks.com/lakeozark/cave.htm
N38° 03.259'
W92°34.995'

Ozark Caverns
Road

To Hwy. A

OZARK CAVERNS AND COAKLEY HOLLOW FEN NATURAL AREA are two special features located at the same area. Ozark Caverns is a tour cave operated by the staff at the visitor center. Once a commercial cave, the electrical wiring inside the cave was removed to provide a more natural setting. Now, accompanied by a tour guide, you get to explore the cave by way of an electric lantern. With your own light source you can view stalactites, stalagmites, soda straws, helictites, cave coral and other interesting cave features. One highlight of the tour is Angel Showers, an unusual cave feature with a perennial shower that seems to come out of the solid rock ceiling and falls into a crystalline basin rising from the floor of the cave.

Ozark Caverns is closed from October 16 through April 15, however, the rest of the year tours are offered at certain hours of the day so be sure to check with the visitors center for the schedule. There are various tours you can select from with fees ranging from free to $6, depending upon your age. Touring the cave with your own light source is a rare opportunity to see some neat cave features and gain some sense of what it is like exploring caves on your own.

Coakley Hollow Fen Natural Area contains one of the Ozarks most unique natural features, a rare type of wetland known as a fen. These open areas are boglike with moist, spongy soil that never seems to dry out. This is because the fen is constantly saturated by water seeping from the base of the hill above it. Unique, specialized plants grow here and you have an opportunity to observe them from a boardwalk right over the fen. This special feature was designated as a state natural area in 1982. The fen is located along the

Golden Alexanders bloom along the ledge of a spring fed creek.

Coakley Hollow Trail, which begins at the parking area. Be sure to obtain a self-guiding trail booklet at the trailhead or at the visitor center before beginning the hike. Eight stations along the trail interpret special features including north and south slopes, spring-fed stream, dolomite glade, chert rock, an old mill site, and the fen.

Directions: About 4 miles east of Camdenton on Hwy. 54, take Hwy. A south for about 7 miles and turn left on McCubbins Drive; proceed 0.7 mile to Ozark Caverns Road on the right and go 0.8 mile to the parking area.

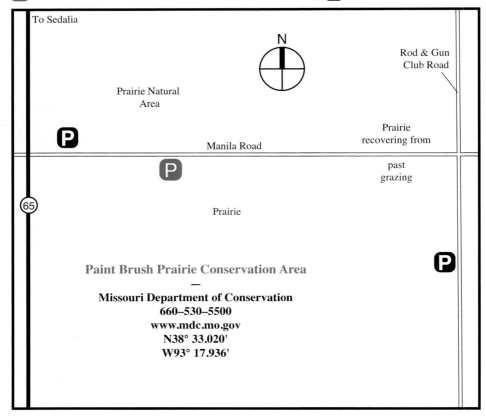

Paint Brush Prairie Conservation Area
—
Missouri Department of Conservation
660–530–5500
www.mdc.mo.gov
N38° 33.020'
W93° 17.936'

PAINT BRUSH PRAIRIE CONSERVATION AREA is named for the showy Indian paintbrush that blooms in April. The brilliant red color of the flower heads reminded someone of a brush used to apply war paint to the face of a Native American Indian. This is a very diverse prairie highlighted with some special plants and animals including a pink katydid, the rare prairie mole cricket, the regal fritillary butterfly, and the federally endangered Mead's milkweed. The 314-acre prairie has on the east end, two 80-acre tracts, one on each side of the road, that are in a restoration phase after having been heavily grazed by the former owners. While the 80-acre prairie on the south side of the road with the parking lot is of good quality and offers some nice views from its higher vantage point. But, the 80-acre prairie north of the parking lot, which was the first purchase (1978), has the highest quality and greatest diversity in the area. Designated a state natural area, it is my favorite part to wander around on. In early June, I like to head north from the parking lot, crossing the road and going about 300 feet across the prairie where the slope drops down to the prairie draw. If the conditions are right, you will find loads of pale purple coneflower and yellow coneflower in heavy bloom on the lower slope. I can't recall seeing another prairie where both are found growing together. As you approach the slope, notice the characteristic mima mounds that are found in many of the Missouri prairies. Also, as you wander about the prairie, notice the small clumps of grass with their long fine leaves forming mounds about 2 feet across. This is prairie dropseed, a grass that is sensitive to disturbance and an indicator of a high quality prairie. If you visit the prairie in June or July, keep your eyes peeled for pink katydids. Most katydids are green but there is an uncommon pink form that totally looks out of place.

A mixture of pale purple and yellow coneflowers respond positively to an earlier prescribed burn. (above)

The showy, long flowering Indian paintbrush inspired the name for this prairie. (right)

Most of the prairie is dry-mesic, which is the most common type of prairie found in the southwestern part of the state. The soil is shallow over bedrock so moisture is not available for very long. If you walk east along the prairie draw, you come to a low area near an old boundary line. This 2 or 3 acre patch is mesic prairie. The soil is deeper and holds more moisture, which is favorable for plants like bunchflower, a lily with a tall wand of cream-colored flowers that bloom in mid-to-late June.

Directions: Proceed 9.0 miles south of Sedalia on Hwy. 65, turn left (east) on Manila Road, passing the first parking lot on the left (north) and proceed 0.3 mile to the parking area on the right (south).

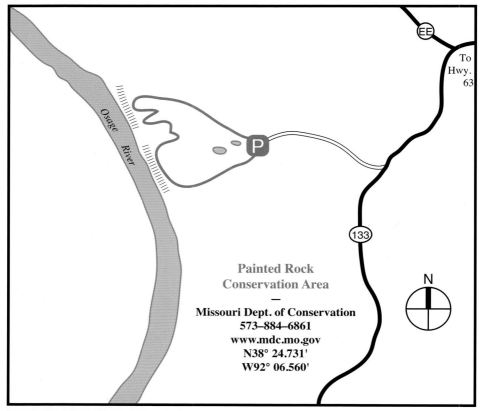

PAINTED ROCK CONSERVATION AREA contains several special features that are highlighted along the 1.6-mile Osage Bluff Scenic Trail and described in an 18-page booklet, which you can kind find in a box a short distance down the trail. The features described include an Indian burial cairn, spectacular views overlooking the Osage River, interesting rock outcrops and forest management practices. The area is named for a feature first noted in 1806 by the famous explorer Zebulon Pike. High on the cliff there are some paintings (pictographs) representing a buffalo, a man with upraised arms, a serpent, and some turkey tracks. I have not seen these paintings but they were said to be mostly obliterated when reported by an observer in 1881.

About 1.2 miles further south on Hwy. 133 from the main entrance to Painted Rocks Conservation Area, there is a gravel road on the right (west) that leads down to a small fishing lake, a privy, two primitive camping sites, and access to the Osage River.

Along the road to the parking area there is an open area with a scenic view. Here, you are driving through a small dolomite glade. Although not a very diverse one, you will see Missouri coneflower blooming in the summer and little bluestem grass turning orange in the fall. The loop trail begins in the northwest corner of the parking area and ends at the southwest corner. The trail is a little easier to hike in reverse because of one fairly rigorous but short section. It also takes you to the better of the two overlooks first if that is your main interest. The brochure can be picked up a short distance down the trailhead. When approaching the 140-foot bluffs use caution if you have children. There are overlook decks with railings and benches that provide great views up and down the Osage River.

About 1.2 miles further south on Hwy. 133 from the main entrance to Painted Rocks Conservation Area, there is a gravel road on the right (west) that leads down to a small fishing lake, a privy, two primitive camping sites, and access to the Osage River.

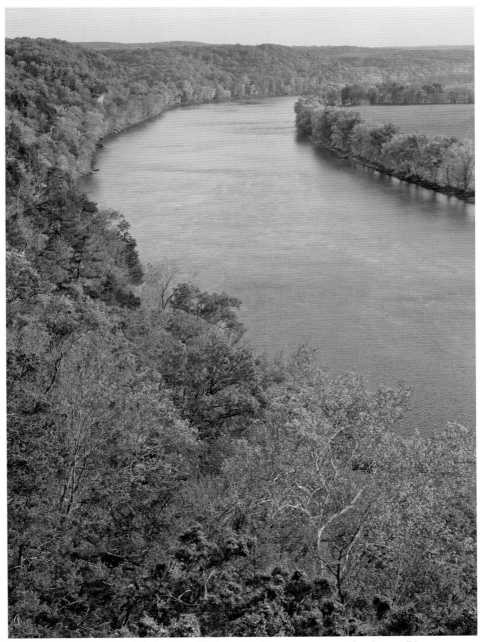

Fall colors highlight one of Missouri's largest streams, the Osage River.

Directions: From the intersection of Hwy. 63 and Hwy. 50 southeast of Jefferson City, go 3 miles south on Hwy. 63 and turn right (west) on Hwy. 133, proceed 6.6 miles to the entrance of Painted Rock Conservation Area and go 0.6 mile to the parking area.

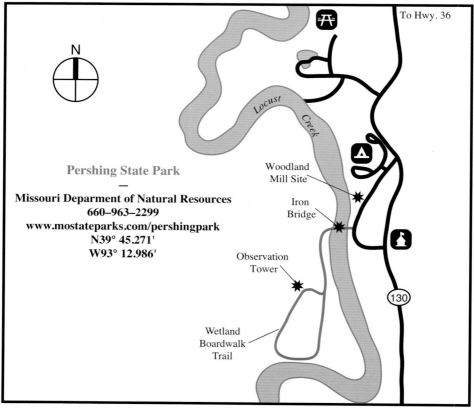

To Hwy. 36

Pershing State Park
—
Missouri Deparment of Natural Resources
660–963–2299
www.mostateparks.com/pershingpark
N39° 45.271'
W93° 12.986'

Woodland Mill Site

Iron Bridge

Observation Tower

Wetland Boardwalk Trail

130

PERSHING STATE PARK, named in honor of General John J. Pershing, who hiked and played in the area as a kid, is a special place for several reasons. The 3,565-acre park is one of the few areas left in north Missouri with an unstraightened, unchannelized stream and associated floodplain. Locust Creek is allowed to meander along creating and maintaining sloughs, shrub swamps, marshes, wet prairies and enriching floodplain forests. Most other bottomland areas have been drained, cleared and converted to crop and pasture land. The best way to experience the diversity of this natural habitat at the park is to take the 1.5-mile Wetland Boardwalk Trail. This is an easy loop trail with interpretive signs posted along the way that discuss the importance of the stream, the bottomland forest and the plants and animals that use these habitats for food, cover and the rearing of their young.

The trail begins at an iron bridge crossing over Locust Creek. Once on the other side, you enter a wet bottomland forest dominated by silver maple, cottonwood, sycamore, green ash, boxelder, and slippery elm. This bottomland forest is a magnet for spring and fall migrating birds and a popular destination for birders. Notice where there is a slight change in elevation and you will also see a change in the vegetation. This becomes a slightly better drained wet-mesic bottomland forest dominated by shellbark hickory, swamp white oak, bur oak, and pin oak. The boardwalk continues for 0.5 mile to an intersection; go straight instead of turning right. Soon, you will come upon a shrub swamp, which is an abandoned channel of the meandering Locust Creek. The creek still flows through this area during high water and replenishes the swamp with nutrients. Note that the shrub swamp is changing over time, as many wetland communities do, and gradually

October leaves, beginning to change into their fall attire, are supported by the smooth white limbs and trunk of a large sycamore tree.

filling with sediment. The buttonbush that once dominated has now been replaced by cottonwood and willow trees. It will someday become a bottomland forest unless a terrific scouring event caused by the river reclaims the channel. Continue on to an overlook of Locust Creek and shortly beyond that you enter the 1,040-acre wet prairie. An interpretive sign explains the significance of this special habitat. Continue on to an observation tower that gives you a better view of the vast wet prairie. Beyond the tower, another old abandoned channel of Locust Creek forms a marsh.

Directions: At the intersection of Hwy. 36 and Hwy. 130, 18 miles east of Chillicothe or 7 miles west of Brookfield, take Hwy. 130 south 1.4 miles; turn right (west) and go 0.3 mile to the parking area.

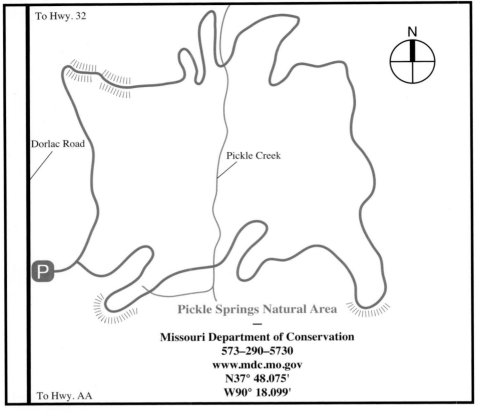

To Hwy. 32

Dorlac Road

Pickle Creek

N

Pickle Springs Natural Area

—

Missouri Department of Conservation
573–290–5730
www.mdc.mo.gov
N37° 48.075'
W90° 18.099'

To Hwy. AA

PICKLE SPRINGS NATURAL AREA is loaded with incredible sandstone features packed within its 257 acres. Here you will find exposed sandstone bedrock that has been sculptured by the forces of wind, rain, and ice. A 2-mile trail leads you to rock pillars (called "hoodoos"), gigantic boulders, arches, narrow fissures, waterfalls and box canyons. Some of these rock formations have been given names based on their inspired shapes such as The Slot, Cauliflower Rocks, Terrapin Rock, Double Arch, Spirit Canyon, and Headwall Falls to name a few. The trailhead starts just a short distance from the parking area. Be sure to grab a Trail Through Time interpretive booklet at the map display and begin the loop trail by going left.

As you walk along the trail, notice the sandy texture of the soil. This is a result of weathering of the coarse-grained LaMotte sandstone, deposited around 500 million years ago and the oldest sedimentary rock in the state. The sandstone is named for the community of Mine LaMotte, an old lead mines region about 16 miles south of here. You can also find special shapes and forms of this unusual sandstone at Hickory Canyons Natural Area and Hawn State Park.

The somewhat acidic, well-drained sandy soils support plants that thrive under those conditions. Most of the natural area is dry-mesic upland forest. Notice along the slopes the stands of shortleaf pine mixed in with white and black oak, hickory, red maple, black gum, flowering dogwood, and eastern hop hornbeam. As you drop into the canyon, where there is more soil moisture and cooler conditions, northern red oak, white oak, sugar maple, and slippery elm become more evident. Here you will also find showy wild azalea

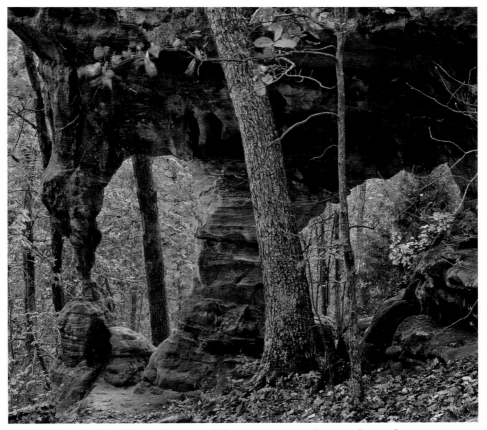

A unique double arch is one of the many outstanding sandstone features found in this natural area.

blooming on the lower slopes in early May. In the cool, shaded canyons, the moist sandstone cliffs provide habitat for the rare hay-scented fern, cinnamon fern, marginal shield fern, partridge berry, and a variety of mosses and liverworts.

After experiencing the lush greenery that the canyons have to offer during the growing season, include plans for a winter visit, especially after a series of melting and freezing events. You'll be pleasantly rewarded with loads of icicles hanging from the rock ledges and frozen waterfalls suspended from massive cliff pour offs.

Directions: Take Hwy. 32, 16 miles west of I-55 (exit 150) or 6 miles east of the intersection of Hwy. 32 and Hwy. OO at Farmington and turn east on Hwy. AA; proceed 1.5 miles and turn left (north) on Dorlac Road, follow it about 0.2 mile to the parking area.

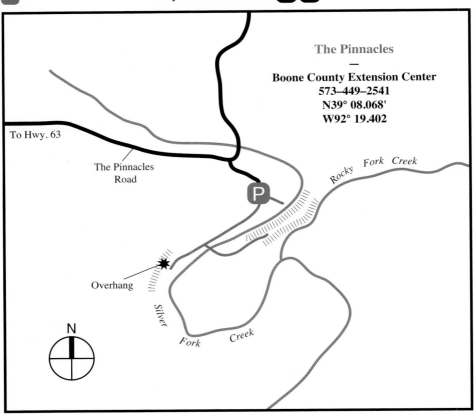

The Pinnacles
—
Boone County Extension Center
573–449–2541
N39° 08.068'
W92° 19.402

To Hwy. 63

The Pinnacles
Road

Rocky Fork Creek

Overhang

Silver Fork Creek

N

THE PINNACLES or the Boone County Pinnacles Youth Park, contains an interesting geologic formation also known as "The Narrows." This is where two streams that closely parallel each other keep eroding away at a shared ridge thus making it narrower and narrower until it eventually disappears. Geologists call this a "senile" ridge and it only has a few thousand years remaining so you'd better make plans to visit it soon.

The Pinnacles is a designated state natural area, so recognized for its geologic and aquatic features. The 27-acre natural area contains the narrow ridge with Silver Fork Creek on the west and south side and Rocky Fork Creek on the east side. The ridge, measuring 75 feet high and about 1,000 feet long is so narrow that two windows or arches are clearly visible. The rock is Burlington Limestone, named for Burlington, Iowa, where it was first discovered and described by an early geologist. If you look closely at the rock surface, you'll see small animal fossils called "crinoids," which happens to be the Missouri state fossil. Crinoids are also known as "sea lilies" because they had a stalk that supported a flower-like head. Look for the round broken segments on the exposed rock.

For a nice view of The Pinnacles, walk down the slope from the parking lot to the stream's edge. Notice the expansive cliff face with the two sky windows. There is a route that will take you up to the top of the ridge that involves crossing the creek further downstream. The ridge is very narrow in places so travel at your own comfort level. The best way to access the ridge is to go back to the parking lot and head south along a path for about 600 feet. At that point, you will notice a red metal building on the slope to the right. Ahead, you will see a small wooden bridge. A short walk beyond the bridge leads to

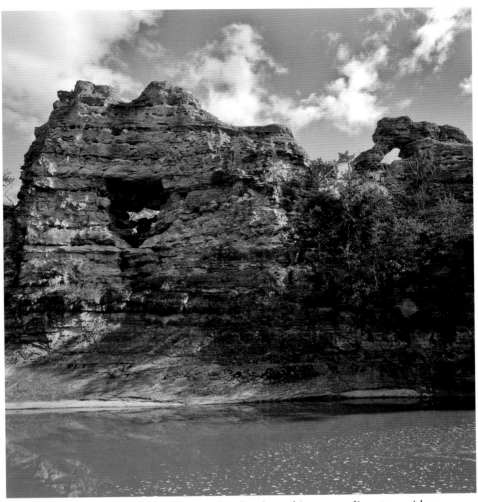

Two arches provide windows to the sky along this narrow limestone ridge.

a neat looking overhang where Silver Fork Creek takes a sharp bend while scouring away at the little bluff. Return back to the wooden bridge, cross over and look for a path that leads down to the creek. There you will find some disarranged stepping stones across the creek. You're bound to get your shoes wet, even at normal flow so be prepared for that. Do not attempt to cross after a heavy rain when the creek is high! Once across, there is a path up the bank that leads to the trail up the ridge. The ridge gets narrower as you walk so be very careful about your footing. Travel as far as you feel comfortable and be sure to take in the great views on either side of the ridge. If you get as far as the wood's edge, you need to return the same route because it is private property beyond that.

Directions: From the intersection of I-70 and Hwy. 63 (exit 128) at Columbia, go north 7.9 miles on Hwy. 63 and turn right (east) on The Pinnacles Road, then proceed 0.6 mile to the entrance on the right.

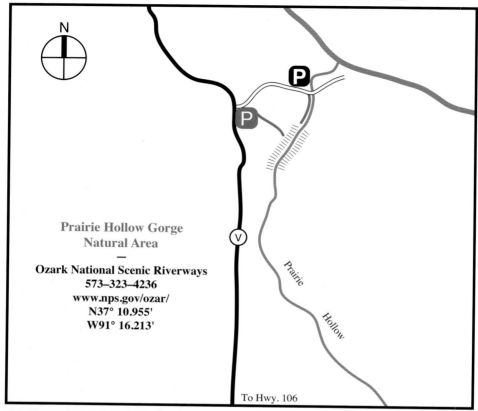

Prairie Hollow Gorge
Natural Area
—

Ozark National Scenic Riverways
573–323–4236
www.nps.gov/ozar/
N37° 10.955'
W91° 16.213'

To Hwy. 106

PRAIRIE HOLLOW GORGE NATURAL AREA is a unique, steep-walled, narrow shut-ins cut into igneous bedrock by a small intermittent stream. This geologic feature is so special that it was designated as a state natural area in 1980. You can view the scenic gorge or shut-ins from the cliff edge or hike in the gorge along pools, waterfalls, and gravel washes interspersed with large boulders. If you have the time, I would recommend doing both. The cliff-edge trail begins at the south side of the small parking area. A narrow woods path, about 0.3 mile long, takes you up a slope dominated by shortleaf pine and white oak trees. Along the way, you will encounter large trees lying in different directions suggesting a swirling action made by either powerful winds or a tornado. In fact, the trees were downed by a small tornado crossing the hill in early 2007. The trail opens onto an igneous glade with lichen-covered rocks and shallow pockets of soil supporting various grasses, wildflowers, and stunted trees. The environment is very harsh alternating between periods of waterlogged soils to extreme heat and drought. Be sure to note where the unmarked trail first enters the glade or you may be bushwacking your way back to the parking area. At the glade opening, immediately turn left and walk about 50 feet, where you will find a trail marked with rock cairns. You can follow this primitive trail down to the cliff edge where an impressive view of the gorge awaits. From there, you can wander around on the glade and cliff's edge but be careful of your footing because it is a sheer drop.

 The gorge trail begins at the parking area. Follow the road down a steep hill for 0.3 mile or drive down the hill to a one-vehicle pulloff on the left side of the road. The trail begins along the right side of the creek and goes for about 0.25 mile where it enters

*Water flow through the gorge takes on many shapes and sizes
as it traverses the igneous rocks.*

a gravel wash with large boulders. You are on your own from there. It is best to wear sneakers and prepare to do a little wading in parts depending on the amount of water in the creek. Along the way, you will encounter pools deep enough for a dip, waterfalls, a small cave and an arch. Entering the gorge when the intermittent creek is at high flow is not recommended. Feel free to wander as far up the gorge as you want and then return on the same route back.

Directions: At the intersection of Hwy. 19 and Hwy. 106 in Eminence, take Hwy. 106 for 5.2 miles and turn left (north) on Hwy. V for 2.3 miles; just after the "Entering Ozark Scenic Riverways" sign, turn right (east) onto a narrow county road and park just into the woods on the right where it is large enough for 2 or 3 vehicles. Or, you can drive further down the county road to a pulloff for one vehicle just before the stream crossing. Even though there is a sign that says "Private Road," I checked at the Ozark National Scenic Riverways office in Van Buren and was told that there is public access to just beyond the stream crossing so feel free to park just to the left of the crossing. Please do not block the county road.

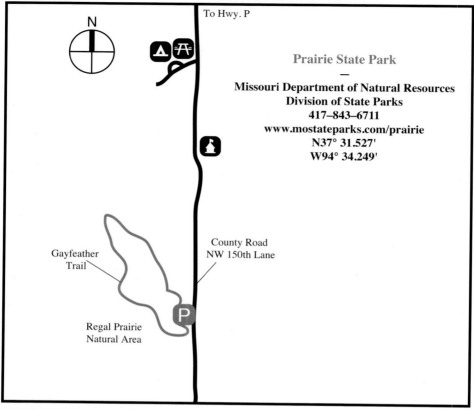

To Hwy. P

Prairie State Park
—
Missouri Department of Natural Resources
Division of State Parks
417–843–6711
www.mostateparks.com/prairie
N37° 31.527'
W94° 34.249'

Gayfeather
Trail

County Road
NW 150th Lane

Regal Prairie
Natural Area

PRAIRIE STATE PARK, with its 3,942 acres, is the largest remaining prairie left in the state. And, with 5 trails totaling 12 miles, you have an opportunity to experience what it must have been like roaming the prairie over 200 years ago. An added feature is being able to observe a herd of bison complete with bulls, cows, and calves all living on the prairie as a family unit. It is a rare experience being able to observe, up-close, patches of ground where they graze, trails where they walk, and buffalo wallows where they roll in, dusting themselves, to ward off insects.

The visitor center is a good place to stop to obtain information on what trails to hike, to check out the prairie diorama, and to pick up any brochures and maps to make your visit more rewarding. For hiking, I would recommend starting out on the Gayfeather Trail, so named for the tall blazing star, a prairie forb, that appears in mass display during July. The 1.5-mile trail starts at the Regal Prairie parking lot, which is 1.0 mile south of the visitor center. Regal Prairie, was designated a state natural area in 1981. The 240-acre prairie has the highest natural quality and best floral display in the park. A map showing the location of the three other natural areas and the other hiking trails can be obtained at the visitor center.

One visit to Prairie State Park is simply not enough. The color and texture of the prairie changes throughout the season and you never know where the bison are going to be as they roam around within the park. Seeing a herd of 40 or so bison grazing along a hillside or crossing the road is an experience that you won't forget. Along with the bison, over 25 elk graze the western portion of the prairie. Unfortunately, they typically remain out of site. In addition to the bison and elk, staff at the park has recorded 23 other

Mid-July is the time for tall blazing star to put on its finest display.

It seems that even the staunchy bison can display a sense of humor.

mammals, 150 birds, 25 reptiles, 12 amphibians and 350 kinds of plants. Of these plants and animals, over 25 are classified as rare or endangered. So the park is also providing protection for species in peril.

Directions: At the intersection of Hwy. 43 and Hwy. K, which is west and south of Nevada, take Hwy. K west through Liberal for 4 miles to Hwy. P, then turn left (south) on County Road NW 150th Lane and go 1.3 miles to the visitor center.

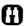
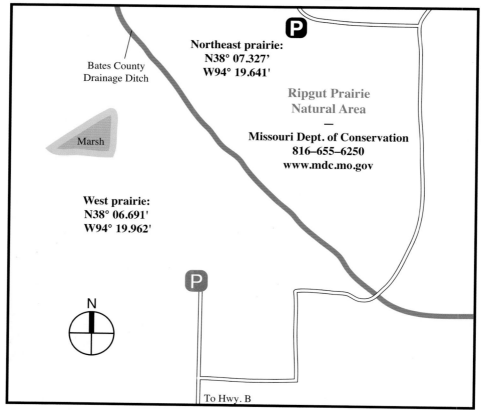

Northeast prairie:
N38° 07.327'
W94° 19.641'

Ripgut Prairie
Natural Area
—
Missouri Dept. of Conservation
816–655–6250
www.mdc.mo.gov

Bates County
Drainage Ditch

Marsh

West prairie:
N38° 06.691'
W94° 19.962'

N

To Hwy. B

RIPGUT PRAIRIE NATURAL AREA contains excellent examples of two rare kinds of prairie: wet prairie and wet-mesic prairie. These deep-soiled prairies have always been more restricted because they occur within the floodplain of rivers mostly in the Osage Plains of southwestern Missouri and in the glaciated plains of northern Missouri. They are rare today because of channelizing, draining, and converting the prairies to cropland. In this case, the Bates County Drainage Ditch, which cut off the nearby Marais des Cygens River eliminated much of the wet prairie in the region. We are fortunate to have high quality examples of both of these types of prairies remaining at Ripgut Prairie Natural Area. The 280-acre Ripgut Prairie contains about 94 acres of wet prairie, 35 acres of wet-mesic prairie, a small shallow marsh, 50 acres in woods and 106 acres in cropland, which is gradually being restored to wet prairie.

The name "ripgut" comes from a large grass that is also known as cord grass and prairie slough grass. The long grass blades have serrated edges that can cut so wearing shorts is not recommended. Folklore tells us that a horse being ridden across the wet prairie had its belly ripped open by the sawlike grass blades. As large and as dense as these bottomland prairies used to be, I guess that repetitive cuts could do some damage to a horse.

Wet prairie is subject to flooding for short periods of time and this favors certain plants adapted to these conditions. In addition to cord grass, you'll find switch grass, various sedges and rushes, prairie milkweed, swamp milkweed, water parsley, seedbox, southern blue flag, and tickseed sunflower to name a few. The smaller wet-mesic prai-

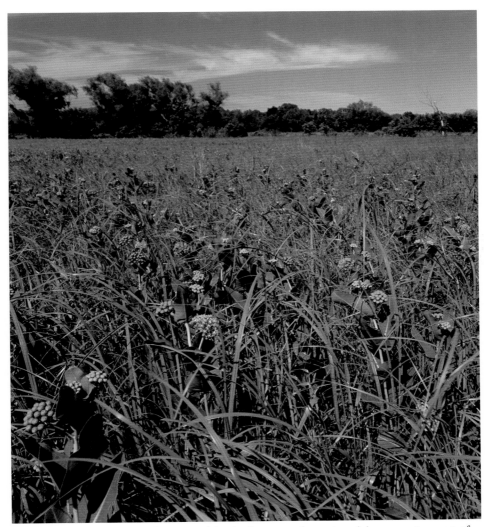

One of the rarest natural communities in the state, the wet prairie supports a sea of cord grass sprinkled with the uncommon prairie milkweed.

rie on the east side of the natural area is on a little higher ground and subjected to less flooding so plants like big bluestem, bluejoint grass, various sedges, sawtooth sunflower, white wild indigo, leather flower and others can be found here.

Directions: From the intersection of Hwy. 71 and Hwy. B at Rich Hill, go 0.4 mile on Hwy. B and turn left (north) on a gravel road; proceed north 1.2 miles to where the road bends, go left on the side road for 0.2 mile to the parking area; walk the field road around to the wet prairie, a distance of about 400 feet. For access to the wet-mesic prairie, continue on the main gravel road for 1.2 miles while crossing over the Bates County Drainage Ditch to a road intersection, go left for 0.6 mile to a bend in the road, pull off on the left side of the road and walk the woods road 365 feet to the prairie opening.

Riverbluff Cave
—
Missouri Institute of Natural Science
417–883–0594
www.riverbluffcave.com
N37° 06.375'
W93°19.747'

To Springfield

160

Farm Road 182

Farm Road 141

Field House

Farm Road 190

N

To Nixa

RIVERBLUFF CAVE is like no other documented cave in the North America. It is the oldest Ice Age cave ever discovered with fossilized remains dating back almost one million years. What has been discovered so far are tracks and remains of the extinct short-faced bear, fossilized turtle shells of a species new to science, peccary tracks, saber-toothed tiger claw marks and a host of other significant discoveries. Also, the cave is filled with a vast array of cave formations including stalactites, stalagmites, columns, draperies, flowstone, and soda straws. And, most importantly, there are no signs of humans having ever entered the cave. This is because the entrance was covered over by mud and dirt many thousands of years ago, thus creating an airtight environment. Air is known to dry out a cave and cause the environment of the cave to change, which deteriorates the habitat of cave animals, slows down the growth of cave formations, and causes breakdown of historic animal remains. The once-sealed cave was accidently broken into when workers were blasting bedrock for a new county road. When they discovered that the blast uncovered an opening to a large cavern they notified cave experts. And, when realizing the significance of the finding, the opening was sealed off to protect the pristine condition of the cave and to prevent vandalism from occurring.

Since that event in 2001, a remarkable amount of information has been collected by Matt Forir, executive director and cave geologist, and the staff of the newly formed Missouri Institute of Natural Science. With the addition of an above ground field house, you can tour their working lab and view fossils on display from this site as well as from other locations in North America.

The now extinct short-faced bear (left) was probably a formidable challenge to an average-sized black bear (right).

The field house is open Monday through Friday from 10 am to 4 pm and on Saturdays by appointment only. A large facility has recently been constructed to serve as a working museum and houses more fossils and accommodates more visitors. The museum is open Monday through Friday from 10 am to 4 pm and on Saturdays by appointment only. Because this is an evolving operation, it is best to call ahead first to make sure that your visit won't conflict with some scheduled tour or classroom session. Although the goal is to have part of the cave available for educational tours, it is not currently open to the public.

Directions: At the intersection of Hwy. 65 and Hwy. 60 on the southeast side of Springfield, take Hwy. 60 (called the James River Expressway) west about 4 miles and take the Hwy. 160 exit; then turn left (south) on Campbell Ave. for 1.4 miles and turn right (west) on Farm Road 182; then proceed 1.75 miles to Farm Road 141 and turn left (south); then go 0.6 mile and turn right (west) on Farm Road 190 and look for the sign and entrance road on the right.

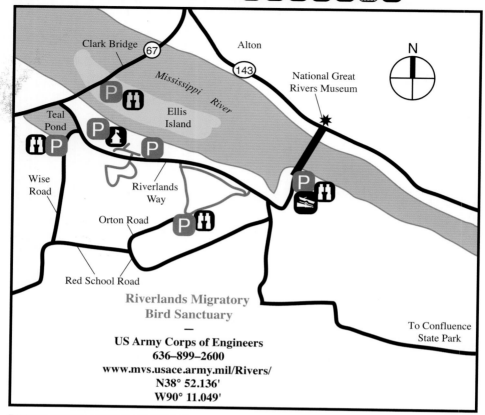

Riverlands Migratory Bird Sanctuary
—
US Army Corps of Engineers
636–899–2600
www.mvs.usace.army.mil/Rivers/
N38° 52.136'
W90° 11.049'

RIVERLANDS MIGRATORY BIRD SANCTUARY offers great opportunities to view a variety of migratory and resident birds in a variety of habitats. Access is easy with many roads and parking areas that put you within close range of the birds. Of course, binoculars or spotting scopes makes the viewing much more rewarding. The 3,700-acre sanctuary was developed in 1988, after the construction of the Melvin Price Locks & Dam. The area, which contains 1,200 acres of restored bottomland grasslands and marshes, was designated by the Audubon Society in 2005 as an Important Birding Area. Increased birding activity here begins in the summer and fall as the shorebirds migrate through on their way south. Winter brings in geese, ducks, bald eagles, trumpeter swans, white pelicans, gulls and others followed by returning shorebirds in the spring.

There are two short trails in the area that allow you to walk to the river and along the various wetland and grassland areas. Also, a visit to the Edward "Ted" and Pat Jones-Confluence State Park provides an opportunity to view the joining of the Missouri and Mississippi Rivers. This site is just opposite Columbia Bottom Conservation Area (see directory). A short wheelchair accessible trail takes you to a viewing deck with interpretive displays. To get to the park, continue on Riverlands Way and turn right onto a 4.4-mile gravel road that goes to a parking lot and trailhead. Visit www.mostateparks.com/confluence.htm for more information. While in the area, be sure to visit the National Great Rivers Museum located on the Illinois side of the Melvin Price Locks & Dam. Take Hwy. 67 across the Clark Bridge into Alton. Turn right (south) onto Hwy. 143, proceed 2.1 miles and turn right again onto Lock and Dam Way for 0.6 mile to the museum. The

Canada geese mingle in the glitter path of a setting sun.

modern museum has 20 interactive exhibits that tell stories of the Mississippi River, also a 25-minute film, a tour of the lock & dam, a gift shop and restrooms.

Directions: In northern St. Louis County at the intersection of I-270 and Hwy. 367 (exit 31), take Hwy. 367 north for 3.4 miles where it becomes Hwy. 67. Continue on, crossing the Missouri River in 1.6 miles, and proceed another 2.5 miles to the last road on the right, called Riverlands Way, before the Clark Bridge over the Mississippi River. Take Riverlands Way about 0.5 mile to the Rivers Project Office/Visitor Center for more information about the area.

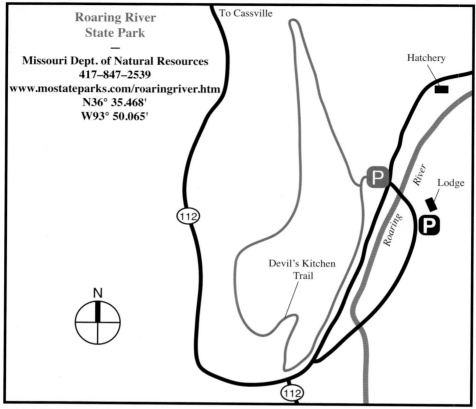

**Roaring River
State Park**
—
**Missouri Dept. of Natural Resources
417–847–2539
www.mostateparks.com/roaringriver.htm
N36° 35.468'
W93° 50.065'**

To Cassville

Hatchery

Lodge

112

Devil's Kitchen
Trail

N

Roaring River

112

ROARING RIVER STATE PARK is probably known more for its trout fishing, being one of three trout parks in the state. However, there are also many special natural features ranging from scenic rock formations to an interesting variety of plants and animals that will capture your attention. There are many things to see and do here but I will recommend five activities that will give you an idea of what the park has to offer. First, there's the 1.5-mile Devil's Kitchen Trail. (See directions below.) Before you begin the hike, be sure to get a copy of the Devil's Kitchen Trail Self-guiding Brochure. They can be found at the state park office, which is located along the road to the first campground. Follow the blue trail signs for the length of the trail but if you want to go right to the Devil's Kitchen, there is a shortcut across the slope marked by yellow trail signs. The self-guiding brochure does a nice job of interpreting the special features along the trail.

Roaring River Spring is a must see. Park near the trout rearing pools and take the walkway past the pools to the grotto-like gorge at the base of a high dolomite cliff. This is the tenth largest spring in the state and issues an average of 22 million gallons per day. Divers have measured the vent to a depth of 215 feet where it ends at several cave passageways from where the water collects. It has been said that before the dam was built in 1880 to pool the spring, the waters rushed from the grotto over rocks with a sound and splash that gave merit to the spring's name. For a short but rigorous hike, take the 0.2-mile Deer Leap Trail that begins along the spring walkway and leads to a great overlook of the hatchery complex.

Be sure to visit the Ozark Chinquapin Nature Center, which is located just off Hwy.

*The tilted stacked layers of blue-gray colored limestone
guard the entrance to Devil's Kitchen.*

F. The nature center contains exhibits interpreting the natural history of the area, plus maps and brochures and field guides for sale. In front of the building, the staff maintains an excellent display of native wildflowers that can be found growing in the park. The plants are labeled for easy identification. There is also an opportunity to see a large dolomite glade complex on the east side of the park. Ask the staff at the nature center for directions to the glade.

Directions: At the intersection of Hwy. 76 and Hwy. 112 on the east side of Cassville, take Hwy. 112 south for 6 miles to Roaring River State Park; at the bottom of the hill, turn left on the road leading to the hatchery, spring and lodge; proceed 0.3 mile, crossing the bridge over Roaring River and park on the west side of the road to access the Devil's Kitchen Trail.

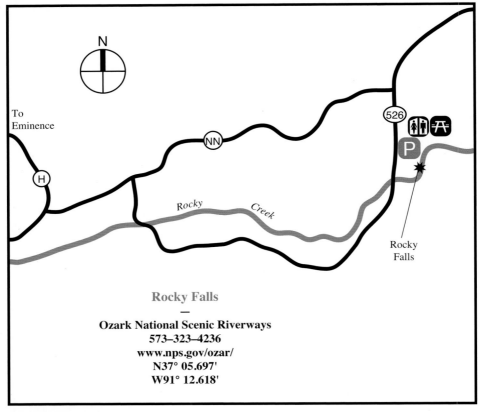

Rocky Falls

—

Ozark National Scenic Riverways
573–323–4236
www.nps.gov/ozar/
N37° 05.697'
W91° 12.618'

ROCKY FALLS is visually the most impressive waterfalls in the state. It is best viewed in the spring when Rocky Creek cascades with a continuous roar over the 40-foot igneous falls. Then, for the rest of the year, after a good downpour, you won't be disappointed with a visit. Rocky Falls is one of three shut-ins carved out by the creek as it journeys to the Current River. (See Mill Mountain, p. 106 and Klepzig Mill, p. 94.)

The landscape around you is composed of ancient volcanoes and lava flows that have been dormant for about 1.5 billion years. As the landscape continued to erode away, Rocky Creek found a path of least resistance and gradually wore into the extremely hard bedrock. Eventually, the stream became trapped or shut-in and its path became what you see today. Rocky Creek is now flanked on the right by a small knob of about 70 feet in height and to the left by a much larger 400-foot knob that is part of Stegall Mountain. (See p. 174.)

If you want to get to the top of Rocky Falls, there is a path on the right that involves a bit of a scramble up the side. It is not that difficult, you just have to watch where you step and be sure to where sneakers or boots with good traction that are either waterproof or that you don't mind getting wet. Once on top, you can wade across the shallow, narrow creek to the other side of the shut-in. You can do this at normal flow but I would not recommend crossing when the creek is at high flow or you may end up getting a fast, bumpy ride down the falls. The large plunge pool at the base of the falls is a popular swimming hole during the hot summer months.

Directions: At the intersection of Hwy. 19 and Hwy. 106 in Eminence, go east on

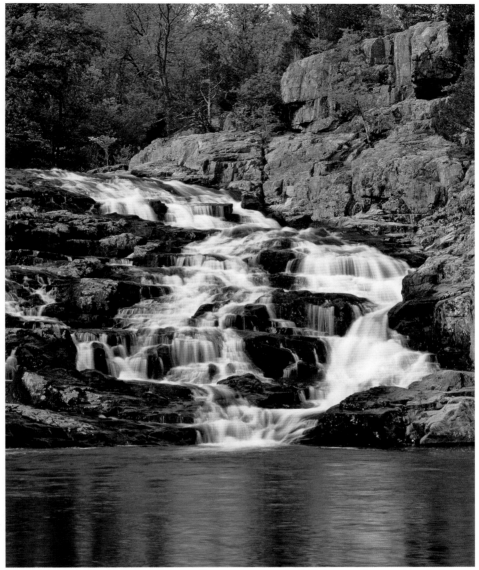

The plunge pool below Rocky Falls is a swimmer's delight on a hot summer's day.

Hwy. 106 for 7 miles, turn right (south) on Hwy. H for 4.4 miles, then turn left (east) on Hwy. NN; proceed 2.0 miles, turn right (south) on Shannon County Road 526, go 0.3 mile and turn left (east) on the entrance road that leads to the parking area.

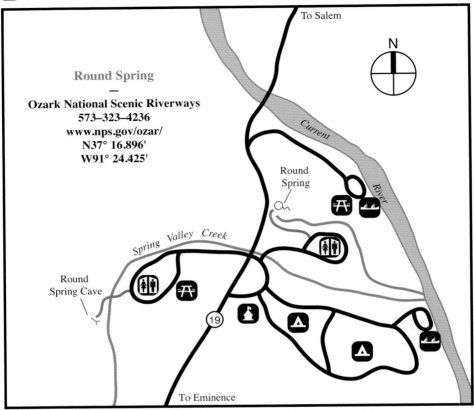

ROUND SPRING, is the 16th largest spring in the state, with a daily flow of 26 million gallons of water. A wheelchair accessible trail takes you to a nice view overlooking a collapsed cavern. Below lies a circular pool with milky blue water emerging from the far side. Divers have investigated the depth of the spring outlet down to about 50 feet. To locate the source of the spring, a nonharmful dye is released into cracks and crevices at certain locations in the surrounding watershed. When the dye emerges at the spring opening a record is kept showing where a particular dye was released. Eventually, a map is compiled showing the underground water drainage pattern that feeds the spring. Studies here show a surprising fact that about 20% of the water supply for Round Spring actually flows under the bed of the Current River on its way to the spring opening. The spring then flows through a natural tunnel below a small bluff, which is actually the one you are standing on when viewing Round Spring. You can see where the spring emerges at the base of the bluff from the trail on the way to the overlook. From there, the spring run flows 800 feet before it enters the Current River. In the crystal clear water of the spring run, submerged eelgrass and mounds of water cress are a common site. Watch for muskrats, with their thick fur, scurrying about looking quite comfortable in the cold spring water.

Nearby, Round Spring Cave is open for touring during the summer months from Memorial Day to Labor Day. The two-hour, lantern tour is a bit strenuous but offers views of nice cave formations. The tour is offered twice a day and there is a fee. Check with the website or the information sign at the cave parking lot for fee rates and tour hours.

Murky blue water emerges from the aptly named Round Spring before it flows under a natural bridge on its way to the Current River.

Directions: Located along Hwy. 19, 13 miles north of Eminence, turn right (east) at the entrance and follow the signs to the spring.

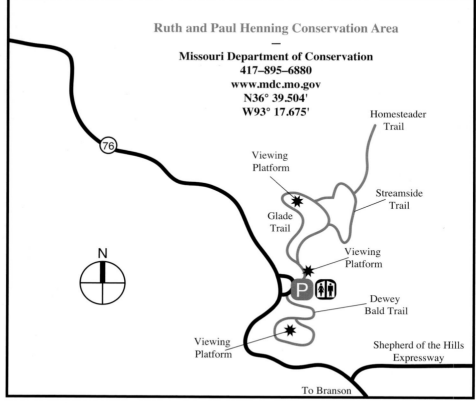

RUTH AND PAUL HENNING CONSERVATION AREA, within its 1,534 acres, contains the largest dolomite glade complex in Missouri, and probably in the rest of the United States too. Their size, openness and high natural quality are unmatched. Glades are like miniature deserts. The thin soil over bedrock holds little water with most of it running down the slopes, plus with this little protection from the sun provides habitat suitable to drought tolerant plants and animals more typically found in the Southwestern deserts. Here, you can find roadrunners, collared lizards, six-lined racerunners, tarantulas and scorpions as well as plants like prickly pear cactus, palafoxia, stenosiphon, Ashe juniper, an acacia, and a yucca to name a few.

Within the Ruth and Paul Henning Conservation Area, you will find the White River Balds Natural Area, which is named for the river that is now a series of lakes from Arkansas through Missouri and back into Arkansas. Balds is a historic reference for the once treeless knobs in this region. The 362-acre natural area contains high quality large glades, open woods, and plants restricted in Missouri to the White River Region.

There are a series of trails that take you through the various habitats. I would recommend the Glade Trail that begins at the covered deck next to the parking area. If you have limited time, the 0.75-mile trail to the overlook is recommended. The trail continues another mile back to the parking area. Along the way, the Streamside Trail takes you through a forested area with a wet weather stream. Taking this outer loop adds another 0.5 mile to complete a 1.5-mile trail. Along the Streamside Trail, there is a crossover trail to the 3.4-mile Homesteader Trail, which deals more with interpreting old farms

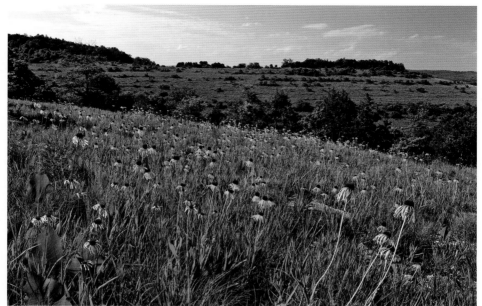

Yellow and pale purple coneflowers respond favorably to an earlier prescribed burn on the largest dolomite glade complex of its type.

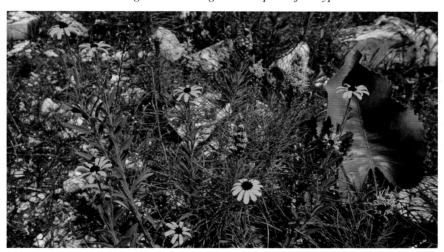

Missouri coneflowers and bottlebrush blazing stars are a common site on the glades beginning in late July.

and homesteads that have since been reclaimed by nature. A third trail begins near the entrance to the parking lot. The 0.5-mile paved loop trail goes to a 40-foot observation tower that overlooks Branson and the surrounding White River Hills. It is hard to believe that such an important natural feature as the Ruth and Paul Henning Conservation Area lies within the city limits of Branson but that is another story.

Directions: From the junction of Hwy. 65 and Hwy. 465, five miles north of Branson, take Hwy. 465 (Ozark Mountain High Road) west for 7 miles to Hwy. 76; then proceed east on Hwy. 76 for 2 miles to the entrance on the left (east). Or, at the intersection of Hwy. 76 and Hwy. 376, take Hwy. 76 west, 0.75 mile.

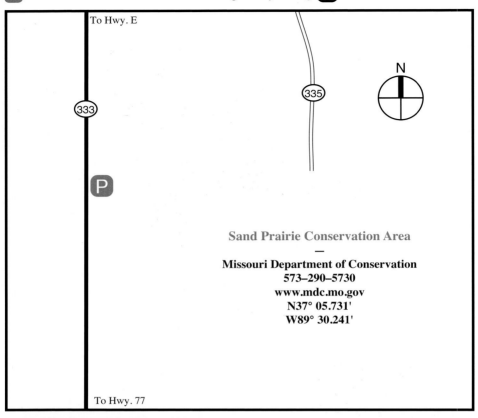
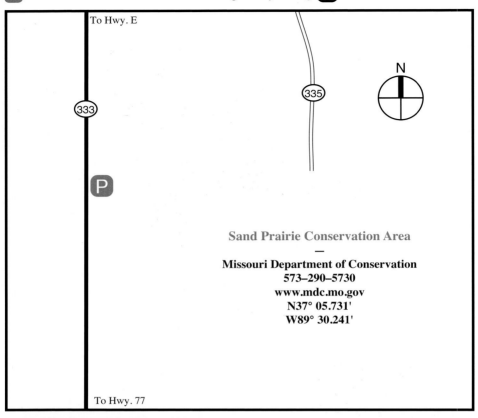

SAND PRAIRIE CONSERVATION AREA contains a unique natural feature that has been all but eliminated in the Missouri Bootheel. Original land surveyors in the early 1800s found over 60 square miles of sand prairie in the southeastern part of the state. Today, less than 1% remains so that makes the Sand Prairie Conservation Area very special. The sand prairie is located on Sikeston Ridge, which begins just north of here and extends south to just below New Madrid. It is about 30 miles long, 2-3 miles wide and from 15 to 20 feet high. The ridge was formed tens of thousands of years ago when glacial meltwaters from the north deposited vast amounts of sand, most of which was then eroded away by the shifting channel of the Mississippi River leaving what is known today as Sikeston Ridge. The dunes were then formed from blowing winds that built up sand deposits, created blowouts and left behind sandy swales that filled with water after heavy rains. Fortunately the 200-acre Sand Prairie Conservation Area was recently acquired to protect an example of this rare type of habitat.

As you walk across the sand prairie, notice the short and patchy vegetation. Most of the plants have narrow leaves protected by a coating of tiny hairs that help limit water loss in this desert-like environment. Because the soil is very sandy, moisture is not retained for very long. Here you will find plants such as prickly pear cactus, puccoon, clasping milk-weed, creeping St. John's wort, and butterfly pea, to name a few. The dominant grass is splitbeard bluestem, with its showy silvery heads that develop in late summer.

Watch for the six-lined racerunner lizard and northern fence lizard as they scurry across the open sand, seeking shelter in nearby clumps of grass. In late winter/early

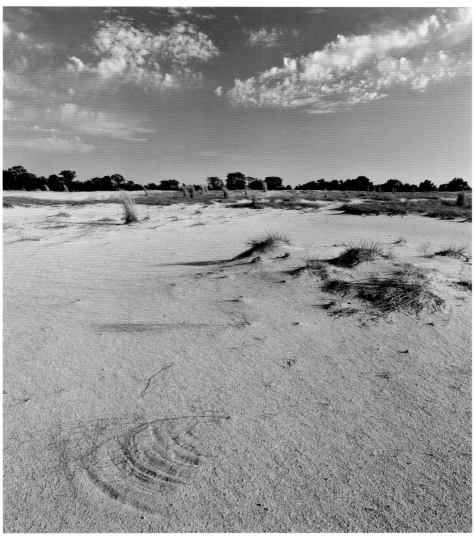

A wind driven plant skeleton leaves an impression in the sand.

spring, you'll hear a distinct high-pitched series of rapid, bird-like whistles from the male Illinois chorus frog. They call in the evening from sandy swales (depressions) that have filled with water after a heavy rain. Later, from April to August, you may hear a quick series of coarse "wank, wank, wank" sounds repeated every few seconds in the evening after heavy rains. That is the call of the eastern spadefoot toad. The pools are so temporary due to the sandy soil that both of these amphibians emerge from their living year-round in the sand, lay their eggs in the pools, have the eggs hatch in a few days, then grow from tadpoles to frogs in as early as 30 days. Unfortunately, both of these specialized amphibian species are classified as rare across their range, due to the loss of this type of sandy habitat. This is what makes the Sand Prairie Conservation Area even more special.

Directions: At the intersection of I-55 and Hwy. 77 (exit 80) east of Benton, take Hwy. 77 east 2.2 miles and turn left (north) on County Road 333, go 2 miles and turn east (right) into the parking area.

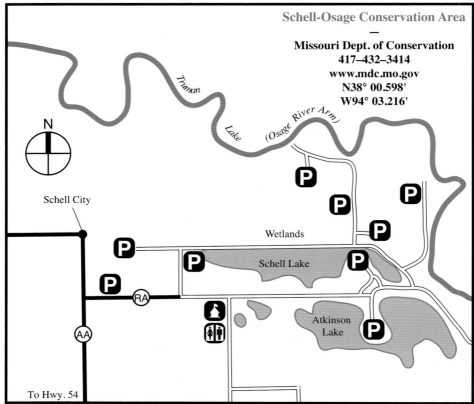

SCHELL-OSAGE CONSERVATION AREA is large in acreage and diversity. This probably accounts for its high bird count. Of 802 areas in Missouri surveyed by volunteers of the Audubon Society of Missouri, Schell-Osage Conservation Area has the highest number of birds recorded at 279 species. This includes waterfowl, marsh and shorebirds, wading birds, songbirds and raptors. There are only 3 other areas out of the 802 surveyed that number above 200. (I might add that Squaw Creek National Wildlife Refuge has a remarkable count total of 321 observed birds and that survey is kept up-to-date by the Friends of Squaw Creek National Wildlife Refuge.)

The primary features within the 8,635 acres are 1,783 acres of wetland, 961 acres of lakes/ponds, and 1,914 acres of forest and woodland. There are also 42 acres of native prairie in five separate tracts. (Refer to the area brochure for locations.) During the waterfowl hunting season from October 15 to February 15, the road that continues from Hwy. RA between Schell Lake and Atkinson Lake and those south of that remain open but the main road and side roads north of Schell Lake are closed. During that period, you can still see waterfowl at Atkinson Lake and from the North Campground area. Be sure to visit after February 15 for full access and you won't be disappointed. There are lots of geese, pelicans, ducks, and other water birds plus numerous bald eagles overwintering and staging for their spring migration northward.

Schell-Osage Conservation Area has an important distinction. The Missouri Department of Conservation (MDC) established a hacking (to raise and feed) tower at the edge of Bell Pond in the 1980s with the goal of rearing young bald eagles and releasing them

Double-crested cormorants are a common site at the wetland complex during spring and fall migrations.

into the wild. It had been decades since bald eagles nested in the state and the hope was that the eagles would imprint on their surroundings and stay year round. So, for several years, young Wisconsin bald eagles (about 60 total) were traded for Missouri wild turkeys and were hacked in the tower. The program turned out to be a huge success and the eagles began to again nest in Missouri. Now after 20 years there are over 200 active nests in the state. To celebrate the return of the bald eagle to Missouri, an Eagle Days event is held here every other year as well as at other department areas in the state. Check with the MDC website for the winter schedule.

You can obtain a bird checklist for Schell-Osage Conservation Area online at this address: http://www.mobirds.org/CACHE/mdcchecklists1.asp?locID=864.

Directions: From El Dorado Springs, take Hwy. 54 west 6 miles to Hwy. AA, turn right (north) and go 12 miles to Hwy. RA, turn right (east) and go 1 mile to the entrance. Follow the signs to the headquarters where you can get an area map.

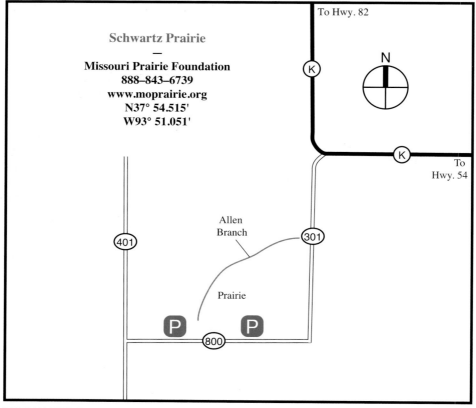

SCHWARTZ PRAIRIE has one of the best landscape views of any prairie in the state. When either viewed from the high point at the southeast gate or from the northwest part of the prairie looking to the southeast, the sweeping view of the slightly bowl-shaped prairie replete with mima mounds is something that immediately prompts you to want to take a picture or two or more. You'll often find this dry-mesic prairie loaded with showy pale purple coneflowers in June and the colorful purple wands of tall blazing stars in July along with a mixture of other showy forbs (wildflowers) that can be seen from April into October. Allen Branch is the small creek that runs through the prairie where, along the south part of the prairie, you'll find small outcrops of sandstone large enough to form miniature sandstone glades. This is an unusual feature for a prairie and highlighted by small depressions that have been eroded by water coursing down the branch. There is one particular pool, about 10 to 12 feet across that never goes dry. In the Southwestern desert country, this is called a tinaja (watering hole).

The 240-acre prairie was purchased in 1991 and named in honor of Charles W. Schwartz and Elizabeth R. Schwartz. This husband and wife duo had a long productive career with the Missouri Department of Conservation. Charlie was a nationally recognized wildlife artist, photographer, and cinematographer. Both he and his wife, Libby, did extensive research on Missouri wildlife, with one aspect of their work cumulating in the award winning ***The Wild Mammals of Missouri***, a book that is still in print.

The owner of Schwartz Prairie, the Missouri Prairie Foundation, is a unique non-profit organization that was established in 1966 by a group of conservation professionals

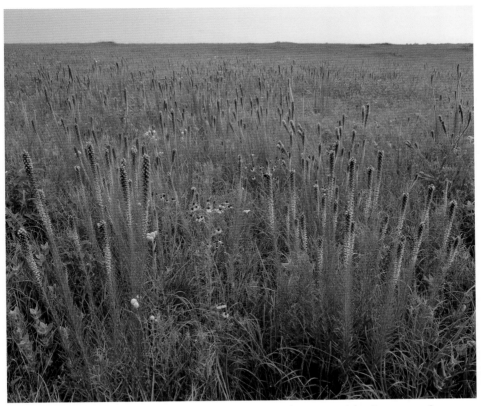

July and tall blazing stars are a winning combination with mima mounds standing vigil on the horizon.

and volunteers that were concerned about the degradation and loss of prairie throughout the state. Over the years, they have protected 13 prairies totaling almost 3,000 acres. Golden Prairie (p. 68) is another one of their prairies that I have included in this book. This is a great organization dedicated to protecting one of our rarest natural communities. Please visit their website and consider becoming a member of this very worthwhile all-volunteer organization.

Directions: From the intersection of Hwy. 54 and Hwy. 82 in El Dorado Springs, take Hwy. 82 north and east 15 miles, then turn right (south) on Hwy. K; proceed 2 miles and on the curve turn right on County Road 301; go 1 mile and follow the road south then turning right (west) where it becomes County Road 800; go 0.3 mile to the first gate; a mowed path may start here some years or at the second gate 0.3 mile further down the road. You can park at either entrance or along the seldom travelled gravel road. (Note: On some visits you may encounter a few head of cattle in this prairie. They are being used as a management tool like prescribed fire and occasional haying so feel free to access the prairie but be sure to close the gate.)

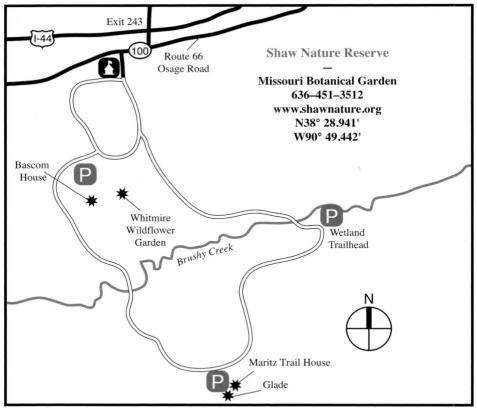

SHAW NATURE RESERVE is one of the few places in the Midwest that is dedicated to maintaining and restoring the region's native flora and fauna in an arboretum setting. An outlier of the world famous Missouri Botanical Garden, the 2,500-acre nature reserve has 13 miles of trails that take you through a variety of different habitats that are representative of the Missouri Ozarks. Of the many places to visit within the nature reserve, I would recommend these three first: the Whitmire Wildflower Garden, the Glades, and the Wetlands. Be sure to pick-up an area map before leaving the visitor center.

To reach the Whitmire Wildflower Garden, follow the one-way drive that begins just beyond the visitor center for 0.5 mile. There are Bascom House/Whitmire Wildflower Garden directional signs to the parking lot. The paved trail leads you through a woodland setting with a carpet of wildflowers and ferns, labeled for easy identification. The trail soon divides into different routes that go to various constructed habitats. The plants are arranged by habitats that include dolomite glade, pine woodland, prairie, woodland, and wetland. The woodland wildflower displays are particularly showy and peak in April into early May.

The Glades habitat is reached by going down the Trail House Loop Road (this road is closed to vehicles Fridays thru Sundays) for 1 mile to the Maritz Trail House parking area. Just west of the parking area, there is a wheelchair accessible walkway that leads to the Crescent Knoll Overlook. Here you can view the dolomite glade's wildflowers and animal life, and the Meramec River valley hills with the aid of a viewing scope. Just south of the Maritz Trail House, a 300-foot boardwalk offers a closer look of the dolomite glade.

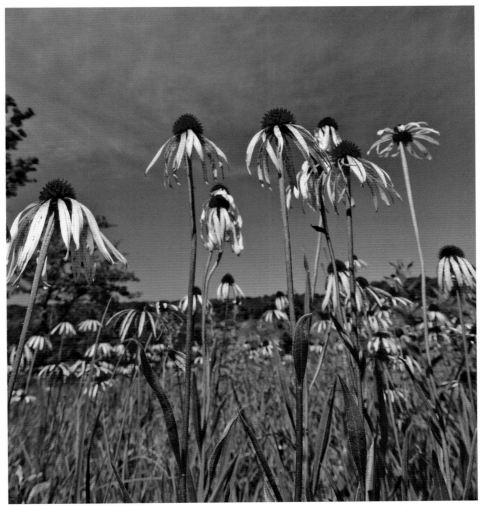

Glade coneflowers reaching for the sky on the dolomite glade below the Maritz Trail House.

Another 0.8 mile along the gravel road leads to the parking area for the Wetlands. Here, a 0.75-mile walk winds past two small amphibian pools, a wet prairie, an upland prairie, and two larger ponds, one of which has a boardwalk constructed out of lumber made from recycled plastic.

And, if you have the time for more extensive hiking, consider the three trails south of the Trail House. Check at the visitor center to see which they recommend depending upon the season.

Directions: At the intersection of Hwy. 100 and I-44 (exit 243) at Gray Summit, take Hwy. 100 West, turn right at the stoplight and proceed 0.1 mile and turn left (south) at the entrance to Shaw Nature Reserve. Park just inside the entrance and pay a small fee just inside the visitor center/gift shop. An entrance fee is waived if you are a member of the Missouri Botanical Garden. Otherwise, it is $3 per adult, $2 per senior (65+) and children (under 12) free. The area is open from 7 am until sunset year round.

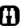
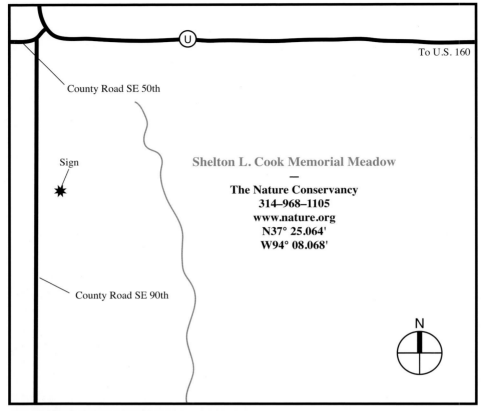

SHELTON L. COOK MEMORIAL MEADOW is known for its highly diverse display of flowering plants with close to 400 species having been recorded on this 185-acre prairie. The prairie was donated to The Nature Conservancy by Mona Cook Morris and named in honor of her father in 1987. In presettlement times this prairie was part of a vast landscape of grassland that made up about 1/3 of Missouri and was located mostly in the northern and western parts of the state. Once estimated at about 15 million acres of prairie, recent inventories have revealed only about 70,000 acres left with approximately 25,000 acres protected by various agencies and organizations. At least 95% of what remains is located in western Missouri because the soil was too shallow to till so the prairies were used for haying and grazing, much as they are today.

Like other prairies, the Shelton L. Cook Memorial Meadow has a lot of flowering activity going on from late April into October. About every two to three weeks you can find a new array of prairie forbs showing off their best displays. Various prairie birds can also be seen here like the scissor-tailed flycatcher, upland sandpiper, dickcissel, and Henslow's and vesper sparrows. Most of the prairie is called dry-mesic, which is halfway between dry and mesic (moist). Some mesic prairie occurs on this site bordering the little creek that courses through the center of the prairie. With more available moisture and better soil, you will see that the plants appear a little denser and larger.

On the north side of the area, you will see what is called a "flatwoods." This is an uncommon feature in the state. Here water drainage is slow and the soil stays wet for longer periods of time. Trees that can tolerate these conditions include post oak, black jack oak, and mockernut hickory among others.

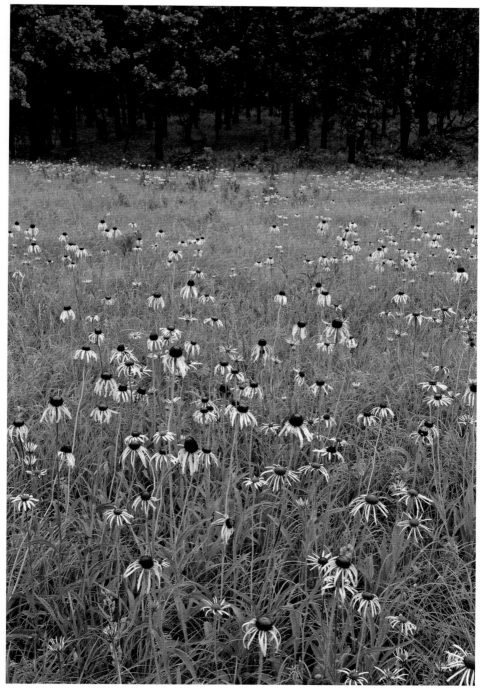

An array of pale purple coneflowers seems to lead a path into the flatwoods.

Directions: From Golden City, go 2 miles on Hwy. 160 north to Hwy. U. Proceed on Hwy. U, 2 miles and turn left on County Road SE 50th, then turn immediately on County Road SE90th and go 0.5 mile. Park along the road and the prairie is on the east side.

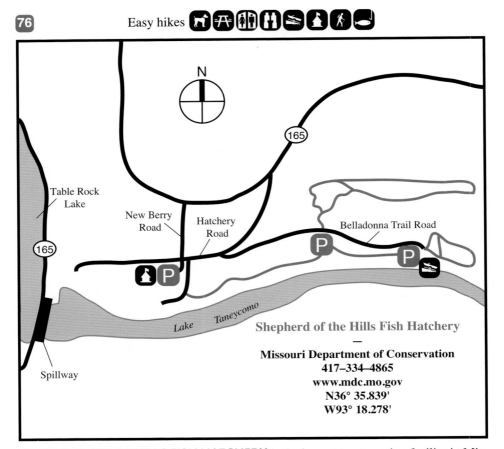

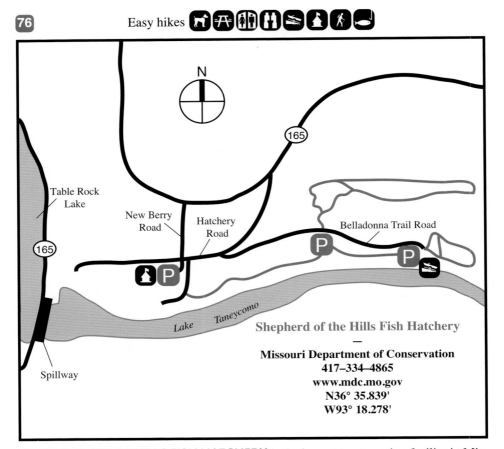

N

165

Table Rock
Lake

New Berry
Road

Hatchery
Road

Belladonna Trail Road

165

P

P

P

Lake Taneycomo

Shepherd of the Hills Fish Hatchery
—
Missouri Department of Conservation
417–334–4865
www.mdc.mo.gov
N36° 35.839'
W93° 18.278'

Spillway

SHEPHERD OF THE HILLS FISH HATCHERY is the largest trout-rearing facility in Missouri. The area also contains the largest winter gathering of both turkey vultures and black vultures in the state and probably the Midwest. The high concentration of wintering vultures is such a spectacle that a special "Vulture Venture" event is held, usually the third Saturday in February each year, with a special indoor program and outdoor viewing complete with spotting scopes. Of course, you can visit the hatchery anytime during the winter and see the large vulture gathering with numbers ranging from 700 to 1,000 turkey and black vultures. It is quite a site watching them assembling and riding thermals in late afternoon through twilight in large kettles. Kettle is a term birdwatchers use to describe a group of birds spiraling in the air. They ride the thermals upward like steam rising off a kettle in the fireplace. A thermal is a column of rising air created by uneven heating of the Earth's surface from solar radiation. The sun warms the ground, which in turn warms the air directly above it. Birds use thermals to gain altitude while conserving strength. I suspect that the vultures congregate in this winter retreat because the canyon-like topography provides a haven from cold winter winds. Also, the local winter temperature is moderated by the steady supply of water issuing from the base of the dam that averages 50 degrees Fahrenheit year-round. And, the large sycamore trees along Lake Taneycomo Lake provide excellent roosting because of their large open canopies that make for easier landing and departure.

The best place to view the vulture kettles is from the parking lot just before the boat ramp at the east end of Belladonna Trail Road. The show begins in late afternoon and

The turkey vulture is so named for its resemblance to a wild turkey...at a distance.

extends into the twilight period. From the parking lot, look south across the lake and you will see large nests in the tops of sycamore trees. This is a great blue heron rookery. Along with the herons, vultures may also be found roosting there for the night.

The two vultures are fairly easy to tell apart. Black vultures have a gray head, a white patch on the underside of each wing tip, shorter and rounder wings, and are found usually soaring in a group. They are more aggressive than turkey vultures and will drive the latter from a carcass; they also depend on their vision to find food.

Turkey vultures are slightly larger, have a red head, the wings are silvery white underneath, the wings are narrower and longer, they flap less frequently and roll and sway from side to side. They also have an acute sense of smell and are more solitary.

While at the hatchery, take the time to visit the conservation visitor center where you can view aquariums; learn about trout culture, aquatic life, fishing and the department's role in aquatic resource management. The center is open throughout the year and is free of charge. There are four hiking trails, check with staff at the conservation visitor center for recommendations

Directions: At Branson, take Hwy. 65 south 3 miles and turn right (west) on Hwy. 165 for about 7 miles, crossing the Table Rock Dam and at the Hwy. 265/Hwy 165 intersection stay right on Hwy. 165, and at about 0.5 mile, turn right at the entrance to the hatchery.

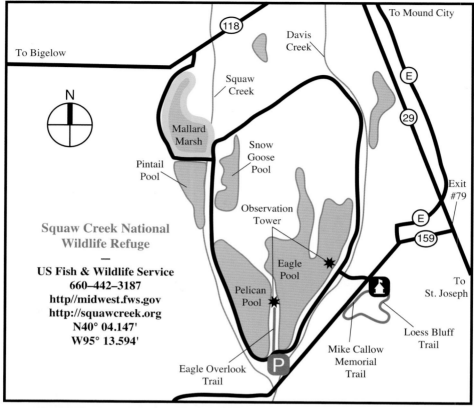

To Mound City

118

Davis
Creek

To Bigelow

E

Squaw
Creek

29

N

Mallard
Marsh

Snow
Goose
Pool

Pintail
Pool

Exit
#79

Observation
Tower

E

**Squaw Creek National
Wildlife Refuge**
—
**US Fish & Wildlife Service
660–442–3187
http//midwest.fws.gov
http://squawcreek.org
N40° 04.147'
W95° 13.594'**

159

Eagle
Pool

To
St. Joseph

Pelican
Pool

Loess Bluff
Trail

Mike Callow
Memorial
Trail

P

Eagle Overlook
Trail

SQUAW CREEK NATIONAL WILDLIFE REFUGE at certain times of the year contains incredible numbers of migrating waterfowl that goes beyond belief. Imagine viewing 600,000 snow geese, 100,000 ducks, and 300 bald eagles all within easy distance from your vehicle. That's what happens in late November/early December as peak numbers of migrating birds congregate at the refuge before they move further south. The 7,350-acre refuge, located in the Missouri River bottoms, was established in 1935 as a feeding and breeding ground for migratory birds and other wildlife. Here, the wetlands range from open pools and mud flats, to flooded woodlands, and cattail-filled marshes that also provide habitat for year-round wildlife residents. In late winter/early spring waterfowl migrants return as they head north to their breeding grounds. Numbers of snow geese in recent years have peaked at 1.6 million. Here you can witness huge flocks of geese landing, resting, and "blasting off" as they erupt in a tremendous flash of solid white producing a hair raising cacophony of water splashing, wings beating and loud honking. Visits in September and October, and March through April also offer viewing of migrating shorebirds (I call them mudwalkers.) that feed on mud flats and in shallow water. All totaled, 321 species of birds have been recorded at the refuge.

Be sure to stop at the visitor center first to gather maps (especially the Squaw Creek Auto Tour Guide), brochures, view the exhibits and get the latest information on what is happening on the refuge. Also, by calling the refuge telephone number during spring and fall migrations, you can get a recorded message on the latest bird counts. The http://squawcreek.org website also provides bird count information.

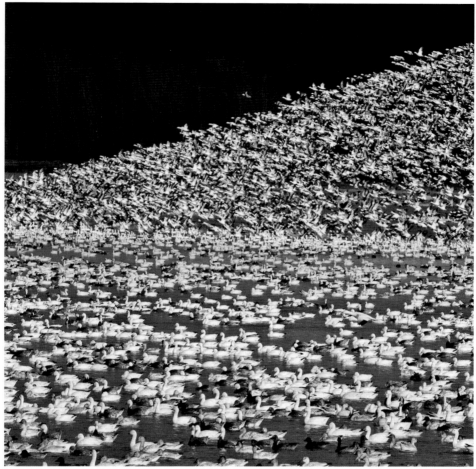

Known as a "blast-off," snow geese erupt in a pattern of reverse tumbling dominos.

There are three trails on the refuge. The Eagle Overlook Trail, a 1.5-mile round-trip walk allows visitors to hike between the two largest wetland pools. The Loess Bluff Trail, a 1-mile loop trail that climbs 200 feet on rock steps, hand-laid by the Civilian Conservation Corps, to the top of bluffs that offer a panoramic view of the refuge. And the Callow Memorial Trail, a 0.5-mile round trip wheelchair accessible trail that leads to the base of the bluff.

A good time to see and learn more about bald eagles is during the annual Eagle Day event. Usually held the first weekend in December, the event includes live eagle programs, exhibits, videos, and guides with spotting scopes. Check the Missouri Department of Conservation website to learn when and where the events statewide are being held.

Directions: At the intersection of I-29 (exit 79) and Hwy. 159, south of Mound City, take Hwy. 159 west for 2 miles to the visitor center.

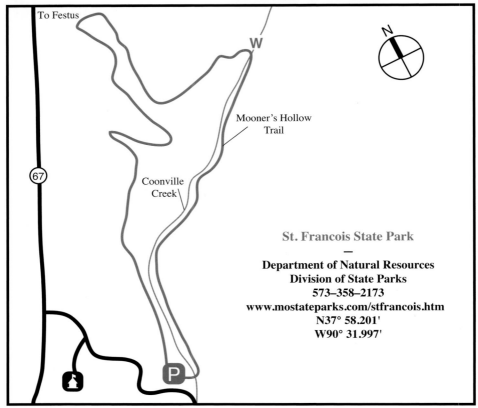

ST. FRANCOIS STATE PARK offers four trails ranging from 2.7 miles to 11 miles but I think the 2.7-mile Mooner's Hollow Trail offers such a great diversity of natural features in such a small area. It is a good introduction to the kinds of features that makes the Ozarks so special. The trail begins at the picnic area on the left after the steep descent down the park entrance road, a distance of 0.4 mile. (You have to cross the shallow creek once upstream so make sure you wear waterproof boots or ones you don't mind getting slightly wet. Do not attempt to cross if the water is running high.) Coonville Creek, dedicated as a state natural area in 1979, is a high quality Ozark stream that is fed by small springs, seeps, and wooded hillsides that filter the water as it runs into the stream. Coonville Creek is a short creek by most standards, extending only two miles upstream from here but surprisingly harbors 18 species of fish including southern redbelly dace, fantail darter, and the orangethroat darter. The diversity and types of fish indicates that water pollution is low and erosion, which is caused from soil loss is minimal. The name Coonville comes from a 1908 report about the abundance of raccoons in the vicinity. The Mooner's Hollow Trail is named after Mooner's Hollow, the deep narrow valley along Coonville Creek where moonshiners used to conceal their stills and get their water from the clear flowing creek.

The trail starts by crossing a bridge over Coonville Creek and paralleling the creek for about 1 mile. Follow the blue arrow signs nailed to the trees marking the route. Notice the moss covered boulders along the way. This area is rich in spring wildflowers and ferns. One particularly interesting fern is found growing on the boulders. Look for a long,

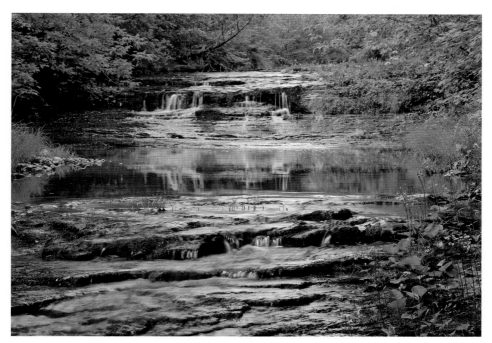

Coonville Creek, a high quality Ozark stream, caught in a languid interval between rain events.

narrow, triangular-shaped fern called walking fern. As the tip of the fern touches a suitable mossy area or small pocket of soil, it sprouts a new fern that will grow and continue the walk across the boulder. The trail offers views of the stream along the way and then ascends to a dolomite glade. This desert-like environment contains a variety of wildflowers so there is usually something blooming throughout the season. The trail then descends and continues along the creek to a stream crossing. You will have to wade across the shallow water crossing. Look upstream and notice a series of cascades and waterfalls extending 50 yards upstream. The trail turns and now parallels the creek downstream. Notice the small seeps along the way. These small wet meadows or fens harbor special plants that survived a time when the climate was cooler and glaciers once covered the northern region. Several plants such as marsh fern, certain sedges, swamp loosestrife, and swamp ragwort need the cool, permanent flow of these seep springs to exist. The trail soon winds through wooded valleys and ridges under a canopy of tall, impressive trees and crosses another dolomite glade with a nice view looking south. The trail finishes along the creek, with mossy outcroppings, boulders, and overhanging rock ledges along the hillside.

Directions: From the intersection of Hwy. 67 and I-55 in Festus, go 20 miles south on Hwy. 67 to the entrance on the east side of the highway. Or, from the intersection of Hwy. 67 and Hwy. 47 at Bonne Terre, go 4 miles north and turn right at the entrance.

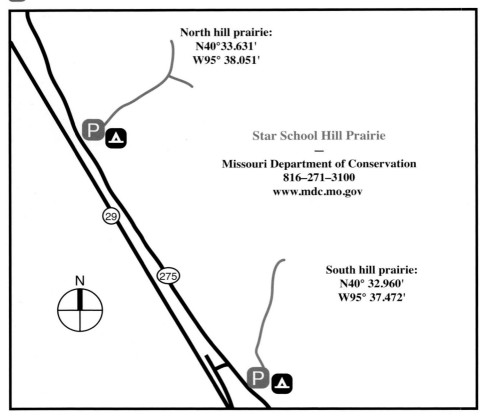

North hill prairie:
N40°33.631'
W95° 38.051'

Star School Hill Prairie
—
Missouri Department of Conservation
816–271–3100
www.mdc.mo.gov

South hill prairie:
N40° 32.960'
W95° 37.472'

N

STAR SCHOOL HILL PRAIRIE is a very rare type of prairie. That wasn't always the case. Prairies once occurred on the first line of hills along the east side of the Missouri River valley from Council Bluffs, Iowa, south all the way to Kansas City, Missouri, ending where the river took an eastward turn. Today, only about 110 acres of this prairie type remains in Missouri compared to 70,000 acres of other types of prairie left in the state. Of course, Missouri used to have 15 million acres of prairie prior to European settlement so any kind of prairie is rare and special and should be managed to ensure their existence.

Upon arrival at either hill prairie, you will immediately notice the steepness of the prairie. These mounds of pure soil were once hundreds of feet higher but have slowly declined since the end of the last Ice Age around 11,000 years ago. During that last cold period, which lasted for about 100,000 years, soil was deposited in mounds when glacial melt waters receded in the winter leaving a vast exposed floodplain. Strong westerly winds blew this fine silt called "loess" into mounds on the east side of the valley. Plants colonized the nutrient rich mounds and kept the soil from rapidly eroding away. Only specially adapted plants and animals can live on these hill prairies where rainwater drains fast, the grade is steep, and the slopes typically front hot westerly summer winds and intense solar radiation. These drought tolerant plants and animals are more commonly found living in the Great Plains, which begins over 100 miles away to the west. Plants such as blue grama grass, hairy grama grass, large beard-tongue, scarlet gaura and animals like the Great Plains skink and Plains pocket mouse are examples. Twelve plants and 2 animals of special conservation concern are protected at Star School Hill Prairie.

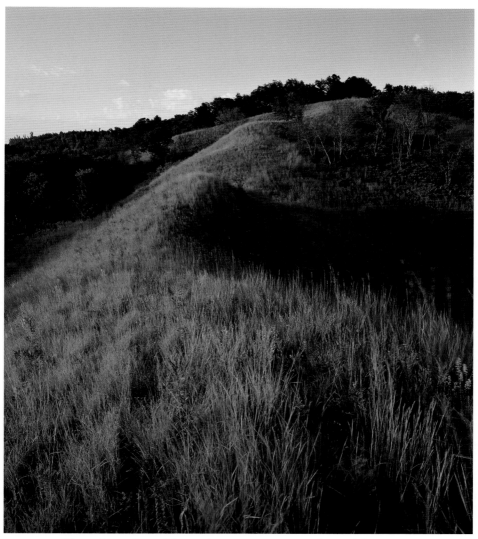

*The golden glow of the setting sun accentuates the prairie grasses
as they take on their fall color.*

The hill prairies are also state designated natural areas because of their high quality and rarity. The south unit is easily accessed from the parking lot. There is no trail so feel free to wander about. The north unit is a bit more treacherous. The slope is vertical in several places and the drop is over 30 feet. It is best to walk towards the back of the north hill along a path that reaches a saddle between two higher points on the hill prairie. Be sure to stay on the ridge and watch your footing. The view from there is spectacular. On a clear day, 4 states (Missouri, Iowa, Nebraska, and Kansas) can be seen.

Directions: At the intersection of I-29 (exit 110) and Hwy. 136 at Rock Port, go right (east) on Hwy. 136 for 1.4 miles and turn left (north) on Hwy. 275. Proceed 13 miles and turn right to go to the south unit parking area. The north unit can be reached by returning to Hwy. 275 and going north 0.9 mile and turning right to access the parking area.

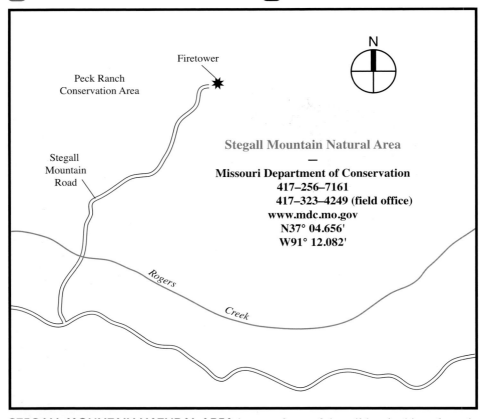

N

Firetower

Peck Ranch
Conservation Area

Stegall
Mountain
Road

Stegall Mountain Natural Area
—
Missouri Department of Conservation
417–256–7161
417–323–4249 (field office)
www.mdc.mo.gov
N37° 04.656'
W91° 12.082'

Rogers

Creek

STEGALL MOUNTAIN NATURAL AREA is part of one of the wildest looking places in the state. There are very few areas in the Ozarks where you can get up high enough for far reaching views and see unspoiled beauty but you can certainly do that here with the aid of climbing a firetower. During fire seasons, it has proven to be more economical to do airplane patrols over high risk areas. So, the majority of firetowers have been removed and of those that remain only a few offer such spectacular views. Along with the great view, you can see one of the best igneous glade and igneous woodland complexes in the Ozarks. Because of its significance, Stegall Mountain was designated as a state natural area in 1971. More was added in 1993 for a total of 3,872 acres. This includes additional high quality glades and woodlands owned by the National Park Service and The Nature Conservancy. As you look across the landscape from the firetower, one particular mountain to the northeast stands out for its size and number of igneous glades that are spread out across its slope. That is Thorny Mountain, which is owned by The Nature Conservancy.

Along the road up Stegall Mountain, there are excellent examples of igneous woodlands. These areas have a more open landscape compared to forests. An occasional prescribed fire is used to keep the understory open so that wildflowers, sedges, and grasses can flourish. You may see evidence of a recent controlled fire on one of your visits. Although it looks damaging at first, the vegetation responds quickly and excells.

After taking a view from the firetower, be sure to visit an igneous glade. The easiest to find is just to the south. Locate a huge igneous boulder near the firetower. It measures

A shortleaf pine seedling and one strand of reindeer lichen emerge from a carpet of hair cap moss on the igneous glade.

about 15 ft high and 20 ft across. Go just to the right of the boulder and walk out onto the igneous glade. Here you'll find areas of igneous rock of varying sizes with pockets of soil interspersed. Plants finding a living in this desert-like environment include little bluestem grass, Indian grass, big bluestem grass, wild hyacinth, downy phlox, lance-leaved coreopsis, and lots of lichens and mosses. In late May and June, you'll find flower-of-an-hour blooming. Also called fame flower, it waits until late afternoon, usually around 4 pm, to open its bright purple flowers. The showy flowers are only ½ inch across atop stems about 6 inches tall. Also, in early morning before the rocks get too hot, you may be lucky enough to spot a collard lizard sunning itself. The largest species of lizard in the state was reintroduced here about 30 years ago. If you continue walking across the glade going down the slope, you will come across a woods road. Turn right (west) and follow it back to the main road to where you started.

Directions: From the intersection of Hwy. 106 and Hwy. H, which is 7 miles east of Eminence, take Hwy. H south 7 miles to the Peck Ranch Conservation Area sign and turn left (east) on a gravel road for 3.6 miles, then turn left on Stegall Mountain Road. At 0.4 mile, there is a low water crossing over Rogers Creek about 15 feet wide and normally 12 to 15 inches deep. Use your own judgment here. The drive ends at a locked pipe gate, walk on the road another 800 feet to the fire tower. (Note: There are plans for a small parking area before the pipe gate and an upgrade for the low water crossing.)

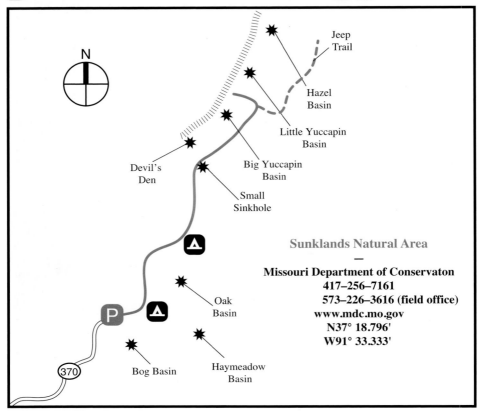

SUNKLANDS NATURAL AREA contains the largest sinkhole complex in the state. This is a region that once contained large underground caverns that were formed in Gasconade dolomite and, at some point, underwent a major collapse maybe all at once or more likely at random occurrences. Here you'll find seven large sinkholes distributed along either side of a long ridge that is the trail. The Sunklands, located on the west side of the ridge, contains the longest sinkhole in the state at over 0.5 mile. Within, you'll find four basins of varying sizes and compositions. They are accessed by going down a steep slope along an old road. It is not too bad if you take your time and watch your footing especially on the way down the hill.

As you begin your journey, immediately east of the parking area, notice the steep slope; that is Bog Basin, it is 25 acres in size with a small wetland at the bottom. There are no trails down to this one. Continuing on the trail you'll see a primitive camping area on the right. From this point to the next primitive camping site all of the area on the east side of the trail is a 35-acre sinkhole called Oak Basin. It is almost completely forested. To the east of Oak Basin and not seen from the trail is Haymeadow Basin. At 45 acres in size it is the largest of the seven sinkhole basins and was once used for farming, hence the name. About 0.25 miles past the second camping area, note the small sinkhole along the east side of the trail. It is a dry sinkhole and measure about 70 feet across and about 25 feet deep. Opposite this sinkhole, there is a great view of the Sunklands, whose expanse from ridge to ridge is 0.25 miles and at a depth of 180 feet, is better appreciated when there are no leaves on the trees. Continuing on the trail another 0.25 miles, look

Buttonbush (left) and downy skullcap (right)

for a rather steep path down the slope on the left just before the trail starts to bend to the right. This old road down the slope is the access to the four sinkholes in the Sunklands. As you get towards the bottom, notice a trail to the right. That goes first to Little Yuccapin Basin, which contains a one acre shrub swamp dominated with buttonbush. Beyond this sinkhole is a steep slope up and over into Hazel Basin, a 6-acre sinkhole with a meadow in the center. I think this is the least interesting of the four sinkholes in the Sunklands plus having to hike up and over a steep ridge to get to it. The other two sinkholes can be reached by heading south. The first is the longest at 0.25 miles and is called Big Yuccapin Basin. The marsh contains a variety of aquatic plants including buttonbush, rose mallow hibiscus, lotus and a variety of sedges and grasses. Continuing south, you'll encounter the last sinkhole called Devil's Den, which is a dry sink about 2 acres in size. Return the same way you came in and feel good about having explored the largest karst complex in the state and one of the wildest destinations offered in this book.

Directions: At the intersection of Hwy. 17 and Hwy. 106 on the west side of Summerville, take Hwy. 17 north for 0.7 mile and turn right (north) on Hwy. K; proceed 9.5 miles (passing a Sunklands Conservation Area entrance on the left at 9.1 miles); pass that and turn right (east) on CR KB. Go 0.7 mile to where the road splits, bear left on CR 360 and go 2 miles to another split then turn left on CR 370; proceed 2.4 miles to a parking area on the left. Notice two woods roads; take the one to the right.

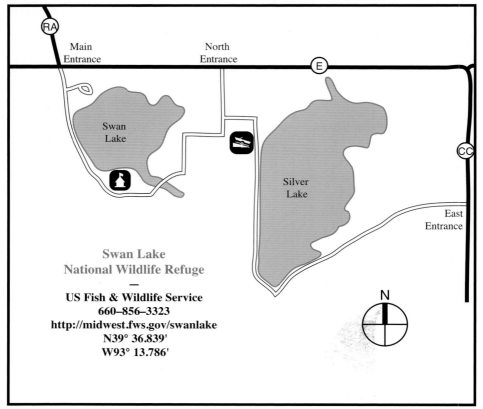

Swan Lake
National Wildlife Refuge
—
US Fish & Wildlife Service
660–856–3323
http://midwest.fws.gov/swanlake
N39° 36.839'
W93° 13.786'

N

SWAN LAKE NATIONAL WILDLIFE REFUGE provides a great opportunity to view large numbers of waterfowl and eagles from fall into spring. The refuge is 10,795 acres in size and was purchased in 1937, for the purpose of providing nesting, resting, and feeding areas for waterfowl. In terms of total waterfowl numbers for state or federally managed wetlands in Missouri, it is probably second only to Squaw Creek National Wildlife Refuge.

The interior roads of the refuge are closed from October 15 to March 1 but during that period, you can still view waterfowl along the drive to the visitor center which skirts the west edge of Swan Lake and by taking the nature trail from the visitor center to the south side of Swan Lake. During late fall and again in late winter, Swan Lake National Wildlife Refuge hosts around 100,000 Canada geese, 200,000 snow geese, 100-200 bald eagles, and a wide variety of ducks, white pelicans, and double-crested cormorants. (At times, when the lakes freeze over, expect those numbers to decline as the birds move further south.) In addition, the fall and spring migrations bring in at least 31 different kinds of shorebirds and numerous songbirds. A bird checklist, available at the visitor center lists 241 species of birds that have been recorded on the refuge. You can also get a checklist here: www.mobirds.org/CACHE/mdcchecklists1.asp?locID=249 . Be sure to drive the interior roads, which are open from March 1 to October 15. There is a long drive along Silver Lake that provides good wildlife viewing opportunities. The road eventually leads to the refuge's east entrance.

Directions: At the intersection of Hwy. 36 and Hwy. 139, which is 5 miles west of

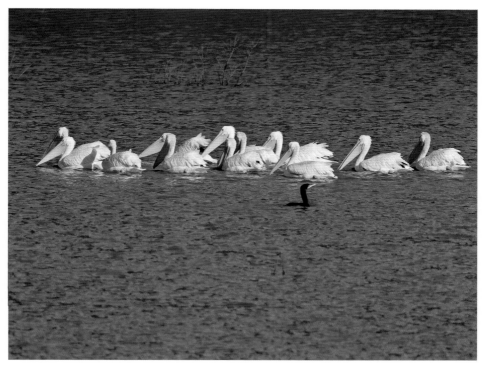

A lone double-crested cormorant watches a group of American white pelicans just before they simultaneous dip their heads into the water to catch unsuspecting fish.

Brookfield, take Hwy. 139 south 12 miles and turn left (south) on Hwy. RA, go 1 mile to the entrance of the refuge. If you continue on Hwy. 139 into Sumner be sure to visit the "World's Largest Goose" at the community park. It has a height of 40 feet, wing span of 61 feet and weighs 3 tons and supposedly rotates according to wind direction. Now, that's a goose!

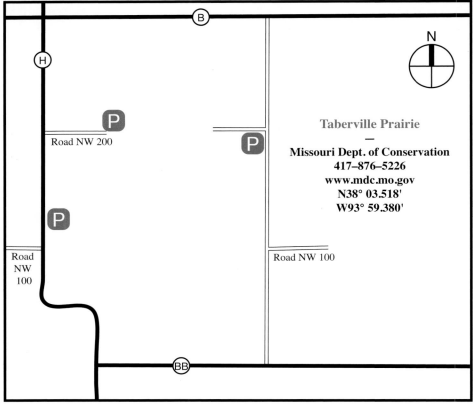

TABERVILLE PRAIRIE offers one of the most picturesque views of any prairie in the state. My favorite view is looking south from a ridge on the north end. There before you lies a large valley with 1,410 acres of pure prairie. There is little on the horizon to remind you that you are living in the present. Taberville Prairie is the first public prairie in Missouri. Purchased in 1959 with an addition in 1961, the acquisition goal for the 1,680-acre area was to provide habitat for a statewide decline of the greater prairie-chicken. Once numbering in the hundreds of thousands before European settlement, the population had diminished to around 8,000 statewide by 1959. Unfortunately, the greater prairie-chicken numbers have continued to dwindle with current estimates below 500 birds. Reintroduction efforts and the application of certain management strategies are underway to help strengthen the numbers of this prairie icon.

Taberville Prairie was designated a state natural area in 1971. It also has the distinction of being a Registered National Natural Landmark. Beginning in 2010, a mowed trail will be established leading from the northeast parking area to the National Natural Landmark monument and a view of the scenic prairie valley then it will loop back to the parking area. In succeeding years, the mowed trail will begin at the northwest parking lot, lead to a view of the prairie valley, travel into the valley and return by way of the National Natural Landmark monument to the beginning of the trail. This should make for a great trail! With over 400 species of plants recorded from this prairie, there is always something in bloom from April through October. The prairie is primarily dry-mesic with pockets of mesic prairie along the stream. Small sandstone glades and rock outcroppings

A commanding view of one of the state's largest prairies accentuated by the autumn color of sumac and a weathered sandstone outrcrop.

are interesting additions to the landscape. This prairie is popular with birders. In the spring and fall, warblers can be found along the prairie headwater stream. There are also a wide variety of nesting birds including Henslow's sparrows, upland sandpiper, scissor-tailed flycatcher, northern harrier, and greater prairie-chicken. Short-eared owls often make Taberville Prairie their winter home.

Directions: One mile north of El Dorado Springs, at the intersection of Hwy. 82 and Hwy. H go north about 11 miles to the parking area on the right (east) side of the road. To access the prairie from the northwest, proceed past the parking lot and go north another 0.8 mile; turn right on County Road NW200 and go 0.6 mile to the parking area. Access from the north begins at the intersection Hwy. B and Hwy. H, go south on Hwy. H 1 mile to County Road NW200 and turn left (east), then go 0.6 mile to the parking area. (Note: Parts of Taberville Prairie are being grazed with cattle as an experiment to see if plants, wildlife, and livestock can live together simultaneously. Results of this study may benefit ranchers in better managing their grasslands.)

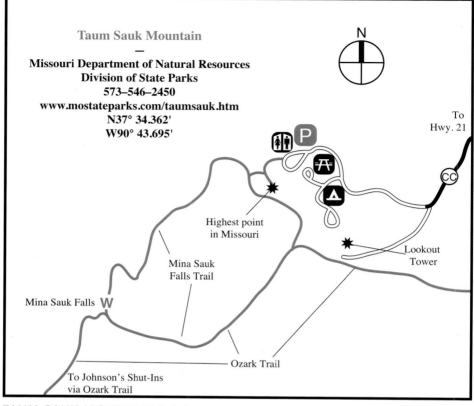

Taum Sauk Mountain
—
Missouri Department of Natural Resources
Division of State Parks
573–546–2450
www.mostateparks.com/taumsauk.htm
N37° 34.362'
W90° 43.695'

To
Hwy. 21

Highest point
in Missouri

Mina Sauk
Falls Trail

Mina Sauk Falls W

Lookout
Tower

Ozark Trail

To Johnson's Shut-Ins
via Ozark Trail

TAUM SAUK MOUNTAIN is Missouri's highest point at 1,772 feet above sea level. Although the peak is relatively flat and wooded, there are several places along the rim of the mountain where the views are far ranging and some of the best in the state. A 3-mile hiking trail takes you through oak/hickory woodlands, igneous glades, and offers spectacular scenic views, impressive geologic formations, the tallest waterfall in the state, and a pristine headwater stream.

Taum Sauk Mountain is part of a cluster of volcano remnants that were formed over 2 billion years ago. Once 6,000 feet taller, these volcanoes exploded and subsequently collapsed forming a basin or caldera. That collapse and subsequent erosion are the remains of what you see today. Because this area is so unique, it was designated as a state natural area in 1996. The 7,028-acre St. Francois Mountains Natural Area includes all of Taum Sauk Mountain State Park, Proffit Mountain Conservation Area to the west, and 80 acres of Johnson's Shut-Ins State Park (see p. 90). It is the largest natural area in the state, selected for its high quality igneous glades and woodlands, its geologic features, and an Ozark headwater stream, Taum Sauk Creek, which was also recognized as an Outstanding State Resource Water.

The 3-mile loop trail begins just after the spur to the highest point in the state. The trail is not wheelchair accessible beyond the spur. You'll find the route marked by red arrow signs, tree blazes, and rock cairns across the open glades. The views from the igneous glades are one of the highlights of the hike. From the first opening, you'll be looking at the deepest valley in the state, a drop of 811 feet. The halfway point takes you to Mina

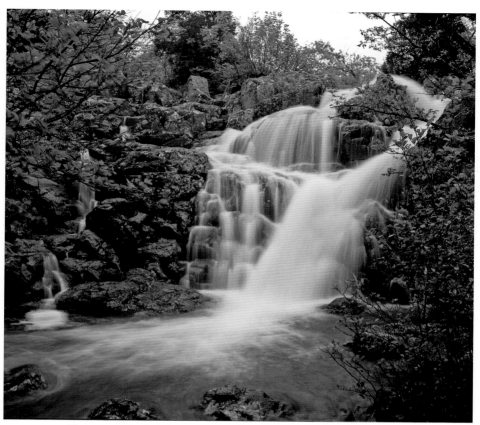

Heavy rains can transform Mina Sauk Falls into a roaring titan.

Sauk Falls, which is both the longest and the highest waterfall in Missouri. It plunges a total of 132 feet in cascades, with the main cascade falling a distance of 105 feet. The wet-weather waterfall's flow depends on how much rain accumulates in the small watershed that feeds it. During springtime and after a heavy summer downpour are the best times to see Mina Sauk Falls in action. Just before Mina Sauk Falls, the Ozark Trail branches off and in one mile passes through Devil's Toll Gate. This is an 8-foot wide gap in a 50-foot-long, 30-foot-high ridge of orange and red igneous rock. The gap probably began as a vertical rock fracture that was enlarged by weathering. Notice that this is a 1 mile downhill and 1 mile return trip if you care to take it. You can get to the base of the waterfalls by heading down the Ozark Trail to where it meets the creek. (Note: on the return trip to the summit after the waterfalls, some prefer the same route back through the glades rather than the walk through the woods.)

Directions: At the intersection of Hwy. 72 and Hwy. 21 on the south side of Ironton, proceed 5 miles south on Hwy. 21 and turn right (west) on Hwy. CC for 3 miles to the parking area. (Note: The top of the mountain is fairly flat and covered with trees so don't expect to get a panoramic view from there. But you can get one by climbing the firetower maintained by the Missouri Department of Conservation. You can reach it by staying left as the paved road ends instead of turning right to the state park.)

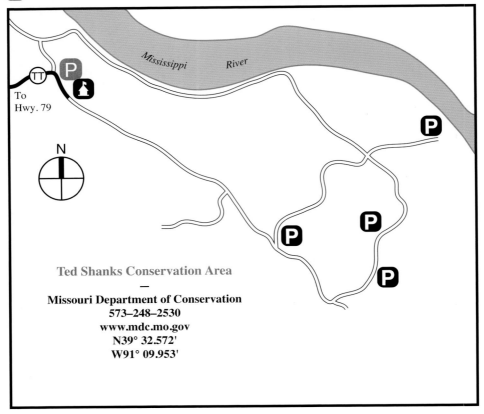

Ted Shanks Conservation Area

—

Missouri Department of Conservation
573–248–2530
www.mdc.mo.gov
N39° 32.572'
W91° 09.953'

TED SHANKS CONSERVATION AREA, with its 14 miles of interior roads, provides excellent viewing opportunities for wildlife found in a diversity of habitats such as open marsh, shrub wetlands, oxbow lakes and sloughs, and bottomland and upland forest. Located along the Mississippi Flyway, the area is a popular layover for migratory waterfowl and songbirds during their spring and fall migration. There is also a wide assortment of nesting birds including bald eagle, king rail, pied-billed grebe, least and American bittern, American coot, wood duck, little blue heron, and hooded merganser. In the summer, watch for Mississippi kite and fish crow, two southern species that travel up the Mississippi River and nest as far north as here. A checklist for area birds can be found here: http://www.mobirds.org/CACHE/mdcchecklists1.asp?locID=767. Also watch for such mammals as beaver, muskrat, otter, mink, weasel, and white-tailed deer.

Ted Shanks Conservation Area is huge at 3,827 acres with another 2,878 acres managed under a cooperative agreement with the US Fish and Wildlife Service and the US Army Corps of Engineers for a total of 6,705 acres. Along with the extensive Mississippi River bottoms, there is also an extensive upland. In the fall, the view of the hills from the wetlands is striking with the bright reds from sugar maple, the yellows from hickory, and the purple from the oaks. This landscape is part of the Lincoln Hills, a distinct geologic feature where the bedrock buckled into a series of hills hundreds of millions years ago. This range, from Hannibal south to beyond Louisiana, MO, is about 60 miles long and 15 miles wide. Unaffected by glaciers, its rugged nature remains intact. This stretch of Hwy. 79 is a designated state scenic byway and is especially popular as a fall color destination.

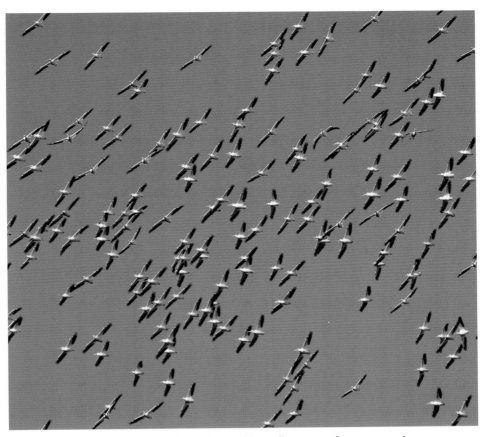

Impressive flocks of American white pelicans can be seen passing over the area during fall migration.

There are several scenic turnouts in the hills just north of Ted Shanks Conservation Area but the one that offers the best view is located 1.7 miles north of the junction of Hwy. 79 and Hwy. TT. Here lies before you a side channel of the Mississippi River called Gilbert Chute with Gilbert Island just beyond that and, on the horizon, the Illinois hills, a distance of 8.5 miles.

Directions: At the intersection of Hwy. 79 and Hwy. TT, which is 14 miles north of Louisiana, take Hwy. TT 1.2 miles to arrive at the entrance to Ted Shank Conservation Area. In another 0.4 mile stop at the headquarters and pick up an area brochure and map. (Note: The interior roads are closed for waterfowl hunting season from October 15 to typically the end of December.)

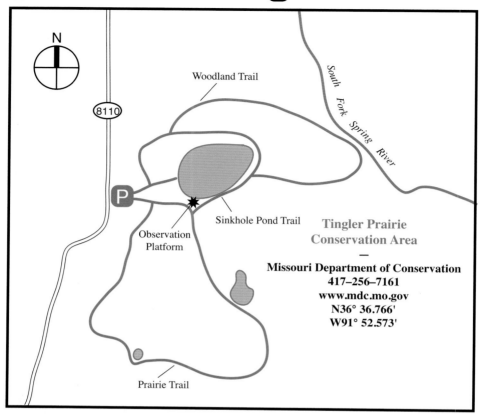

Woodland Trail

South Fork Spring River

8110

P

Sinkhole Pond Trail

Observation
Platform

**Tingler Prairie
Conservation Area**
—
**Missouri Department of Conservation
417–256–7161
www.mdc.mo.gov
N36° 36.766'
W91° 52.573'**

Prairie Trail

TINGLER PRAIRIE CONSERVATION AREA contains one of the rarest types of prairie remaining in Missouri, a wet-mesic prairie. Once located in low, slowly drained parts of prairies, most were ditched and often plowed. Here you will find 20 acres of good quality wet-mesic prairie surrounded by a restored grassland landscape. A trail follows the edge of the wet-mesic prairie and affords good views of the various forbs (wildflowers) that bloom from late spring through fall. The grassland that you see was once 90 acres of upland prairie that was converted to fescue for cattle grazing. Upon acquiring the property, Missouri Department of Conservation staff systematically converted the fescue to native prairie grasses and forbs. The dominant grasses are Indian grass and big bluestem grass. The 1-mile Prairie Trail takes you through the restored prairie and around the wet-mesic prairie.

Another trail, the 0.5-mile Sinkhole Pond Trail, circles a 3-acre sinkhole pond and, at one point, leads to a platform overlooking the pond. The water in the pond is too shallow for fish but turtles, frogs, and dragonflies find it quite suitable. Also, along the edge you'll find buttonbush, pickerel weed, beggar's ticks, and a variety of sedges.

The Woodland Trail is a 0.5-mile loop trail that is attached to the Sinkhole Pond Trail where it winds through upland and bottomland forest and along the South Fork of the Spring River. Notice on the upper part of the hills the rocky surface strewn with dolomite and chert rocks. Here you will find trees that tolerate drier conditions including black jack oak, post oak, and black hickory and an understory of flowering dogwood, redbud, and eastern redcedar. Where the trail levels out along the South Fork of the Spring River,

*Tall goldenrod stands against a backdrop of Indian grass
and big bluestem grass as autumn comes over the prairie.*

you'll find a bottomland forest with white oak, red oak, and sycamore trees towering over flowering dogwood, musclewood, hazelnut, and buckbrush.

Directions: At the intersection of Hwy. 63 and Hwy. 17, on the south side of West Plains, take Hwy. 17 south for 6 miles and turn right (west) on County Road 9100. Go 0.7 mile and turn left (south) on County Road 8110 and proceed 1.3 miles to the parking lot on the left (east).

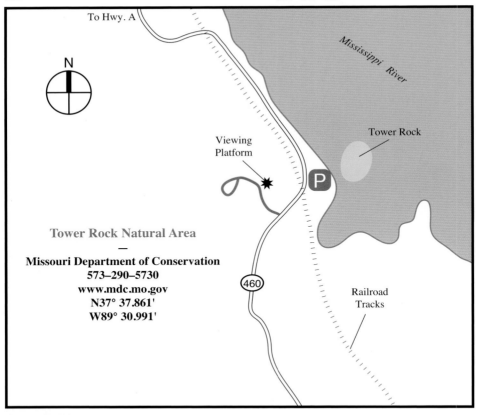

TOWER ROCK NATURAL AREA is one of my favorite places to visit in Missouri. This prominent rock outcrop has been a major landmark along the Mississippi River for as long as humans have navigated its waters. Early explorers Father Marquette along with fur trader Joliet, while navigating the river in 1673 by canoe, made note of the island in his journal. He mentions a "Place that is dreaded by savages, because they believe that a Manitou is there, that is to say, a demon that devours travelers." To protect themselves from the demons hiding at its base, Father Marquette and Joliet, erected a cross on top of Tower Rock. La Salle made note of the island while passing by in 1682 and Lewis and Clark camped just upstream of it on the mainland on November 25-26, 1803. Lewis was rowed over to the north end of the island and took measurements from on top. There was another island just a few hundred feet downstream from Tower Rock but it was quarried away in the mid-1800s. When word got out that Tower Rock was next in line, local residents became alarmed along with General Ulysses S. Grant, who was familiar with the island, having traveled by it several times during the Civil War. In 1871, President Grant, when he got word that it was going to be blasted away, issued a presidential decree to save it for public use. The island was transferred to the Missouri Department of Conservation in the 1990s.

Today, Tower Rock is a dedicated Missouri natural area. This includes a forested tract along the mainland, which was donated by Mr. and Mrs. Charles Bussen for a total of 33 acres. If you walk or drive the road that leads across the railroad tracks and into the rich woods, there is a pull-off area on the right. From there, a trail heads up the hill to a

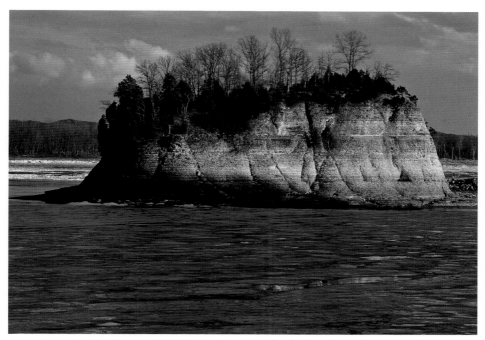

*A reflecting pool highlights the warmth of winter's setting sun on
one of the most notable landmarks along the Mississippi River.*

viewing platform that overlooks Tower Rock, the Mississippi River, and Illinois on the far side. The island is reached by boat but during major dry spells, the shallow, narrow channel on the west side stops flowing, exposing bedrock that allows for easy access to the island. Having been on the island myself, the only way up is from the upstream or north side. A few years ago, I was standing downstream on the island that had been quarried away. A fisherman brought his boat within shouting distance and asked if I would like a ride over to Tower Rock. When I got onboard, he steered the boat around the east side of the island and, with his depth finder, showed me that the reading in the main channel was 130 feet deep! The main channel is typically maintained at a depth of 10 to 20 feet deep along the Mississippi River for navigation purposes. I can only think that the swirling action caused by the mighty Mississippi hitting that prominent island scoured out such a hole that is very likely the deepest part of the river along its entire length before it empties into the Gulf of Mexico.

Directions: Located between Perryville and Cape Girardeau, at the intersection of I-55 (exit 177) and Hwy. KK, take Hwy. KK east 3 miles and turn left (north) on Hwy. 61, go 2 miles and turn right (east) on Hwy. A, proceed 12.5 miles to County Road 460, turn right (south) and go 1.5 miles to the parking area on the left side of the road. (Caution: be very careful crossing the railroad tracks near the parking area and again on the way to the overlook.)

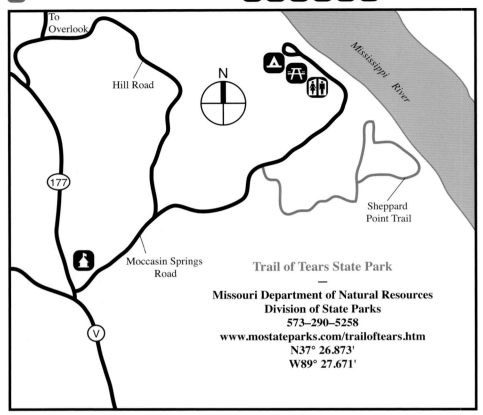

Trail of Tears State Park
—
Missouri Department of Natural Resources
Division of State Parks
573–290–5258
www.mostateparks.com/trailoftears.htm
N37° 26.873'
W89° 27.671'

TRAIL OF TEARS STATE PARK offers a combination of exceptional views, tall trees, luxurious vegetation, and dramatic topography that is unmatched in the state. The park also has a sad story to interpret being named for the 13,000 Cherokee Indians who were forced to march from their homeland in the southeastern United States to a reservation in Oklahoma during the winter of 1838-1839. One of the groups that crossed the Mississippi River did so here, where the park now stands. Visit the visitor center to learn more about this regrettable chapter in America's history.

Also at the visitors center there are exhibits highlighting the unique features of the park. This part of the state typically receives more rainfall, which together with the rich loess soils produces dense, vigorous vegetation. This is especially pronounced in the height and density of the forests. Here tall keen trees emerge out of the deep ravines and north slopes that are more similar in appearance to the cove forests of the Appalachian Mountains. A reminder of this is the presence of American beech, tulip poplar, and cucumber magnolia which are on the northwestern edge of their range and barely enter the state. Deep forested ravines in the Boston Mountains of Arkansas also share these eastern trees but there they lack the size and vigor because of less rainfall and poorer soil.

Of the several trail systems in the park, the 3.0-mile Sheppard Point Trail provides a good example of why this part of the state is so special. It is a rugged trail in parts but if you take your time, it is doable. Because of a recent landslide, the trailhead was moved to Greens Ferry Shelter which added another mile to the hike. This is good because you get to see more of the ravine forests and ridge tops that add to the overall experience.

A late October drive along Hill Road offers an artist's palette of colors.

Along the trail, when you get to the loop that goes up and down Sheppard Point, I would suggest going right or counterclockwise on the trail. It is a little less strenuous. I find that the hike through the primeval looking forest is actually more interesting than reaching the actual summit. Along the way, you'll see a variety of wildflowers and ferns but be careful on the ridges because they tend to favor poison ivy. There are two small creek crossings that add diversity to the hike, and, as you hike up the south slope of Sheppard Point notice the limestone outcrops and chert pebbles. The environment is drier here and you'll see thinner soil, smaller trees, and lichens and mosses that indicate you've gone from a mesic upland forest to a dry upland forest. As you make it to the top of Sheppard Point, there are three small openings where you get to look out and across the river valley to the Illinois bluffs 4.5 miles away. The setting is peaceful and a good place to relax and enjoy the 0.5-mile river span 170 ft below you. The ledge rock that affords this view is Devonian limestone that is also responsible for the rock outcrop known as Tower Rock Natural Area (p. 188).

For a much larger view of the Mississippi River and its valley, be sure to follow the signs to the Scenic Overlook. I think it's the best view on public land of the mighty Mississippi River in the state.

Directions: North of Cape Girardeau at the I-55 (exit 105) and Hwy. 61, go east 1 mile on Hwy. 61 to Hwy. 177; proceed 11.5 miles on Hwy. 177 to the park entrance. The visitor center is at 0.3 mile and another 0.9 mile to the Greens Ferry Shelter, which is the trailhead for the Sheppard Point Trail. The park is open from 7 am to 10 pm.

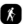
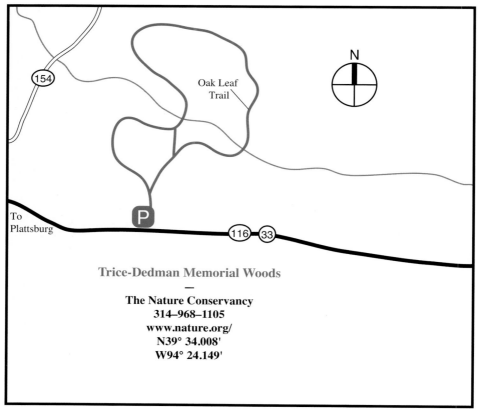

Trice-Dedman Memorial Woods

—

The Nature Conservancy
314–968–1105
www.nature.org/
N39° 34.008'
W94° 24.149'

TRICE-DEDMAN MEMORIAL WOODS takes you back in time when old growth woodland meandered through the prairie landscape all across northern Missouri. This is where wildfires, started by lightning but more often by Native American Indians, burned through the prairies and into the woods. This kept the woodlands open with scattered trees and a spacious understory that made travel simpler and game easier to find. With the advent of settlement, large old trees were cut, fires were suppressed and the woodlands closed into a forest setting. Thanks to The Nature Conservancy and the staff from nearby Wallace State Park, you have an opportunity to experience what an earlier traveler would have encountered a few hundred years ago.

The first part of the Oak Leaf Trail takes you through an area of forest. Notice the grove of pawpaw trees about 200 feet down the trail. In the spring, you can find an array of wildflowers blooming such as Dutchman's breeches, white dogtooth violet, spring beauty, violets, horse gentian, yellow honeysuckle, green dragon, and three species of orchids. Further down the trail, a crossover loop shortens the trail back to the parking area by 0.5 mile. If you take that route, you'll miss the woodland. The main trail soon crosses a wooden bridge. This area is being invaded by garlic mustard, a weed from Europe that is rapidly spreading through moist, wooded areas throughout the Midwest. Efforts are underway to eradicate this biennial plant by hand pulling, prescribed fire, and herbicide. The first year produces a single heart-shaped leaf that overwinters. The leaves when crushed have the odor of garlic so it is easy to identify. The second year, it produces a 3-foot stalk with alternate, coarsely toothed leaves along the stem. The small,

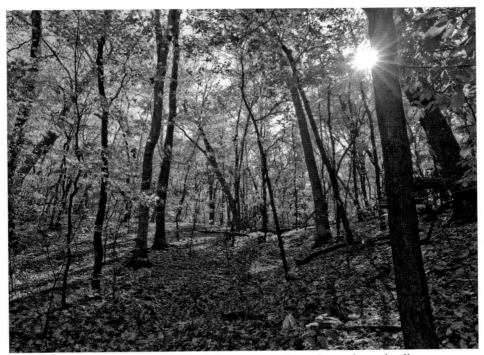

*Autumn turns green leaves into an array of purples, reds, and yellows
along the Oak Leaf Trail.*

4-petaled white flowers change into long narrow pods that produce numerous tiny seeds that easily spread by adhering to the fur of passing white-tailed deer. I don't think that the managers would mind if you take the opportunity to pull up some of these invasive plants. As the trail turns west, you will soon see a fireline extending south through the trees with forest on the left (east) and woodland on the right (west). Notice the difference in the character of the trees and the understory. This is what occasional prescribed burning has done to restore the woodland to some semblance of its past natural quality. You will also see less slippery elm and black maple here due to their thinner bark and greater sensitivity to fire. Woodland plants such as yellow pimpernel, purple milkweed, tickseed coreopsis, Michigan lily and Culver's root are now rare here and don't flower much but they may become more common with continued management. The trail soon crosses the little unnamed tributary to Grindstone Creek and again enters the forest on its route back to the parking area.

Directions: From the intersection of Hwy. 116 and Hwy. C at Plattsburg, go 3 miles east and park in the small pull-off on the left (north) side of the road.

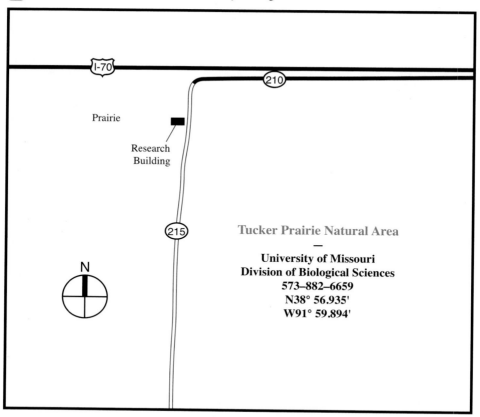

Prairie

Research
Building

210

215

N

Tucker Prairie Natural Area
—
**University of Missouri
Division of Biological Sciences
573–882–6659
N38° 56.935'
W91° 59.894'**

TUCKER PRAIRIE NATURAL AREA is the last native prairie occurring in a region that was known as the Grand Prairie. This is an area beginning in St. Charles County, extending west to northern Boone County, and north through Shelby County. The land is very flat and was referenced by earlier travelers as a "plains of high grass." Take Hwy. 50 north from Kingdom City to Bowling Green and you will see how flat the landscape looks even today. Audrain County was considered the center of the Grand Prairie with 75% of the county in prairie "often growing high enough…to completely hide horses and cattle which were feeding on it" (Gottfried Duden 1829).

Tucker Prairie also has the distinction, along with Wah-Sha-She Prairie Natural Area (p. 206), of being a hardpan prairie, one of the rarest prairie types in the Tallgrass Prairie Region, an area that covers parts of 13 states. Tucker Prairie was staked out from the Public Domain around 1819 by a pioneer settler of the Tucker family from nearby Fulton, MO. The Tucker family went on to use the grassland for haying and cattle grazing for 125 years until it was acquired by the University of Missouri with assistance from other sources in 1957. Since then, it has been used as a research station by university faculty and students. The prairie was once 160 acres in size but the creation of I-70 along the north side took 14 acres. There is a brochure box at the welcome sign that contains a checklist of the plants found on the prairie and a trail brochure that explains the history of the area and the different types of management practiced in order to maintain the prairie.

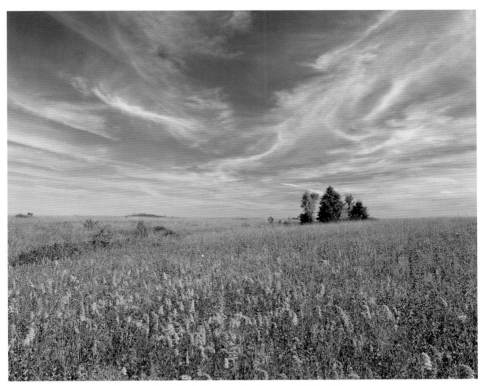

Cirrus clouds drift over the last prairie of its type.

As you walk the prairie, the constant sounds emanating from the I-70 traffic are soon ignored as the various kinds of plants and animals encountered begin to draw your attention. It is fortunate that we are able to set foot on the very last remnant of the Grand Prairie.

Directions: At the intersection of I-70 (exit 148) and Hwy. 54 at Kingdom City, go south on Hwy. 54 0.9 mile and turn right (west) and then left (south) on County Road 220, then go 0.7 mile and turn right (north); proceed 1.3 miles on County Road 210 that turns left (west) on a frontage road, go 1.6 miles, then turn left (south) and go 0.2 mile on County Road 215, pull along the side to access the prairie to the west.

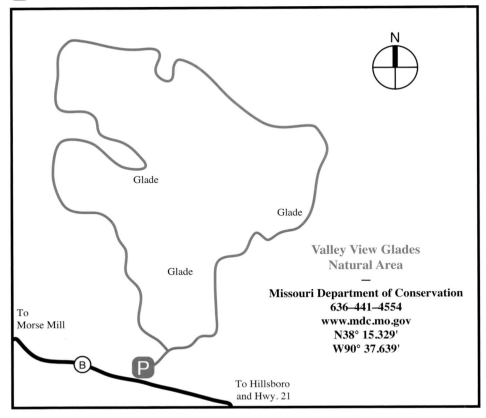

Glade

Glade

Glade

**Valley View Glades
Natural Area**
—
**Missouri Department of Conservation
636–441–4554
www.mdc.mo.gov
N38° 15.329'
W90° 37.639'**

To
Morse Mill

B P

To Hillsboro
and Hwy. 21

VALLEY VIEW GLADES NATURAL AREA is a special gem tucked away in the hills bordering the Big River to the west. Here you will be guided by a 2.5-mile trail that weaves through the 225-acre natural area. Along the way, you will see scenic dolomite glades, showy wildflowers, interesting rock ledges and overhangs, and waterfalls, some up to 6 feet that flow during and after rains. There are about 100 acres of glades here and that is the primary reason this area was acquired then designated a state natural area in 1982. With Jefferson County continuing to undergo development, many of these special types of areas are being converted into residential areas. Fortunately, this glade complex along with Victoria Glades (see p. 198) have been protected for future generations to enjoy.

The trail begins at the northeast corner of the parking lot. Grab an area brochure at the trailhead information sign. A short descent down a wooded slope opens to a spectacular view of a valley carpeted with glades and wooded creeks, hence the name. Take the trail to the left going clockwise around the area. As you walk through the glade, notice the patchwork of rocks, bare ground, clumps of grass and the variety of wildflowers that begin to bloom as early as April. (Unfortunately, many of the rocks have been flipped by vandals looking for scorpions and tarantulas to use as pets or for the commercial trade. This type of activity is not allowed and subject to a fine.) The trail soon enters a patch of woods and drops into a hollow with interesting rock formations including ledges with wet-weather waterfalls. As the trail ascends a hill, avoid taking the shortcuts through the woods to reconnect to the trail. Stay on the main trail and you will be rewarded by stepping out onto the largest glade and a sweeping view of the valley. The trail leaves the

Glade coneflowers highlight one of the largest dolomite glade complexes in the state.

glade and drops into another valley with impressive rock formations and another water-fall. The trail soon connects with an old road. Shortly down the road, look for the trail, which leads to the right and down the hill. This loop goes to a glade opening that offers another great view of the glade-filled valley. The loop reconnects with the old road and goes another .25 mile, where the trail turns right, leaving the old road bed and heading south down the hill. The last trail section crosses more glades and ends back at the start. Congratulations, you have just explored one of the finest glade systems in the state.

Directions: At the intersection of Business Hwy. 21 and Hwy. B, just south of Hillsboro, take Hwy. B for 4.6 miles and turn right (north) at the parking area.

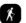
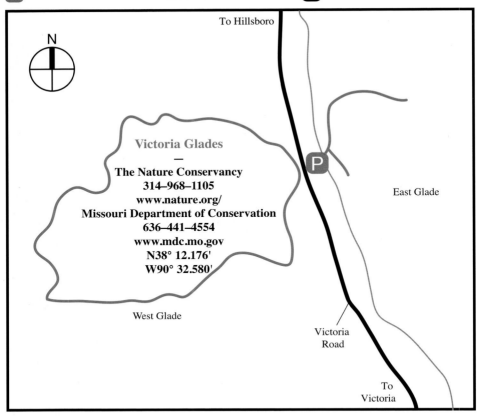

VICTORIA GLADES is actually two glade systems separated by a valley and a road that provides easy access to both areas. Imagine having an opportunity to visit two high quality dolomite glade complexes just half an hour from downtown St. Louis. The glades, named for a community 1.7 miles south, are in joint ownership with the east side of the road under the stewardship of The Nature Conservancy while the west side of the road is owned by the Missouri Department of Conservation, who also built the parking lot. This glade system is part of a band of glades, 2 to 5 miles wide, beginning west of here near the Big River (see Valley View Glades Natural Area, p. 196) and heading east through Hillsboro and Desoto almost to Festus, then turning south where the outcrop ends a few miles into Ste. Genevieve County. Most of these glades are under threat these days from rapidly developing Jefferson County and its urban sprawl. Fortunately, we have two examples of these glade complexes (Valley View Glades Natural Area and Victoria Glades) protected for their intrinsic value and for future generations to enjoy.

From the parking area, the east glade is reached by following the old road east as it climbs the north end of the glade. From there, just wander freely across the glade. If you look to the west, across the valley, you'll clearly see Victoria Glades West. The glades are desert-like in appearance and are subjected to high temperatures and extreme drought during the summer. Here you will find plants and animals that have adapted to these harsh conditions. Beginning in April and running through October, you'll find over 200 species of flowering plants including Indian paintbrush (both red and yellow forms), blue wild indigo, American aloe, blazing star, yellow star grass, Missouri primrose, Missouri cone-

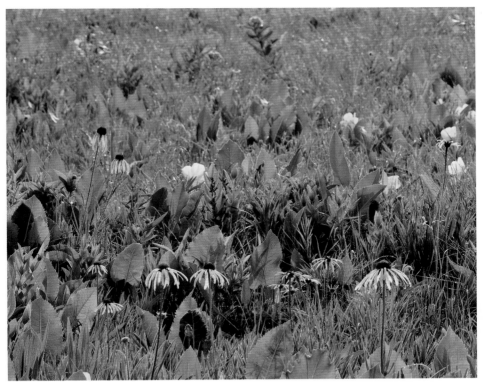

A rich array of glade plants including glade coneflower, Missouri primrose and the large leaves of prairie dock can be seen notably at Victoria Glades East.

flower, glade coneflower, Fremont's leather flower and others. (The latter has an unusual distribution, being found only on dolomite glades in Jefferson County, Missouri, and in a small area along the Kansas-Nebraska border.) And, making their home under the rocks, you'll find animals such as the collared lizard, plains scorpion, tarantula, black widow spider, six-lined racerunner, and northern fence lizard. Unfortunately, these glades are visited by vandals that flip the rocks looking for animals that use them for shelter. This practice is not allowed and is subject to a fine. Not only does it destroy their home, it also damages the natural character of the glade.

Victoria Glades West is reached by crossing the road and hiking up a path through a narrow patch of woods. Again, you can wander around on the glade or take a hiking trail that heads to the right up the hill and into the woods. The 2.3-mile trail essentially leads you around the perimeter of the area through more glades on the west side and then back to the start.

Directions: At the intersection of Business Hwy. 21 and Main Street in Hillsboro, take Main Street east 0.1 mile to Vreeland Drive, turn right (south) and go 0.9 mile to a 4-way stop, continue south and the road becomes Victoria Road, go 1.4 miles and turn left (east) into the parking area.

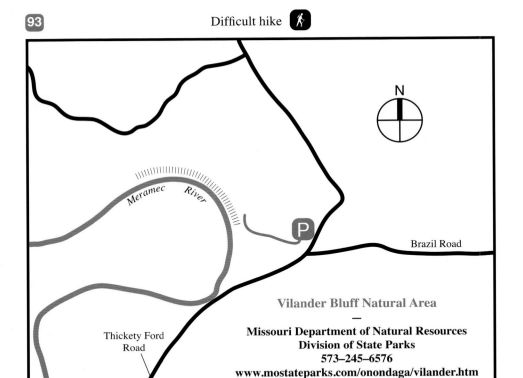

N

Meramec River

P

Brazil Road

Vilander Bluff Natural Area
—
Missouri Department of Natural Resources
Division of State Parks
573–245–6576
www.mostateparks.com/onondaga/vilander.htm
N38° 05.830'
W91° 07.890'

Thickety Ford
Road

To Hwy. N

VILANDER BLUFF NATURAL AREA offers a spectacular view of the Meramec River and the surrounding landscape. The main feature is a massive cliff, almost a mile in length, rising 280 feet above the river. Classified as a high quality dry dolomite cliff, Vilander Bluff was designated as a state natural area in 1994. This is one of the more difficult areas to hike and most views of the massive cliff come while floating down the Meramec River in a canoe. But, you can explore along the rim of the massive cliff on your own and experience some amazing scenery.

The cliff is composed of Gasconade dolomite, which is quite porous in nature and one of the main producers of caves in the state. Why, just along this expanse of cliff, nine caves have been reported. The cliff also provides habitat for a variety of lichens that live along the dry surface. This undisturbed cliff face hosts at least 70 species of lichens with one being new to science. Along the rim of the cliff, you'll find stunted, twisted eastern red cedar trees hanging perilously close to the edge. The thin soil and heat from the western exposure contribute to the cedars' slow growth. At least 70 of the eastern red cedars have been aged to be over 300 years old yet many are less than 10 feet tall.

To access the cliff from the parking area, you'll find a path at the southwest corner of the lot. Follow it through the woods, cross a utility line corridor, and continue through the woods another .25 mile or so to a point overlooking the Meramec River. To the right, an uphill path starts but soon disappears about halfway up the bluff. From there you are on your own to explore the rest of the rim. If you hike close to the cliff, you'll find occasional openings that offer great views. One of the best views is looking back at the

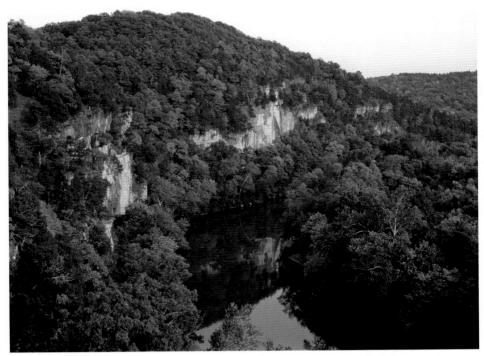

A view looking east at majestic Vilander Bluff as it towers over the Meramec River.

long expanse of the cliff from the north side of the natural area. Again, this is an explore at your own interest kind of hike as there are no official trails in the area and state parks staff have informed me that there are no plans to establish a trail system on Vilander Bluff anytime soon. To return to the parking area, I would recommend taking the same route back. If you choose to hike down the east side of the hill instead, you'll encounter lots of exposed rocks on the forest floor ranging from bowling ball-sized to small boulders that slow down your progress and make for unsure footing.

Directions: From Onondaga Cave State Park, turn left out of the parking lot onto Hwy. H, go 1.25 miles, turn right onto Possum Hollow Road. Proceed 4 miles and turn right onto Hwy. N, go 2.5 miles (crossing the Meramec River) and turn left onto Thickety Ford Road. Drive 1.25 miles, watch for blue State Park Boundary signs on the left, and after a few signs, look for a turn-in on the left to a small parking area. Or, from Bourbon, at the intersection of I-44 (exit 218) and Hwy. C, which becomes Hwy. N, follow Hwy. N into town on Pine Street and continue on Hwy. N for 9 miles (crossing the Meramec River) and turn left onto Thickety Ford Road. Drive 1.25 miles, watch for blue State Park Boundary signs on the left, and after a few signs, look for a turn-in on the left to a small parking area.

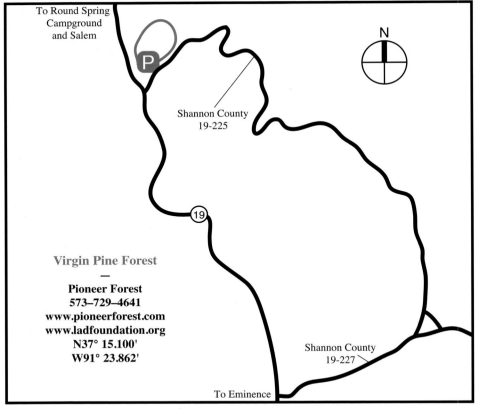

To Round Spring
Campground
and Salem

Shannon County
19-225

Virgin Pine Forest
—
Pioneer Forest
573–729–4641
www.pioneerforest.com
www.ladfoundation.org
N37° 15.100'
W91° 23.862'

Shannon County
19-227

To Eminence

VIRGIN PINE FOREST contains one of the few remaining forests of native, uncut short-leaf pine in Missouri. Here, you will find tall majestic 100-foot pines over 200 years old with their flat-topped crowns dominating the sky. Shortleaf pine once extended over 6.6 million acres in the Missouri Ozarks. Today, they occupy only about 500,000 acres. This reduction is due to extensive logging, which began in the late 1800s. There are few pine woodlands left or "pineries" a term dating back to 1758 to describe a grove of pines. The Virgin Pine Forest is such an example of a pinery. With such large scale logging occurring, the Missouri Department of Transportation, in 1940, purchased this stand of pines along one mile of Hwy. 19 to preserve it for the future. Then, in 1996, the L-A-D Foundation purchased 41.4 acres from the Missouri Department of Transportation, leaving a 50-foot highway right-of-way. The L-A-D Foundation is the nonprofit branch of Pioneer Forest that is dedicated to acquiring and preserving outstanding areas of natural, geologic, cultural and historic interest. To their credit, they have protected 10 natural and cultural areas in Missouri.

The old growth pine along Hwy. 19 is marked by signs at either end of the 1 mile drive. It is easy to spot these huge trees as you drive across this section of the highway. About halfway through it, a road on the east side of the highway is marked by a wooden Virgin Pine Forest sign on the slope. Just 0.1 mile down this road, you'll find a small pull-off. There you will find a 0.3-mile self-guided interpretive trail, called the Virgin Pine Walk that begins at the welcome sign. Pick up a trail brochure before beginning the walk through the old growth pine. You'll see some very impressive trees along the way.

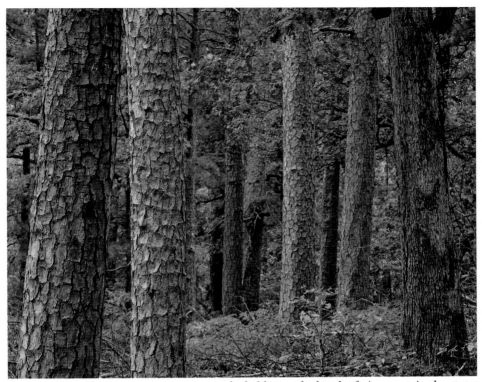
A micro view of the most impressive stand of old growth shortleaf pine trees in the state.

The parking area also marks the beginning of the Pioneer Forest Interpretive Drive, a 2-mile route through Pioneer Forest with stops along the way that demonstrate how their method of selectively cutting trees maintains mature trees and continuously-forested landscapes in the Ozarks. The brochure that is available at the parking area contains both the hiking trail and the interpretive drive.

Directions: On Hwy. 19, 32 miles south of Salem or 13 miles north of Eminence or 2.5 miles south of the Round Spring Campground and Picnic Area entrance, on the east side of Hwy, 19, take Shannon County 19-225, 0.1 mile and park at the pull-off on the left (north) side of the road.

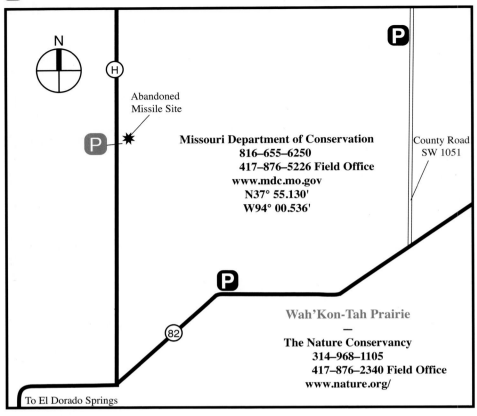

WAH'KON-TAH PRAIRIE is one of the largest prairies in Missouri. Here you'll find 2,331 acres of prairie, with another 280 acres planted to prairie grasses and forbs (prairie wildflowers), and 50 acres in forest and woodland for a total of 3,030 acres. My favorite walk on this prairie is along a broad ridge, where at 945 feet above sea level, you have a view of a great prairie landscape to the east and southeast. This is also some of the highest quality prairie in the area, but more on that below. The name, Wah'Kon-Tah, honors the Osage tribe and means "Great Spirit" or "Great Mystery." The Osages were said to be the largest native people in North America, with the Osage men averaging over 6 feet tall. They originally lived in the Ohio Valley but many migrated by 1673 to what is now western Missouri.

The prairie is predominately dry-mesic and contains over 300 native plants, including the federally endangered Mead's milkweed. Some of the rare or lesser known animals found here include: regal fritillary butterfly, prairie mole cricket, pink katydid, northern crawfish frog, slender glass lizard, Bell's vireo, grasshopper sparrow, loggerhead shrike, short-eared owl, northern harrier, Henslow's sparrow, and upland sandpiper. Greater prairie-chickens were formerly known from here and were reintroduced in 2008 with birds that were trapped and transported from the Flint Hills of Kansas. While there was once hundreds of thousands of prairie-chickens in Missouri, their numbers have more recently dropped to below 500. The goal for the release is to bring in birds with strong genetic stock and to manage the prairie in ways to ensure their survival. The prairie-chicken is

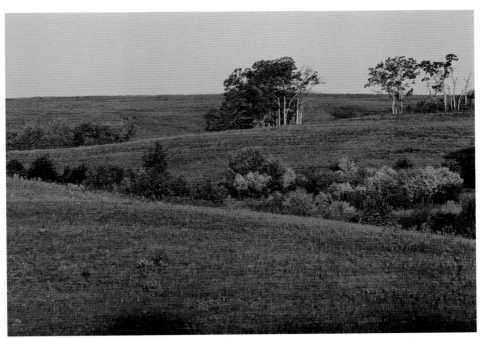

Sunrise casts its golden glow over a small section of this spacious prairie landscape that continues over the ridge.

considered to be an indicator species and if it is doing well, it is an indication that there is a healthy prairie ecosystem functioning.

After you park, go around the chain-linked enclosure and simply walk along the broad ridge to the east and southeast as far as you want to go, while taking in the great view and the variety of prairie plants and animals found here. There are no trails so you are free to wander.

Directions: From the intersection of Hwy. 54 and Hwy. 82 in El Dorado Springs, take Hwy. 82, 3 miles and turn left (north) on Hwy. H, then go 1.3 miles to a small pull-off area on the right (east). This used to be an entrance road to a Minuteman Missile Silo that was decommissioned shortly after 1997.

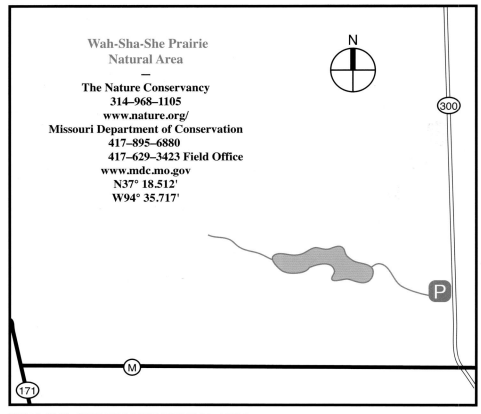

**Wah-Sha-She Prairie
Natural Area**
—
**The Nature Conservancy
314–968–1105
www.nature.org/
Missouri Department of Conservation
417–895–6880
417–629–3423 Field Office
www.mdc.mo.gov
N37° 18.512'
W94° 35.717'**

WAH-SHA-SHE PRAIRIE NATURAL AREA is an extremely rare type of prairie and, at 150 acres; it is also the largest prairie of its type left in Missouri. Fortunately, the previous landowners used the prairie to produce hay instead of plowing it up for rowcrops. Wah-Sha-She Prairie is a hardpan prairie. That means that about 20 inches below the surface, there is a thin layer of clay that accumulated after being weathered down from limestone. Little water gets past the hardpan so the prairie has a perched water table making the soil seasonably wet, especially in the spring, then becoming dry during the summer and fall.

Wah-Sha-She Prairie was designated a state natural area in 1975. It is owned by The Nature Conservancy and managed by the Missouri Department of Conservation. There are 150 acres of hardpan prairie and 10 acres of pond and shallow marsh. The wetland, though not natural, does add diversity to the area by attracting amphibians, reptiles, shorebirds and waterfowl. There are about 300 native plants that have been found on the natural area, which includes aquatic plants from the wetland. The prairie grasses are primarily little bluestem, big bluestem, switch grass and tickle grass. The prairie forbs are their showiest from late spring to midsummer. They include: Indian paintbrush, large-flowered coreopsis, tall blazing star, blue hearts, ashy sunflower and prairie rose gentian. Because of the nearly impenetrable hardpan, you will not find such deep rooted species as pale purple coneflower or compass plant, but that's okay. The diversity of prairie forbs that do live here are a special breed that can tolerate long periods of saturated soil giving way to periods of drought. These are tough plants indeed!

You may have noticed that there is some remaining hardpan prairie in private ownership in close proximity to Wah-Sha-She Prairie. Hopefully, the private prairie landowners and the owners/managers of the natural area can get together someday to protect more of

Purple-headed sneezeweed forms a centerpiece for the
numerous wands of tall blazing star.

this endangered prairie type. There is a great opportunity here to expand Wah-Sha-She Prairie another 200 acres to protect this unique prairie type for its own intrinsic value and for future generations to enjoy.

Directions: At the intersection of Hwy. 96 and Hwy. 171 north of Joplin go north 8 miles and turn right (east) on Hwy. M, proceed 0.8 mile and turn left (north) on County Road 300, then go 0.2 mile to the parking area.

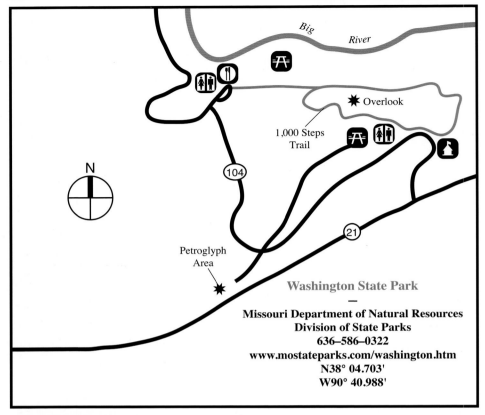

WASHINGTON STATE PARK has two exceptional features that are well worth the visit: the petroglyphs (rock carvings) and the 1,000 Steps Trail. The petroglyphs are Native American Indian carvings dating 1000 A.D. to 1600 A.D. It is believed that the park area served as a ceremonial gathering for Middle Mississippi people who had ties to the Cahokia Mounds village in Illinois. There are about 350 symbols over three sites that constitute more than one-third of the known petroglyphs in the state. (Thousand Hills State Park outside of Kirksville is another important petroglyph location.) Take the short wheelchair accessible walkway from the Petroglyph parking area to the interpretive shelter. Notice along the way, the dolomite glade on the lower slope. You may find some of the glade plants in flower. At the petroglyph site, you will see a wide variety of carvings including human figures, foot prints, turkey tracks, snakes, birds, and various geometric shapes and patterns.

The 1,000 Steps Trail is known for its outstanding display of spring wildflowers and ferns. April is a good month to visit this north slope above the Big River. This section of the park is also a state designated natural area. The 68-acre Washington State Park Hardwoods Natural Area is recognized for its significant mesic forest that contains an assemblage of very old trees many of which are over 150 years old. Here you will see large northern red oak, chinquapin oak, white oak, Kentucky coffee tree, bur oak, sugar maple, and others.

The 1.5-mile trail begins at the northeast end of the Thunderbird Lodge parking lot. Along the way, you'll be using stone steps that were constructed by stonemasons

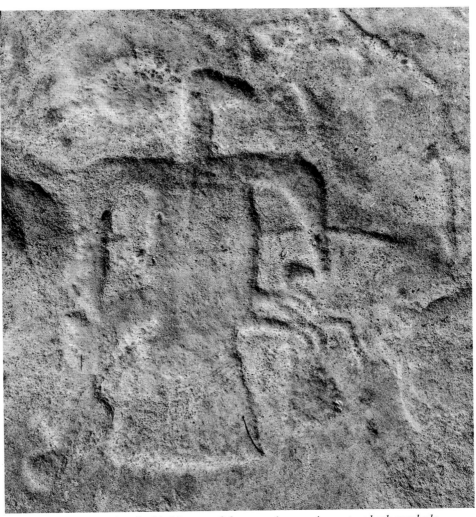

The mighty Thunderbird is one of the more impressive petroglyph symbols at this renowned archeological site.

of the African-American Civilian Conservation Corps. The steps lead to a scenic overlook of the Big River valley and a shelter overlook. The trail continues past a restroom and a small interpretive center. More stone steps lead you down the hill back along the lower slope where you will find wet-weather falls and an abundant variety of wildflowers and ferns.

Directions: Located 8 miles south of Desoto on Hwy. 21, turn right (north) onto Hwy 104 and follow the signs to the Petroglyphs parking lot.

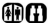

To Hwy. 19

N

Welch
Spring

K

Welch Spring

—

Ozark National Scenic Riverways
573–323–4236
www.nps.gov/ozar/
N37° 23.251'
W91° 34.489'

P

Current

River

To Akers

WELCH SPRING, with its daily flow of 75 million gallons, is the 8th largest spring in Missouri. The spring emerges from the base of a large Gasconade dolomite cliff, flows about 100 feet, then empties into the Current River where it doubles the flow of the river. An easy hiking trail offers close-up views of the crystal clear Current River, an interesting Ozark bluff, a bottomland forest, an old spring run that comes to life again when the river floods and the spring itself.

 The spring is named for Thomas Welch, who bought the spring and surrounding land in 1855. He built a grist mill on the spring branch and operated it for 50 years. After his death, Christian Diehl, an Illinois doctor bought Welch Spring in 1913. He then built a rest camp and sanitarium for asthma sufferers believing that the pollen-free cave air had medicinal qualities. In fact, he built the hospital right over the mouth of Welch Cave. His enterprise was not a big success and, after his death, was sold to a group of people who managed it as a trout fishing resort until it was purchased by the National Park Service in 1967. The cave entrance is now gated to protect habitat for the federally endangered gray bat. From the spring pool, you can see steps on the left that lead up to the old hospital. You can access it by hiking the old road that begins at a gated pullover along Hwy. K, just beyond the road to Welch Spring or by wading across the spring run.

 The hiking trail to Welch Spring begins at the edge of the Current River and parallels it for about one-third of the distance to the spring. You'll begin to see clumps of green water cress in the river, which is a sign that a spring has joined it upstream. Water cress is always found growing in spring water. The trail then travels along the base of a bluff where spring wildflowers bloom and ferns grow along the slope. You then enter a bot-

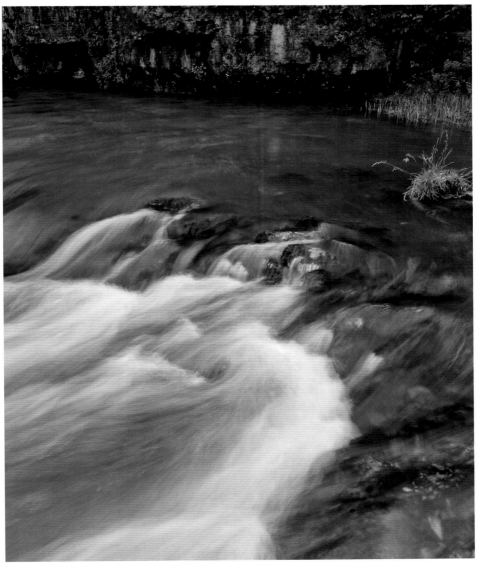

*Welch Spring emerges from the base of a dolomite cliff
followed by a short run to the Current River.*

tomland forest dominated by sycamore, silver maple, and boxelder, with an understory of pawpaw and spice bush. This area floods when the Current River is out of its banks. To the right is the old spring run that was used to operate the grist mill and it isn't long before you hear the roar of Welch Spring as it emerges from the base of a cliff and tumbles over rocks before entering the river. The first time that I walked this trail, I was impressed with the variety of natural features that are present in such a short distance. This trail captures the essence of what a classic Ozark waterway has to offer.

Directions: At the intersection of Hwy. 19 and Hwy. KK, 19 miles south of Salem, turn right (west) on Hwy. KK and proceed 5.8 miles and continue on Hwy. K another 1.5 miles, then turn left(south) on a gravel road, go 0.7 mile to a "Y" in the road, stay right for 100 ft to a parking area.

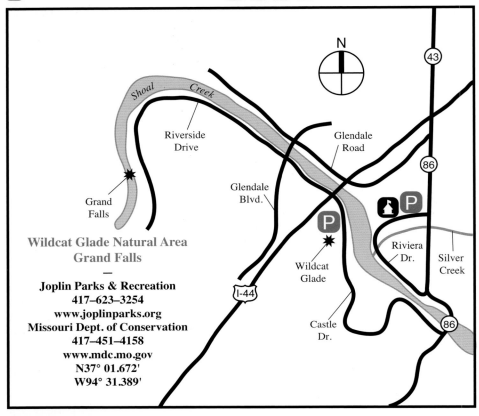

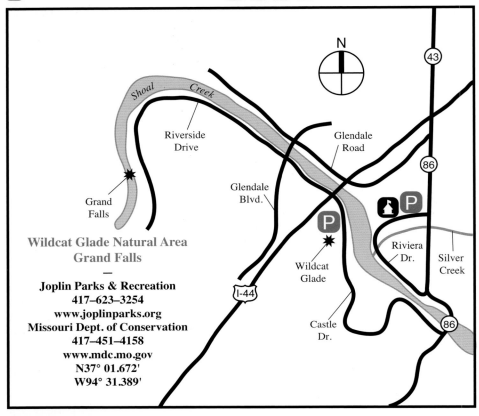

N

43

Shoal Creek

Riverside
Drive

Glendale
Road

86

Grand
Falls

Glendale
Blvd.

P

Riviera
Dr.

Silver
Creek

Wildcat Glade Natural Area
Grand Falls
—

Joplin Parks & Recreation
417–623–3254
www.joplinparks.org
Missouri Dept. of Conservation
417–451–4158
www.mdc.mo.gov
N37° 01.672'
W94° 31.389'

Wildcat
Glade

P

I-44

Castle
Dr.

86

WILDCAT GLADE NATURAL AREA AND GRAND FALLS are both in the same general area so I decided to combine them into one visit. Grand Falls has the distinction of having the greatest height and width of any permanent flowing falls in Missouri. Any falls found greater in height is either intermittent or short-lived. Shoal Creek plunges about 15 feet over solid chert, the hardest bedrock in the state. Geologists named this Mississippian-aged chert "Grand Falls" with outcrops occurring in only a few local areas of Newton and Barry Counties. A dam a short distance upstream from the falls appears to have little effect on the character of the falls but it does make photographing the falls a bit more challenging.

Wildcat Glade was designated a natural area in 1984 to protect an example of the rarest type of glade in the state. I once conducted an aerial survey searching for glades of the Grand Falls chert. I found 16 chert glades with a total of only 60 acres occurring mostly on the south side of Joplin and near the little community of Pioneer, just east into Barry County. Of the combined chert glade acreage, a surprising 27 acres or almost 50% occurs within Wildcat Park. Here, one of the largest glades remaining, Wildcat Glade Natural Area, has 10.4 acres and is owned by the City of Joplin with an adjoining 16.6 acres protected by the Missouri Department of Conservation. In order to see a variety of plants in bloom, this place is best visited from April through June. Look for the flowering of prickly pear cactus, glade wild onion, rock pink, Barbara's buttons, lance-leaved coreopsis, Nuttall's sedum, and Ohio spiderwort amongst patches of little bluestem grass. Here you will also find the lichen grasshopper whose camouflage mimics the lichen found on the chert surface.

While at Wildcat Park be sure to visit the recently built Wildcat Glades Conservation & Audubon Center (417-782-6287; www.wildcatglades.audubon.org). From the

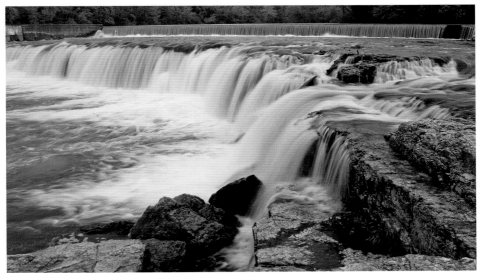

The artificial dam upstream cannot diminish the impressive size and flow of the largest waterfall in Missouri.

Tickseed coreopsis flourishes in the shallow pockets of soil interspersed amongst the lichen-covered chert bedrock.

intersection of I-44 and Hwy. 86, go south on Hwy. 86 for 0.5 mile and turn right (west) at the entrance to the visitor center. Here you will find exhibits, nature trails, naturalist programs, and a gift shop.

Directions: From the intersection of I-44 and Hwy. 86 southwest of Joplin take Hwy. 86 south 0.5 mile and turn right on Glendale Road for 0.8 mile, then turn left (south) and cross the bridge over Shoal Creek; to go to Grand Falls, immediately turn right on Riverside Drive and follow it for 0.9 mile to a parking area on either side of the road; to go to Wildcat Glade, after crossing over Shoal Creek, immediately turn left on Castle Drive, go 0.5 mile to a parking area on the right. When leaving the area, you can continue on Castle Drive, for 2.5 miles back to Hwy. 86.

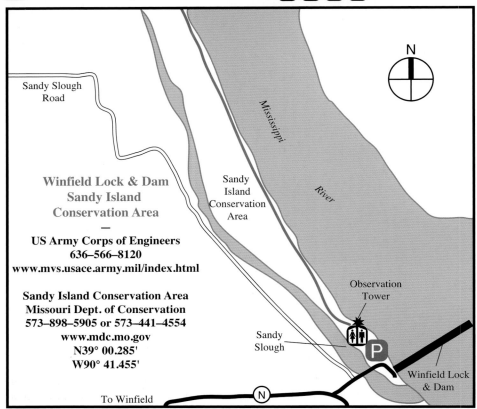

Sandy Slough Road

Mississippi River

Sandy Island Conservation Area

Winfield Lock & Dam Sandy Island Conservation Area
—
US Army Corps of Engineers 636–566–8120 www.mvs.usace.army.mil/index.html

Sandy Island Conservation Area Missouri Dept. of Conservation 573–898–5905 or 573–441–4554 www.mdc.mo.gov N39° 00.285' W90° 41.455'

Observation Tower

Sandy Slough

P

Winfield Lock & Dam

To Winfield

N

N

WINFIELD LOCK & DAM AND SANDY ISLAND CONSERVATION AREA provide visitors the opportunity to easily observe wildlife especially in the winter when bald eagles come into the area to feed and roost. Along with eagles, you will see white pelicans, various species of ducks, a variety of gulls, and other water-related birds. Ducks, gulls, and shorebirds can also be seen in the quiet waters of nearby Sandy Slough. There is a trail across Sandy Slough Road, just southeast of the parking lot. A 900- foot path parallels Sandy Slough and ends at a viewing platform that overlooks the area below the dam. Unfortunately, the upper deck of the two-level platform, which offers the best view, has been closed for sometime due to its wobbly nature. During especially cold weather when the river freezes, you will find the water below the dam clear of ice and that is where a lot of bird activity takes place. Fish, mostly shad, passing through the gates are often dazed or injured and tend to remain near the surface. That provides fishing opportunities for bald eagles and it is a common site to watch them glide over the water snatching fish. If it is a small fish, an eagle will eat it on the wing, but a larger catch will need to be taken to a tree for dining.

Sandy Island Conservation Area is accessed by walking north of the parking lot on the levee road. Along the way, you will find another observation deck overlooking the river. The conservation area begins about 300 yards north of the parking lot. The easy levee walk stretches a little over 2 miles alongside the Mississippi River. I know of no other place in Missouri where you can walk for such a long distance right next to the mighty Mississippi. Feel free to walk the entire distance or as far as you want to go before returning the same way. There is even an eagle nest viewing opportunity from the levee about 0.5 mile distance from the beginning of the conservation area. The first nest, about

A determined bald eagle is on a direct path to a lunchtime perch on a large cottonwood tree.

200 feet into the woods from the levee has been recently abandoned but look east about 0.2 mile and you'll see the new nest in a large sycamore tree. The tree had an active great blue heron rookery before the eagles took it over. Eagle use was the justification for the original purchase of the 308 acres of bottomland forest and wetland. Large cottonwood and silver maple trees were numerous and offered secure roosting at night for the bald eagles. Then along came the Great Floods of 1993 and 1995 that obliterated many of the enormous trees. Since then, the forest has been rejuvenating itself. A few large trees that survived the extended flooding still provide habitat for eagles that have also increased in numbers over the years.

Directions: From Winfield, at the intersection of Hwy. 79 and Hwy. N, go east 2.3 miles on Hwy. N to Sandy Slough Road (Lincoln Co. 957) and proceed 0.4 mile to the parking lot. The area is open from 6 am to sunset.

Glossary

Bethany Falls Limestone At 20 feet thick, it is the most extensively quarried limestone in western Missouri; fractures in the bedrock erode into large blocks showing wavy beds or layers that are interesting to view at places like Blue River Glades Natural Area. See LIMESTONE

Bluff A high steep bank or cliff, which can include the talus (rocky) slope below and the lip or crest above the cliff. See CLIFF

Bootheel That portion of southeastern Missouri that is shaped like the heel of a boot.

Bottomland forest Poorly-drained forest on level to nearly level land adjacent to a stream or river channel that is subject to periodic flooding. See FOREST, UPLAND FOREST

Breadtray granite A unique salmon-colored granite with limited distribution; best examples are exposed at Castor River Shut-ins Natural Area. See GRANITE

Burlington limestone A white to gray limestone commonly found in northern Missouri and less so in the southwestern part of the state; fossils are easily observed on weathered surfaces; the cliffs at Katy Trail State Park are an excellent example. See LIMESTONE

Cave A natural cavity in the bedrock generally large enough to be entered by a human that goes back far enough to reach total darkness; the air temperature typically ranges from 55° to 60°F.

Chert A compact silica-based rock of various colors made up of compressed microorganisms or precipitated silica grains; used by Native American Indians to make arrow heads and various tools.

Chert glade The rarest type of glade in Missouri with outcrops in and around the Joplin area; bedrock is extremely hard with small pockets of acidic soil that is low in fertility; the glades are showy in the spring but go mostly dormant by June due to the very droughty conditions; best example is Wildcat Glade Natural Area. See CHERT, GLADE

Cliff A high steep face of bedrock; a precipice. See BLUFF

Column The joining of a cave stalactite and stalagmite into a continuous unit. See STALACTITE, STALAGMITE, DRAPERY

Creek A stream with a relatively small flowing body of water usually fed by small drainages and emptying into a river or other large body of water. See STREAM, RIVER

Dolomite Common bedrock type found in the southern half of Missouri; made up of magnesium carbonate formed from sediment at the bottom of an ocean over 450 million years ago.

Dolomite glade The largest forming and most numerous glade-type in Missouri; ranging in size from less than an acre to over 300 acres and found mostly in the Ozarks; the best example in the state is at Ruth and Paul Henning Conservation Area. See DOLOMITE, GLADE

Drapery Flowstone in a cave that may grade into thin sheets resembling draperies or curtains where they extend over overhanging portions of the wall; some draperies are translucent, and some have brown and beige layers that look much like bacon (often termed "cave bacon"). See FLOWSTONE

Dry dolomite cliff A vertical rock cliff that is south- or west-facing and virtually devoid of vegetation except for small scattered pockets and crevices that support stress-tolerant trees, shrubs, grasses, sedges, and wildflowers; common along rivers and streams throughout the state excluding the Bootheel. See CLIFF, BOOTHEEL

Dry woodland A woodland with trees forming a canopy that ranges from 30 to 80%

closed with an open, sparse understory and scattered wildflowers, sedges, and grasses; found on upper slopes and narrow ridges on mostly south-, and west-facing hills. See WOODLAND

Dry-mesic prairie Found on nearly level to moderate slopes where the soils are moderately well-drained; the soils range from deep to shallow and soil fertility is moderate to high; the most common type of prairie remaining; the prairies contain a diverse variety of forbs but they are not as rich or dense as a mesic prairie; found scattered across northern Missouri but more frequently in the southwestern part of the state. See PRAIRIE, MESIC PRAIRIE, FORB

Dry-mesic upland forest An upland forest with well-drained soil; the most common forest type in Missouri; located on the mid- and upper-slope of north- and east-facing hills and on broad ridges. See UPLAND FOREST

Dry-mesic woodland A woodland with trees forming a canopy that ranges from 50 to 80% closed with an open, patchy understory and scattered wildflowers, sedges, and grasses; found mainly on mid to upper slopes that are east-, north-, or west-facing and also ridges; the most common type of natural community in the Ozarks.

Eminence dolomite A dark gray, cherty dolomite that is found in the Ozarks; cliffs, glades, caves, and springs are found in this formation but not as commonly as in Gasconade dolomite. See DOLOMITE, GASCONADE DOLOMITE

Fen A fairly steady flow of water slowly emerging at the base of a slope over an area much broader than a seep; occurring mostly in the Ozarks, the shallow wetland with mostly saturated soil are typically small in size but do range from a fraction of an acre up to 40 acres; several specialized and unique plants thrive in this environment. See SEEP, SPRING

Flowstone When drops of water carrying calcium carbonate precipitates out of solution forming sheet-like deposits along a cave wall and out onto the floor.

Forb An Old World term used to describe wildflowers that grow on prairies. See PRAIRIE

Forest An area dominated by trees that form a closed canopy with an understory of smaller trees, shrubs, and spring wildflowers. See SAVANNA, WOODLAND

Fossil The remains or traces of plants or animals which have been preserved in the earth's crust.

Gasconade dolomite A gray, cherty dolomite that is found in the Ozarks; cliffs, glades, caves, and springs are common in this formation; Ha Ha Tonka State Park contains all of these Gasconade dolomite features. See DOLOMITE

Glaciated A region that has been scoured and worn down by past glaciers; this applies to the northern half of the state that was last glaciated over 200,000 years ago.

Glade An opening in the forest with bedrock at or near the surface with patches of wildflowers, sedges, grasses, lichens, and mosses that can withstand the desert-like conditions; periodic fires are important in maintaining the character of glades.

Granite Coarse-grained igneous rock derived from magma that never erupted but remained below the earth's surface and slowly cooled to form large, weakly cemented grains over 2 billion years ago. See RHYOLITE

Habitat A natural environment where a plant or animals lives. See NATURAL COMMUNITY

Hill A portion of the earth's crust that is elevated less than 2,000 feet above the adjacent land. See MOUNTAIN

Hoodoo Rock outcrops that stand above the land in rounded shapes carved over time by ice, wind, and rain.

Ice age A glacial period most frequently referring to the last glacial period, which ended over 11,000 years ago.

Igneous Used to describe rock formed from the cooling of magma or lava. See MAGMA, LAVA

Igneous glade Found on slopes, knobs, and along shut-ins where igneous rock is exposed; the vegetation is typically less diverse than that found on dolomite glades because the soil is more acidic and less fertile; located in southeastern Missouri in a region known as the St. Francois Mountains; Taum Sauk Mountain has excellent examples. See IGNEOUS, GLADE, ST. FRANCOIS MOUNTAINS

Jefferson City dolomite A light brown dolomite, often containing small amounts of clay, averaging 200 feet thick; found to outcrop around the periphery of the Ozarks; known to form large dolomite cliffs along the Missouri River and numerous large glades in Jefferson County; excellent examples are Victoria Glades and Valley View Glades Natural Area. See DOLOMITE

Karst A German word used to describe a region of Slovenia; a type of landscape that is formed over limestone or dolomite by dissolving or solution from water, and that is characterized by sinkholes, caves, and underground drainage. See CAVE, SINKHOLE, SPRING

Kimmswick limestone A white to light-gray rock with distinctive weathering that is notably pitted or honeycombed; fossils are common throughout the formation; infrequently outcropping along a narrow band ranging from St. Louis to Cape Girardeau; an excellent example is at Mastodon State Historic Site. See LIMESTONE

Lake An inland body of water over 5 acres in size. See POND

Lamotte sandstone The oldest (over half a billion years) sedimentary rock in Missouri with coarse to fine grains of quartz derived from eroding volcanoes; varying in color from light gray to yellow, brown, or red; outcropping in the east central part of the Missouri Ozarks; outstanding exposures are found at Pickle Springs Natural Area. See SANDSTONE

Lava Molten rock that flows from a volcano or a crack in the earth's surface. See MAGMA

Limestone Common bedrock type found mainly in the southwestern and northern parts of Missouri; made up of calcium carbonate derived from shell fragments from aquatic organisms that settled at the bottom of an ocean over 350 million years ago

Limestone glade Found primarily in southwestern Missouri; small in number and size (less than 10 acres); soils are moderately alkaline and fertility is good; vegetation diversity is less than dolomite glades but more than igneous, sandstone, and chert glades. See GLADE, LIMESTONE

Loess (Pronounced luss or learse) Fine-grained silt that was wind-blown from dry river beds during glacial periods to form soil layers of varying thicknesses.

Magma Molten rock that does not break the earth's surface. See LAVA

Marsh A mostly treeless, water-filled depression occurring in floodplains of major rivers and streams; dominated by herbaceous plants adapted to living in an aquatic environment; extremely rare due to ditching and draining; best examples include Chloe Lowry Marsh Natural Area, Mingo National Wildlife Refuge and Squaw Creek National Wildlife Refuge.

Mature second growth forest A forest that has been cut over at least once with dominant trees in the range of 40 to 90 years old.

Mesic bottomland forest A forested area where the soil is somewhat drained but may

218

become inundated during floods; the land is slightly elevated such as on a terrace near a river or stream. See BOTTOMLAND FOREST

Mesic prairie A moist prairie on level or nearly level ground, where soils are moderately to somewhat poorly drained, deep, and very fertile; occurring primarily in the glaciated region of northern Missouri; the prairies are rich with a high grass and forb density; a very rare type of prairie due to extensive plowing; Helton Prairie Natural Area is an excellent example. See PRAIRIE, GLACIATED, FORB

Mesic upland forest An upland forest with moderately well-drained soil that is moist for significant periods of time; often located near the base of north- and east-facing slopes and ravines; typically rich with spring wildflowers. See UPLAND FOREST

Mima mound Named for Mima, WA; small mounds of soil scattered across prairies west of the Mississippi River; origin unknown but likely created by a species of pocket gopher that is now extinct.

Mountain A portion of the earth's crust that is elevated a minimum of 2,000 feet above the adjacent land. See HILL

Natural arch A rock arch whose opening has been eroded by ice, wind and rain. See NATURAL BRIDGE

Natural bridge A rock arch whose opening has been eroded by a stream. See NATURAL ARCH

Natural community A natural environment where plants and animals live and interact. See HABITAT

Neotropical The biogeographic region of the New World that stretches southward from the Tropic of Cancer and includes southern Mexico, Central and South America, and the West Indies.

Old growth forest A forest that has never been logged or harvested with the dominant trees over 120 years old.

Ozarks An unglaciated region of the southern half of Missouri that was uplifted over 100 million years ago. See UNGLACIATED

Pine woodland Once a common natural community in the Ozarks; large stands of old growth shortleaf pine over 250 years old was harvested in the late 1800s to early 1900s and, with fire suppression, allowed to be replaced by oaks and hickories; agencies are working to manage select areas to bring back this endangered community; a good example is Virgin Pine Forest. See WOODLAND

Pond An inland body of water less than 5 acres in size. See LAKE

Prairie Native grasslands dominated by warm-season grasses and forbs with very few trees. See FORB

Quartz Is made up of silica, the second most common mineral in the earth's crust and also the most common mineral resistant to weathering. See SANDSTONE

Rhyolite Fine-grained igneous rock derived from lava that erupted in volcanic fashion and quickly cooled to form small, tightly cemented grains over 2 billion years ago. See GRANITE

River A stream with a relatively large flowing body of water usually fed by tributaries and emptying into the ocean or other large body of water. See STREAM, CREEK

Roubidoux sandstone Fine- to medium-grained quartz sand that is red when fresh and weathers to a grayish brown color with age; found to outcrop in the southern part of the state; good exposures are found at Sunklands Natural Area. See SANDSTONE, QUARTZ

St. Francois Mountains A region located in southeastern Missouri that contains the oldest exposed rocks in the Midcontinent United States; these igneous rocks are over 2 to 3 billion years old and have weathered to form prominent knobs and deep valleys. See IGNEOUS

Sand prairie A sand dominated landscape with small dunes, blowouts and depressions supporting sparse to moderate clumps of native grasses and forbs; the sandy soil is moderately to excessively well-drained, deep, and low in nutrients; an extremely rare prairie type found on two sandy ridges in the Bootheel; Sand Prairie Conservation Area is the best example in the state. See PRAIRIE, FORB, BOOTHEEL

Sandstone A cemented accumulation of quartz grains derived from sand. See QUARTZ

Sandstone glade Found on slopes of hills mostly scattered across the Ozarks; typically small in acreage; the vegetation is less diverse than that found on dolomite glades because the soil is more acidic and less fertile; a good example is at Pickle Springs Natural Area. See GLADE, SANDSTONE

Savanna A prairie landscape of grasses and forbs with scattered, open-grown trees covering less than 30% of the area; periodic fires are needed to maintain a savanna's character; this natural community is extremely rare and probably gone from the state due to human activity. See FOREST, WOODLAND, NATURAL COMMUNITY

Sedimentary rock Rocks formed by the accumulation of sediment in water or from air; the sediment may come from rock particles of various sizes including sand, also from mud, or from remains of plants or animals.

Seep A small groundwater discharge area that can go dry for periods of time; either forested or open, they can support some wet soil plants but none that require standing water. See SPRING, FEN

Shrub swamp A swamp that is dominated by shrubs; they occur in floodplains of major rivers and streams and in sinkhole ponds. See SWAMP, SINKHOLE PONDS

Silvermine granite A gray-colored igneous rock so named for the silver mining activity where this bedrock is exposed along the St. Francis River; this feature occurs at Millstream Gardens Conservation Area. See GRANITE, IGNEOUS

Sinkhole A collapsed portion of bedrock above a chamber or passageway of a cave. The Sunklands Natural Area contains the largest example in the state. See CAVE

Sinkhole pond A sinkhole that over time has become plugged with surface debris allowing water to accumulate; a good example is Cupola Pond Natural Area. See SINKHOLE

Slough An abandoned channel of a stream that seasonally or semi permanently holds water.

Soda straw Delicate hollow tubes that begin forming on the ceiling of a cave when water containing calcium carbonate dissolves out of solution on the tip; each successive drop deposits a ring of mineral at its edge causing the straw to grow downward; if the hollow tube becomes clogged, a stalactite will form.

Spring A continual natural flow of water emerging usually from a single outlet that runs along a well-defined channel; the water temperature typically ranges from 56° to 59°F.; the presence of water cress is a good spring indicator. See SEEP, FEN

Spring run A well-defined channel carrying a current of water emitted from a spring opening that eventually empties into a stream or impoundment.

Stalactite As water emerges from a cave ceiling, it combines with oxygen and participates out calcium carbonate that accumulates as a cone-shaped rock hanging from the roof. See STALAGMITE

Stalagmite Water dripping from the cave roof that flows down a growing stalactite hits the floor and begins building up a reverse cone-shaped rock that eventually will meet the stalactite and form a column. See STALACTITE

Stream A flowing body of water with a current, confined within a bed and stream banks; a collective term that includes rivers and creeks. See RIVER, CREEK

Swamp A nearly continuously flooded wetland dominated by trees; the understory is poorly developed or absent and a groundcover is lacking; once an extensive part of the Bootheel, most have been ditched and drained for agriculture; an extremely rare natural community; the best examples are Allred Lake Natural Area, Big Oak Tree State Park, and Mingo National Wildlife Refuge. See BOOTHEEL, WETLAND

Unglaciated A region that was never covered by glaciers; the Ozarks is such an example. See OZARKS

Upland forest Higher, well-drained forest located on the slope and ridge of a hill and not subject to flooding. See FOREST, BOTTOMLAND FOREST

Upland prairie Approximately one-third of Missouri or 15 million acres was once dominated by upland prairie; occurring on nearly level to moderate slopes, the soils are moderately to well-drained, shallow to deep with fertility moderate to high; they were once maintained by periodic fire and bison; today cattle grazing and haying are common practices on private prairies; fortunately, of the 70,000 acres of prairie remaining, about 25,000 acres is protected by various agencies and organizations. See PRAIRIE

Wet bottomland forest A forested area where the soil is poorly drained; water is removed from the soil so slowly that the water table is at or above the surface most of the time. See BOTTOMLAND FOREST

Wet bottomland prairie A grassland occurring in the floodplain along rivers and streams; the areas are subjected to flooding and contain deep, poorly drained soil with high fertility; the primary grass is prairie cord grass with a mixture of other grasses, sedges, and forbs that can tolerate prolonged flooding; once found along major floodplains in northern and western Missouri, there are only five sizable wet prairies remaining in the range of 100 to 200 acres; the best example is Ripgut Prairie Natural Area.

Wet-mesic bottomland prairie A grassland occurring in the floodplain along rivers and streams; the areas are subjected to less flooding than wet bottomland prairie, with deep, somewhat poorly drained soil with high fertility; big bluestem grass along with prairie cord grass dominate along with a more diverse mixture of forbs than wet bottomland prairie; once occurring in major floodplains across the state except for the Ozarks; an excellent example is found at Ripgut Prairie Natural Area. See OZARKS, WET BOTTOMLAND PRAIRIE

Wetland Natural communities that are adapted to prolonged inundation or saturation by water thus creating wet soil conditions that favor the establishment of water tolerant plants.

Woodland An area dominated by trees that form a canopy ranging from 30% to nearly closed; the understory is open and sparse with scattered shrubs, wildflowers, and grasses; periodic fires are needed to maintain a woodland's character. See FOREST, SAVANNA

Young second growth forest A forest that has been cut over at least once with dominant trees in the range of 20 to 40 years old.

Selected Reading

Beveridge, Thomas R. (Vineyard, Jerry D., revised ed.) *Geologic Wonders and Curiosities of Missouri*. Missouri Department of Natural Resources, Jefferson City, MO. 1978, 1990. This is a great reference and guide to unique and special geologic formations across the state.

DeLorme. Missouri Atlas & Gazetteer. DeLorme, Yarmouth, ME. 2007. A set of 71 maps in book form that is much more detailed than a highway or county road map.

Denison, Edgar. *Missouri Wildflowers*. 6th ed. Missouri Department of Conservation, Jefferson City, MO. 2008. A long standard for the identification of common wildflowers in the state.

Division of Geology and Land Survey. *Geologic Map of Missouri 2003*. Missouri Department of Natural Resources, Rolla, MO. 2003. An impressive wall map of the state showing with great accuracy the various bedrock types. I quartered the map and mounted it back to back on two pieces of foam core and carry in my vehicle for reference as I travel.

Jacobs, Brad. *Birds in Missouri*. Missouri Department of Conservation, Jefferson City, MO. 2001. Color illustrations, descriptions, habitats and range maps for 354 Missouri birds.

Kurz, Don. *Ozark Wildflowers*. The Globe Pequot Press (Falcon Guide), Guilford, CT, 1999. Color photos and descriptions of 355 species of wildflowers that occur in the Ozarks.

_____. *Scenic Driving the Ozarks.* The Globe Pequot Press (Falcon Guide), Guilford, CT. 2004. A resource for locating exceptional drives throughout the Ozarks.

_____. *Shrubs and Woody Vines of Missouri*. Missouri Department of Conservation, Jefferson City, MO. 2004. Illustrations and detailed information on 170 species of shrubs and woody vines found in the state.

_____. *Shrubs and Woody Vines of Missouri Field Guide*. Missouri Department of Conservation, Jefferson City, MO. 2009. Based on the original Shrubs and Woody Vines of Missouri, this is a concise, easy-to-carry color field guide.

_____. *Trees of Missouri*. Missouri Department of Conservation, Jefferson City, MO. 2003. Illustrations and detailed information on 167 species of trees found in the state.

_____. *Trees of Missouri Field Guide*. Missouri Department of Conservation, Jefferson City, MO. 2007. Based on the original Trees of Missouri, this is a concise, easy-to-carry color field guide.

Missouri Department of Conservation. *Public Prairies of Missouri*. 4th ed. Missouri Department of Conservation, Jefferson City, MO. 2003. Maps and descriptions for 79 areas that contain prairie.

Missouri Natural Areas Committee. *Directory of Missouri Natural Areas*. Missouri Department of Conservation. 1996. Also: http://mdc.mo.gov/areas/natareas/ Maps and descriptions for 169 state designated natural areas.

Nelson, Paul. *The Terrestrial Natural Communities of Missouri*. Missouri Department of Natural Resources, Jefferson City, MO. 2005. Detailed information is provided on 89 types of forest, savanna, prairie, glade, marsh, fen, cliff, and cave natural communities.

Thompson, Thomas. *The Stratigraphic Succession in Missouri*. Missouri Department of Natural Resources. 1995. For those wanting detailed information on the classification, nomenclature, distribution, origin, and thickness of the various rock units in the state.

Unklesbay, A. and Vineyard, Jerry. *Missouri Geology*. University of Missouri Press, Columbia, MO. 1992. The influence of geology to the geography, history, culture, and economy to the state.

About The Author

After completing masters' degrees in botany and zoology from Southern Illinois University, Carbondale, Don Kurz spent the next 30 years working to inventory, acquire, protect, and manage natural areas, endangered species sites, and other special features. Growing up in Illinois, some of his early jobs included working for the Illinois Environmental Protection Agency and the Illinois Natural Areas Inventory. Later, he was employed by the Missouri Department of Conservation, where he held various supervisory positions in the Natural History Division, including that of Natural History Chief.

For over 30 years, Don has been writing about nature and photographing landscapes, wildlife, and plants. His work has appeared in several calendars and magazines and in numerous wildflower books including Falcon Publishing's *Tallgrass Prairie Wildflowers* and *North Woods Wildflowers*. He is also the author of Falcon's *Scenic Driving the Ozarks, Including the Ouachita Mountains* and *Ozark Wildflowers*, as well as *Shrubs and Woody Vines of Missouri, Shrubs and Woody Vines of Missouri Field Guide, Trees of Missouri*, and *Trees of Missouri Field Guide*, all published by the Missouri Department of Conservation. Another book, *Illinois Wildflowers*, is from Cloudland.net Publishing (who is also the publisher of this guide!).

Maps Legend

———— Main Trail or Scenic Highway	**P** Main Parking Area								
— — — — Main Route—Bushwhack	**P** Other Parking								
– – – – Other Trails or Routes	**A** Visitor Center								
- - - - - - Alternate Bushwhack Route	**W** Waterfall								
≈≈≈ Creek, Streams, Rivers	∩ ⋎ Spring, Cave								
	✳ Point of Interest								
Lake, Swamp/Bayou	/								Bluffline
———— Paved Road	⋏ † Campground, Cemetery								
═══ Gravel Road	(I-40) Interstate Highway								
= = = = Jeep Road	(23)(341) State/County Road-Paved/Gravel								
● ■ Town, Building	[1003] Gravel Forest Service Road								

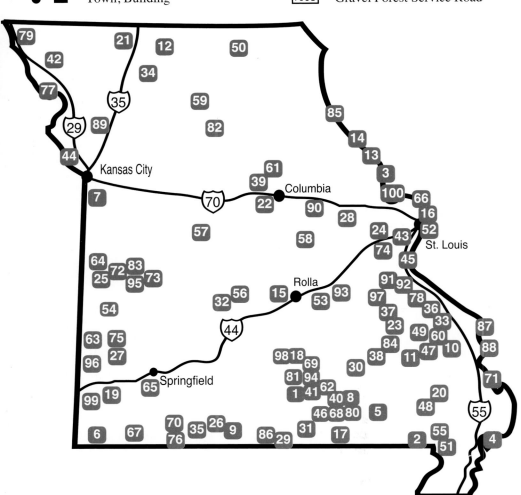

224